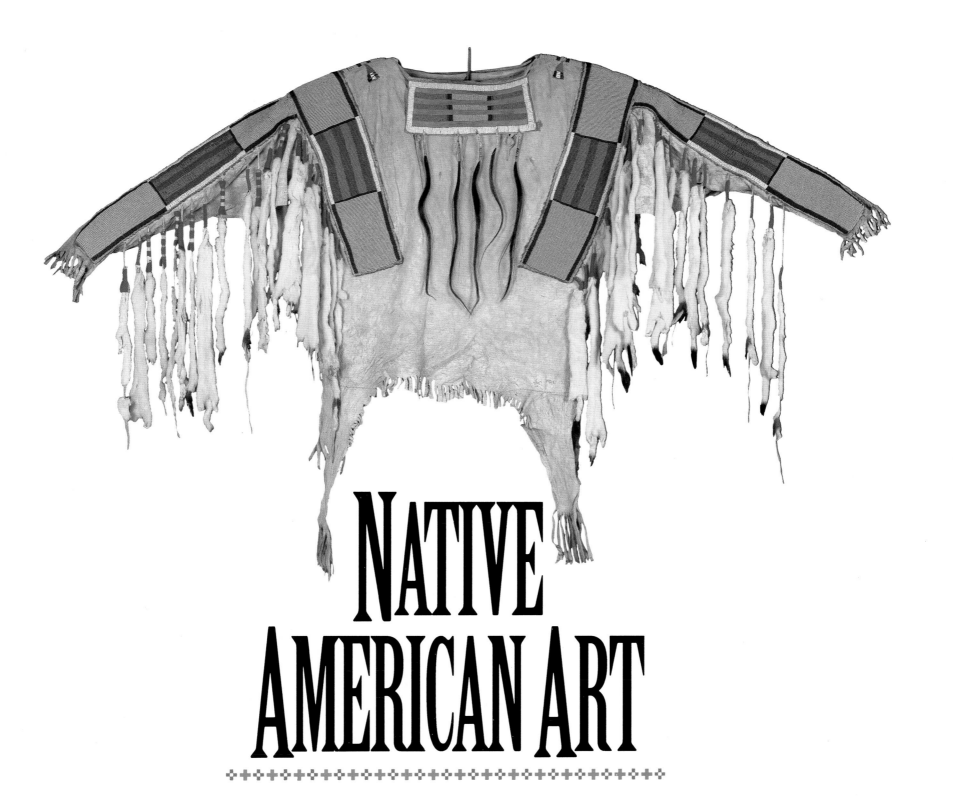

Native American Art

+◆+

NATIVE AMERICAN ART

ROBIN LANGLEY SOMMER

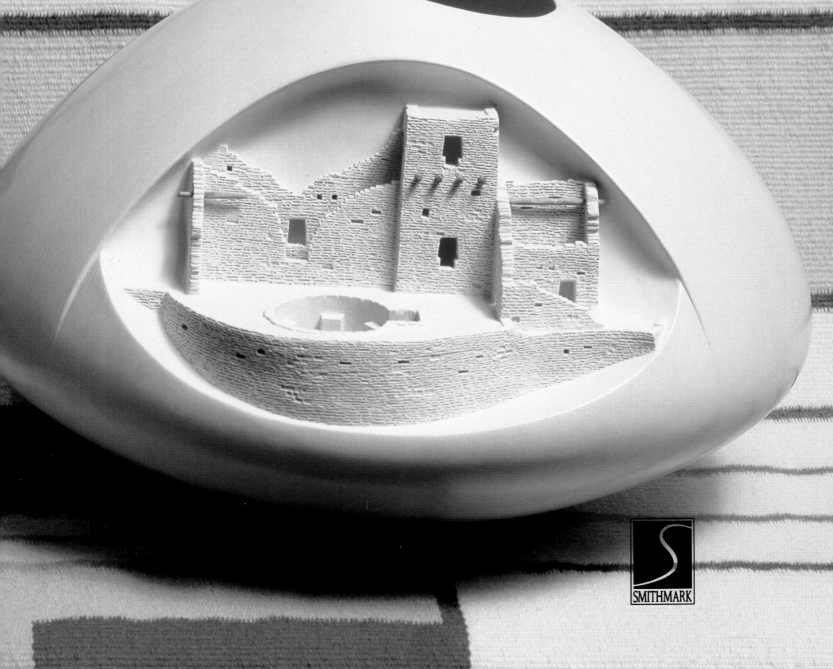

SMITHMARK

Page 1:
Crow War Shirt, c. 1860
Tanned hide, beads, ermine drops, human hairlocks
Courtesy Morning Star Gallery, Santa Fe,
New Mexico
Photography by Addison Doty

Pages 2-3:
Textile:
The Gift #2, FLLW Series
Ramona Sakiestewa–Hopi
43 × 62 inches

Pottery:
Gila Shoulder Cliff Palace, 1991
Al Qoyawayma–Hopi
10 × 15½ inches
Courtesy Gallery 10, Scottsdale, Arizona, and Santa
Fe, New Mexico

These pages:
Potawatomi Woman's Blouse, c. 1875
From David T. Vernon Collection
Colter Bay Indian Arts Museum,
Grand Teton National Park, Wyoming
Photography by Jerry Jacka

This edition published in 1995
by SMITHMARK Publishers Inc.,
16 East 32nd Street
New York, New York 10016.

SMITHMARK books are available for bulk purchase
for sales promotion and premium use. For details
write or telephone the Manager of Special Sales,
SMITHMARK Publishers Inc., 16 East 32nd Street,
New York, NY 10016. (212) 532-6600.

Produced by Brompton Books Corp.,
15 Sherwood Place,
Greenwich, CT 06830.

ISBN 0-8317-6338-8

Printed in Spain

10 9 8 7 6 5 4 3 2

CONTENTS

INTRODUCTION

The second half of the 20th century has seen a renaissance of Native American art. During the long period when the American Indians were being displaced from their ancestral homelands by the pressures of white settlement and commerce, there was little awareness that a priceless artistic heritage was deeply endangered. During the early nineteenth century, only a few ethnologists and artists sounded the alarm, and they were largely ignored. But gradually, the efforts of men like George Catlin, who traveled the West painting Indian tribes and their traditional way of life during the 1830s, began to bear fruit. Collectors acquired Native American artifacts imbued with an artistry that colored every aspect of daily life. Archaeological findings about the antiquity of the native peoples, who crossed the land bridge between Siberia and Alaska when glaciation was at its greatest extent, fostered growing respect for the achievements of those diverse groups, who fanned out across the continent to form cultures as distinct as those of the Southeastern Mound builders and the Northwestern seafarers. In recent times, both Native Americans and those who value their cultural heritage have taken strides to preserve and strengthen it.

The spectrum of Native American art includes pottery; silverwork (jewelry, belts, and ornaments); quillwork; beadwork; leatherwork; weaving (baskets, textiles, and other household objects); ceremonial regalia and representational objects, including masks, pipes, *kachina* dolls, and headdresses; carving and sculpture in wood, stone, bone, horn, and other media; and contemporary oil painting, watercolor, and collage. There are wide variations in design and materials, not only from one culture area to another, but from tribe to tribe within a given culture area. However, there are many commonalities, including a reverence for nature in all its manifestations and the bond between people and their gods, forged and strengthened by ritual acts and ceremonies, including dances, vision quests, sacrificial offerings, and symbolic exchanges of power.

The prehistoric people of the Eastern Woodlands – roughly, the forested regions from the Atlantic Coast to the Mississippi River valleys – left behind many remnants of their culture, especially pottery offerings placed in their burial mounds with the dead. Shell middens provided another rich source of pottery, which can survive inhumation for millennia under the right conditions. Other durable objects include household utensils, pipe bowls, and ceremonial images carved from stone.

Prehistoric pottery included jars, bowls, cups, and vases, many of them in the shape of birds, frogs, and other animals. Sometimes an animal head was modeled separately and applied as decoration. Shell-shaped vessels were not uncommon, and some pottery designs were adopted from basketwork.

Some tribes of the Southern Appalachians made elaborately figured stamps to apply to wet clay, while others incised their designs. Over time, paints made from plants and minerals were applied, and colorful effects were produced by slips – thinned clay used for decorating or coating ceramics. In the Middle Mississippi Valley, as in the prehistoric Southwest, elegant and varied shapes evolved, decorated primarily in white, red, brown, and black. Many designs were common to both culture areas and persist in Native American art down to the present, with some modifications. These include geometric forms, human hands, sunflowers, thunderbirds (representing both eternal happiness and the primal power of the elements), linked scrolls, and cross shapes, signifying the four directions. Bird monsters, sometimes with human heads, recurred as well.

In early historic times, the Northeastern tribes, especially the Iroquois confederation, were known for their pottery, but with European contact, most of their cookware was soon replaced by traded metal utensils. However, the tribes of the Iroquois Nation – Oneida, Seneca, Mohawk, Onondaga, Cayuga, and Tuscarora – made accommodations to European settlement without losing their cultural identity. They lived in "long houses" of bark surrounded by wooden stockades, hunted game and fished, and grew corn, beans, and squash. They taught these skills to white settlers and made treaties with neighboring tribes, including the Delaware, Mohican, Pequot, and Powhatan. Their traditional clothing was made of tanned and softened deerskin, embroidered with moose hair, porcupine quills, and beads. Originally, their beadwork was done in the shell beads used to make wampum belts, in which white and purple predominated. Then white traders began to produce glass beads in these and other colors. Eventually they were traded throughout North America for beadwork in many tribal styles and designs.

Their proximity to white settlers soon made the Iroquois proficient in metalworking, and they began to produce distinctive silver jewelry in the form of brooches and other ornaments. Originally, they hammered and cut silver coins

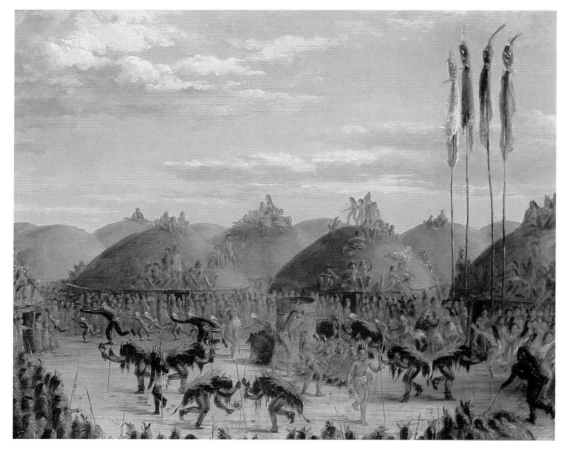

Bottom left: *Mandan Bull Dance, Dakota* (1832) is one of many ethnographically important paintings of Native Americans produced by George Catlin (1796-1872) in the early to mid-19th century. (*Smithsonian Institution*)

Below: This map shows the major linguistic groups of North America's native peoples as well as the locations of the major tribes in the pre-contact period.

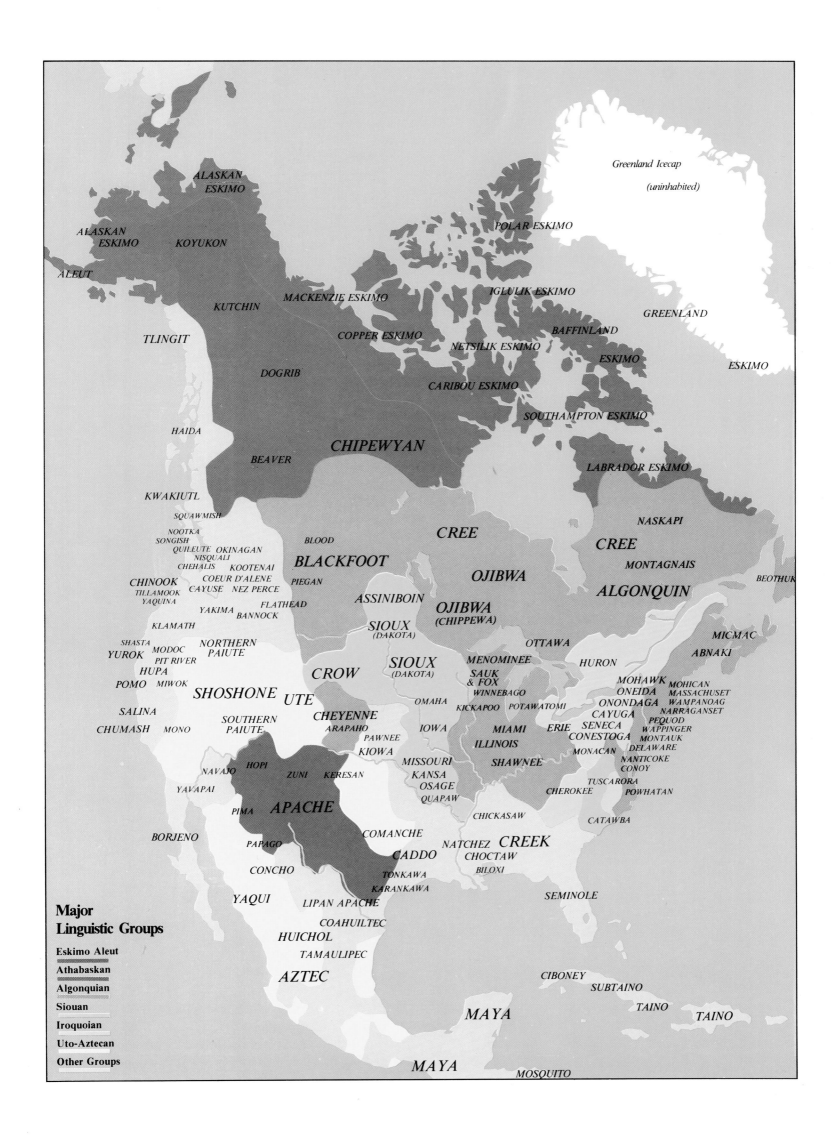

Greenland Icecap

(*uninhabited*)

ALASKAN ESKIMO

POLAR ESKIMO

ALASKAN ESKIMO

KOYUKON

ALEUT

KUTCHIN

MACKENZIE ESKIMO

IGLULIK ESKIMO

GREENLAND

TLINGIT

COPPER ESKIMO

BAFFINLAND

NETSILIK ESKIMO

ESKIMO

ESKIMO

DOGRIB

CARIBOU ESKIMO

HAIDA

SOUTHAMPTON ESKIMO

CHIPEWYAN

BEAVER

LABRADOR ESKIMO

KWAKIUTL

NASKAPI

SQUAWMISH

CREE

CREE

NOOTKA

SONGISH

BLOOD

MONTAGNAIS

QUILEUTE OKINAGAN

NISQUALI

BLACKFOOT

OJIBWA

ALGONQUIN

BEOTHUK

CHEHALIS KOOTENAI

COEUR D'ALENE

CHINOOK CAYUSE NEZ PERCE

PIEGAN

TILLAMOOK

YAQUINA

ASSINIBOIN

OJIBWA

(CHIPPEWA)

MICMAC

YAKIMA FLATHEAD

BANNOCK

SIOUX

(DAKOTA)

OTTAWA

ABNAKI

KLAMATH

SHASTA

MODOC

NORTHERN

PAIUTE

HURON

MOHAWK MOHICAN

YUROK

PIT RIVER

SIOUX

(DAKOTA)

MENOMINEE

ONEIDA MASSACHUSET

HUPA

CROW

SAUK

& FOX

ONONDAGA WAMPANOAG

POMO MIWOK

WINNEBAGO

CAYUGA NARRAGANSET

SHOSHONE UTE

OMAHA

KICKAPOO POTAWATOMI

SENECA PEQUOD

WAPPINGER

SALINA

CHEYENNE

IOWA

MIAMI

ERIE

CONESTOGA

MONTAUK

DELAWARE

CHUMASH MONO

SOUTHERN

PAIUTE

ARAPAHO

ILLINOIS

MONACAN NANTICOKE

CONOY

PAWNEE

SHAWNEE

NAVAJO

HOPI

KIOWA

MISSOURI

TUSCARORA

ZUNI KERESAN

KANSA

POWHATAN

YAVAPAI

OSAGE

CHEROKEE

PIMA

APACHE

QUAPAW

CATAWBA

CHICKASAW

BORJENO

COMANCHE

PAPAGO

CADDO

NATCHEZ CREEK

CONCHO

CHOCTAW

TONKAWA

BILOXI

YAQUI

KARANKAWA

LIPAN APACHE

SEMINOLE

COAHUILTEC

HUICHOL

TAMAULIPEC

AZTEC

CIBONEY

SUBTAINO

MAYA

TAINO

TAINO

MAYA

MOSQUITO

Major Linguistic Groups

Eskimo Aleut

Athabaskan

Algonquian

Siouan

Iroquoian

Uto-Aztecan

Other Groups

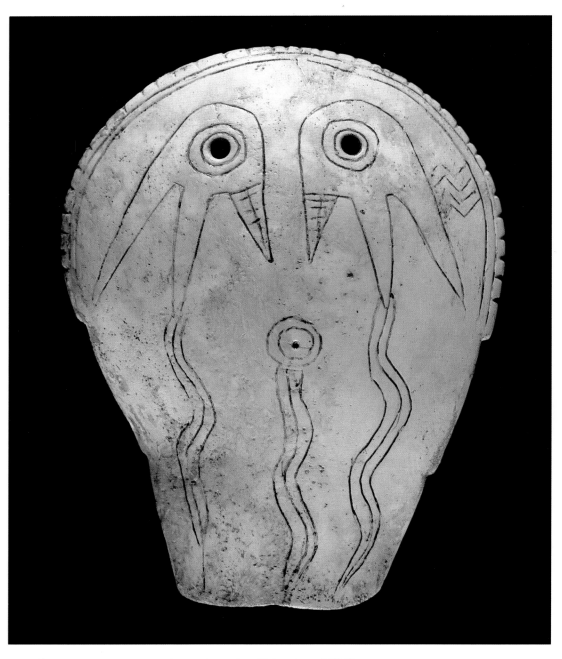

Left: This marine shell miniature (5 × 4 × ½ inches) mask recovered from a Southeastern Mound Culture site dates from A.D. 1300-1500. (*Frank H.McClung Museum, The University of Tennessee, Knoxville/Photography by W. Miles Wright*).

into flat shapes. Later, they molded pure silver into the desired forms. They also carved masks of basswood in the form of grotesque faces worn by shamans to drive away evil spirits.

Throughout the region, bowwoods, pigments, and animal skins had long been traded widely among the various tribes. As European influence increased, so did the number of trade goods designed to win Indian friendship and alliance, and to encourage fur trade with specific merchants. Such goods as ribbons, buttons, nickel silver, and aniline dyes were eagerly adopted by native craftsmen for their work.

The Woodlands people of the Great Lakes had a sedentary pattern of life and an abundant food supply, which enabled them to develop more refined arts than those of the tribes living in harsher climates to the north. All the Great Lakes tribes produced metal ornaments, at first from hammered coins, later from sheets of nickel silver obtained from white traders. They made perforated brooches, finger rings, earrings, bracelets, hat and head bands, and women's combs. They also excelled in ribbon appliqué, done in silk ribbons of assorted widths, which were traded as early as were glass beads. Ribbonwork was applied to bags and garments as edge trim, or cut and folded into designs that were sewn on to men's shirts, women's skirts, and blankets. Dozens of narrow, colorful ribbons might be used to adorn clothing and household goods, increasing the wealth and status of the wearer. Ribbon appliqué was produced in both floral and geometric designs, some of them based on earlier porcupine quillwork. Women of the Sac and Fox tribes were known for their skill in ribbonwork; some of them still practice this craft.

The Great Lakes tribes were also skillful at making boxes of birch bark, woven bags, war clubs carved of wood, and clothing and other objects decorated with quillwork. They brought the art of quillwork to a high form, producing dyes of bright, long-lasting color that were applied to the quills before they were used in various ways: embroidery, weaving, wrapping, and plaiting. The quills were sorted according to size, then washed and dyed. Before they were worked, they were softened in the mouth and drawn through the teeth to flatten them. Eventually, quillwork was taken onto the Great Plains by such tribes as the Sioux and Cheyenne, who left the woodlands to follow the buffalo in the early eighteenth century. There, much quill- and beadwork came to be considered sacred, entrusted only to women who belonged to special guilds. They would invoke a blessing on the object they quilled, whether it was a cradle, a medicine bag, or moccasins. In turn, they would vow to quill a buffalo robe or other ceremonial regalia for a medicine man or a warrior. Some

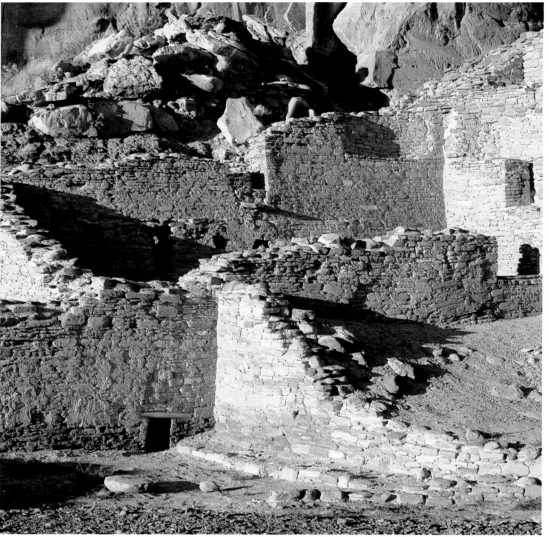

Bottom left: Anasazi ruins at Chaco Canyon, New Mexico, one of several dramatic sites of ancient Anasazi pueblos built into the rocky cliffs of the desert Southwest. (*Gail Russell*)

Below: Designs and symbols first seen in prehistoric petroglyphs such as Newspaper Rock in New Mexico reappear as elements in pottery, basketry, and painting through the ages up to the present day. (*Gail Russell*)

Bottom: Bear paws, seen here on a black fired Santa Clara storage jar from the 1920s, have long been a common element in Native imagery. (*Collection of Mr. and Mrs. Forrest Fenn/Photography by Addison Doty*)

quillwork was done in feathers and carried sacred powers from the birds.

When the Lakota Sioux first encountered the Venetian glass beads imported by white traders in the early 1800s, they resisted using them. They considered the beads as "dead," since they had not come from a living animal, and it was feared that their use might destroy sacred power. The large, opaque beads were colored black, white, red, and sky-blue – the same colors used for quillwork – and were called "pony beads," because they were delivered by pony pack trains. Eventually, they were accepted, and a group of Lakota women started a beadworkers' guild during the 1820s. Like the quillworkers, their designs were revealed to them through dreams and passed on from one generation to another. Thus beadwork came to be strictly regulated by certain traditions that persist among its practitioners to the present day.

When commercial woolen cloth was introduced, the Great Lakes tribes favored dark blue or black for decoration with colored beads, just as they had used leather smoked and dyed to a dark hue as a background for quillwork. The Ojibwa used naturalistic floral designs for their beadwork, and other tribes favored such designs when the beadwork was appliquéd. For loomed beadwork, geometric patterns were most frequently used.

Other art forms common to the Great Lakes and Canadian tribes north of them included splint and wicker basketry, wood carving of spoons and bowls, blankets woven of rabbit fur, and twined bags and burden straps. Rawhide was used to make folded boxes for storage and transport. The Great Lakes people also carved wooden dolls for use in medicine bundles, which were passed down from one generation to another. The dominant religion was the Midéwiwin, or Grand Medicine Society, a secret healing society that was believed to confer supernatural powers on its members. Membership was gained by purchasing initiation into the various levels by gifts and feasts, and a form of pictography was developed as a mnemonic aid to the society's songs and rituals. In some areas, the Drum religion superseded the Midéwiwin. In others, Peyote (Native American Church) or Christianity became the dominant belief system.

In the Southeast, tribes of the Mound Culture made many artifacts in addition to pottery. These included stone and copper gorgets, or pendants, attached to garments or breast coverings for ceremonial use. Shells were used for the same purpose, engraved with many of the same designs found on pottery of the period. These included the cross, symbolizing the four directions and perhaps a tree; the scalloped disk representing the sun; the bird, in many conventionalized forms; and the serpent, which played an import-

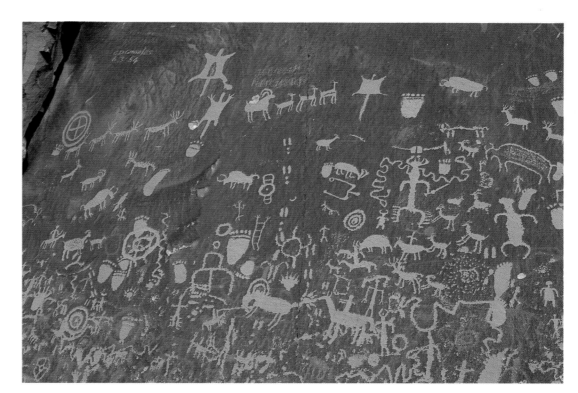

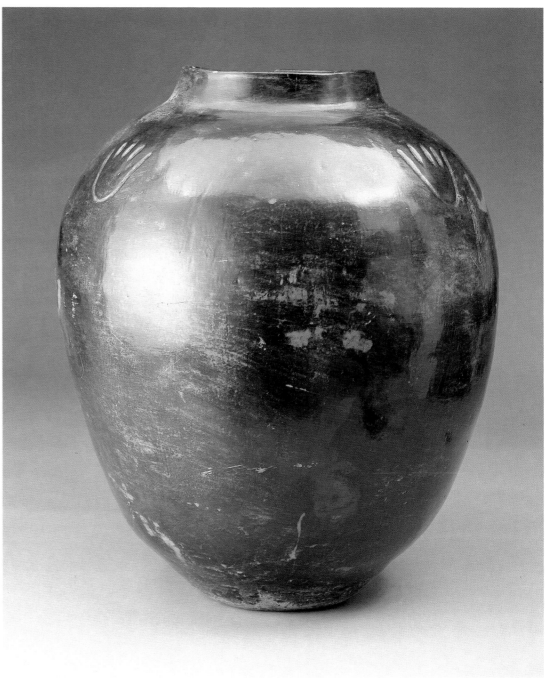

Right: A Navajo silversmith displays examples of his work, including a squash blossom necklace and a concha belt, in this photograph taken by Ben Wittick around 1880. (*National Archives*)

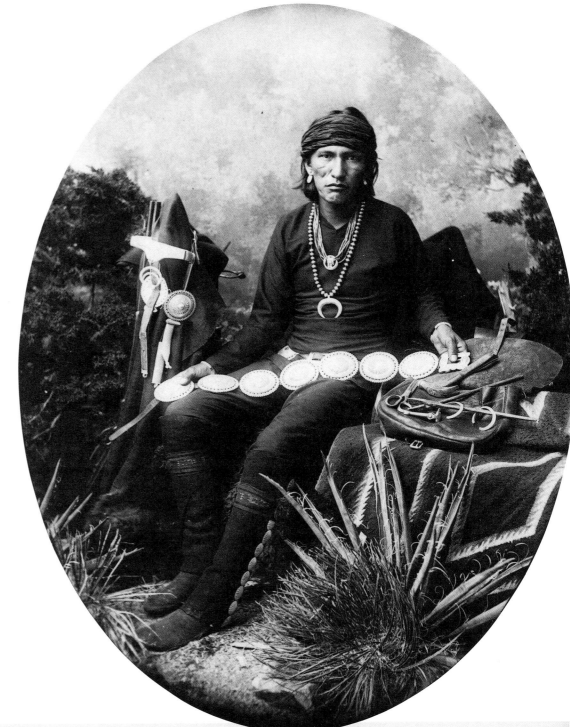

ant part in myths and religion of this culture area. A number of the mounds themselves were built in the form of a coiled serpent. Less frequently, the human face is depicted. Animal forms, including frogs and spiders, are more common.

As in the western half of the country, shells became more valuable the farther they traveled from their native waters. Both fresh- and salt-water shells were used to manufacture beads and decorations. Shell earrings, nose rings, and wrist ornaments have been found in Temple Mounds dating back to A.D. 1400. The Spiro Mound, in Oklahoma, yielded an incised conch shell that had been carried to the site from the Gulf of Mexico some 700 years earlier. Bearing the design of an eagle man, it was a burial offering for one of the elite families interred at this ancient ceremonial center. Such conch shells have been found as far north as Canada.

However, what had been the highest civilization north of Mexico, showing strong Meso-American influence, was eroding even before European contact. White settlement contributed to Southeastern decline, as entire tribes were wiped out by warfare and disease. Others, like the so-called Five Civilized Tribes – Cherokee, Choctaw, Creek, Chickasaw, and Seminole – adopted European clothing and ways. Many of them were moved west to "Indian Territory" in

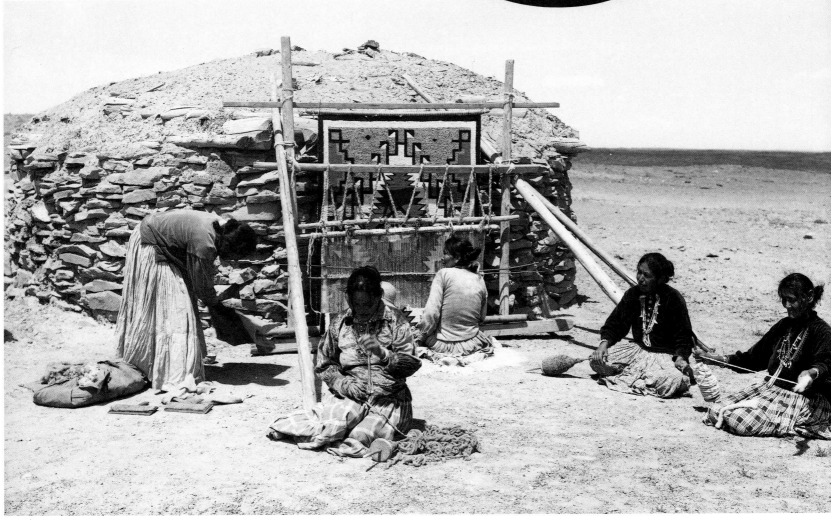

the 1830s, leaving a few scattered groups behind.

Southeastern products of the post-acculturation period include complex yarn sashes, some with beads worked into the design; beaded shoulder pouches; and plaited baskets with the traditional scroll and geometric designs. The Seminole of Florida developed a unique type of patchwork decoration for clothing early in the twentieth century, after they acquired sewing machines. Small pieces of cloth are cut to shape and then sewn together in bands to form skirts, jackets, pinafores, and household objects. Designs range from simple stripes to colorful zigzags, diamonds, crosses, and ricrac edgings. The Seminoles wear their art, some of which is still produced on hand-cranked sewing machines deep in the Everglades.

In the prehistoric Southwest, the arid climate gave rise to a desert tradition, characterized by small bands of hunter-gatherers, some of whom became sedentary with the development of agriculture. Only then were such arts as pottery and weaving developed. Pottery began here about the start of the Christian era – roughly a thousand years later than in the Southeast. The ancestors of the Pueblo peoples, called the Anasazi, or Old Ones, made pottery bearing geometrical designs, animals, mythological figures, and, especially, birds. Food and water bowls and vases were common.

Throughout the Pueblo culture area, centered in New Mexico and Arizona, pottery decoration became increasingly complex. The original rectilinear forms evolved into spirals, stepped frets, meanders, dots, stars, and zigzags. Ceremonial water vases made by the Zia bore realistic animal, insect, and bird motifs along with cross and star patterns.

Prehistoric Hopi pottery was much like modern forms, decorated with human and animal figures showing a wealth of detail and a strong sense of movement. The Hopi produced a distinctive ceramic ware identifiable by the type of clay used. The unslipped pottery fired from an orange to a cream color, unevenly mottled as a result of oxidation in the firing process. Occasionally, the pottery was slipped in red. Designs were painted in red, black, and white. After the Spanish incursion, the quality of Hopi pottery fell into a slow decline, but it was revived late in the 19th century by a Tewa potter named Nampeyó, from First Mesa.

Pueblo groups east of the Hopi – Zuñi, Acoma, Laguna, Santa Ana, Zia, and Isleta – all made a similar type of pottery with a white slip and painted designs in red and black. At Zuñi, the base was slipped with black or brown, rather than red or orange, and designs were laid out in two to four sections, equally divided. Common Zuñi designs are the rosette and the deer or other animal with a heart line – arrows drawn from the mouth to the heart.

Thin and elegant pottery has long been produced at Acoma, painted in black and various shades of red-orange. Decoration tends toward allover patterns of geometric units or naturalistic birds and flowers. In modern times, the famous Acoma potter Lucy Lewis developed a new style based on prehistoric black-on-white ware. Isleta pottery was often slipped in white all over, including the bottom.

The pottery from Santo Domingo was very distinctive, with strong geometric patterns in a black-on-cream style. In recent years, tourism has brought a decline in quality, with some pottery still made in the traditional style but more in black-on-red, red, and polished red ware painted with polychrome after firing. Floral designs are more in evidence than geometrics. Cochiti, San Felipe, and Tesuque are best known for their small designs on a cream background.

San Ildefonso was noted for its black-on-cream ware during the 19th century, but this picture changed in 1907, when the School of American Research began archaeological excavations in the area. Tewa potter Maria Martinez, then about 26 years old, had learned her craft from her aunt at a time when most of the Pueblo's pottery was being made for kitchen use. Maria's husband, Julian Martinez, was working at the research site when the expedition unearthed a pottery shard and asked Maria to create a pot from it. When she had done so, Julian painted it with ancestral designs. In the process of recreating the old-style pottery, the Martinezes accidentally produced some entirely black pots by the process of oxidation during firing. This long-forgotten technique led to the development of the now famous black-on-black ware from San Ildefonso: matt black decoration on a shiny black back-ground. The revival of ceramic production spread to other pueblos, and Maria's pieces can now be found in museums and private collections.

Other contemporary innovations have come in the form of designs carved into the pot in low relief, as introduced at San Ildefonso by Rosalie Aguilar about 1931. Nearby Santa Clara Pueblo experimented with the black-on-black and carved forms while continuing to produce its standard polished red and polished black pottery. San Juan Pueblo specialized in pottery that was partially slipped and polished on the top rim only and revived an ancient light-brown ware with incised geometric designs. Another distinct type was produced at Taos and Picuris pueblos, where the clay has a high mica content that gives a glistening surface to the unslipped brownish pottery.

Elsewhere in the Southwest, pottery never reached the level of basketry, as produced by the Pima, Papago, and Yuman – the Rancheria tribes. These tribes were not deeply influenced by the Pueblo groups, although they, too, practiced agriculture, in southwestern Arizona and along the Colorado and Gila rivers. The Pima and Maricopa made a limited amount of pottery in polished red or cream decorated with black paint, while the Mojave and Colorado River tribes made an unpolished buff and brown ware.

Among the region's Athapaskan tribes – Navajo and Apache – the Navajo once made decorated pottery, but today their production is limited to cooking pots, which are sometimes converted into drums by the addition of skin tympani. The Apache, originally a nomadic group, were little influenced by Pueblo culture, and their way of life precluded the development of pottery, which is not easily portable. Like the

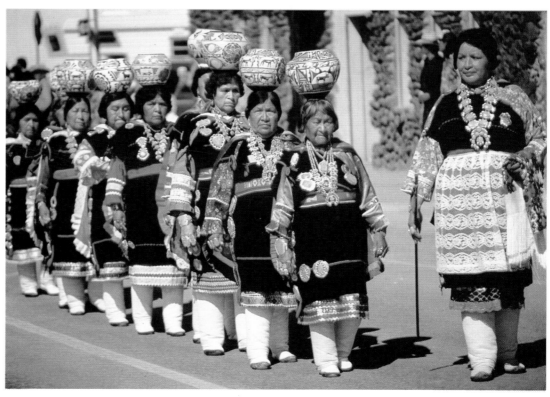

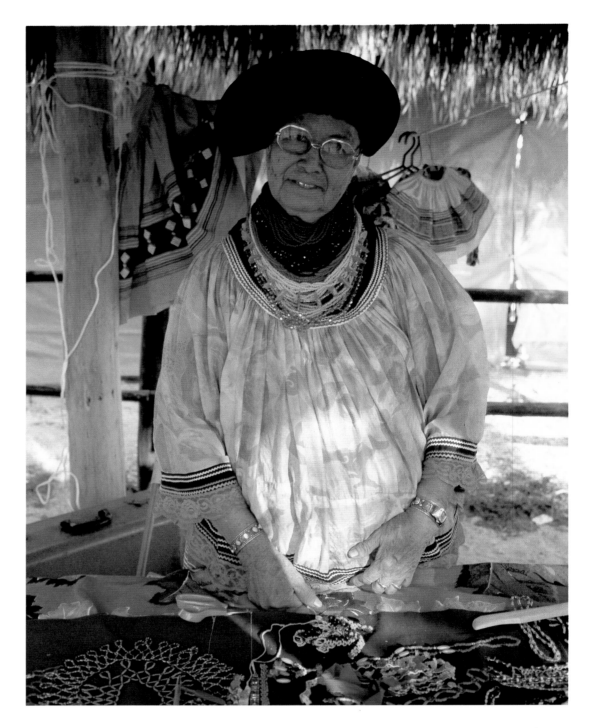

Pima and the southern California tribes, they excelled in basketry.

Jewelry, silverwork, and ornamentation have a long history in Native American art across many culture areas. Intertribal trade brought seashells from the Pacific as far east as the Missouri River, and they were highly prized in the prehistoric Southwest. Feathers, shells, turquoise, and other ornamental goods were traded widely. Anasazi pictographs contemporary with Europe's Middle Ages show ancestors of the Pueblo peoples wearing necklaces and other jewelry.

Southwestern smiths probably began to make silver jewelry in the latter part of the 19th century. The Zuñi became especially well known for their delicate silver jewelry, inlaid with sets of polished turquoise also used in a mosaic style. Some pieces combined turquoise, jet, and red spiny-oyster shell. Today, New Mexico's Fox, Cortez, and Blue Gem mines still produce much of the turquoise used by Zuñi designers. The Hopi developed a cutout overlay technique in which the recessed portions of the design are oxidized black to contrast with the silver. Traditional geometric and naturalistic forms ornament Hopi cuff bracelets and brooches.

The Navajo, originally a seminomadic, warlike people, became sheepherders after the introduction of domestic animals. They learned how to work silver from the Mexicans during the 19th century and soon excelled in the art. Originally, they made silver *conchas*, fastened to leather belts, and other ornaments from hammered silver coins. Later, they obtained sheet and ingot silver from traders and melted it in molds. A frequent motif in Navajo design is the squash blossom, a symbol of fertility. Both men and women wear the squash-blossom necklace, with crescent-moon pendant, and Navajo girls of marriageable age wear the squash-blossom hairstyle with its tightly woven chignons on either side of the head. Navajo jewelry is often inlaid with turquoise and other native stones. Traditional designs include the thunderbird track, indicating bright prospects; the butterfly, for everlasting life; the snake, a sign of both wisdom and defiance; and the skyband, and ancient stepped figure that signifies "leading to happiness."

The Navajo, now the nation's largest tribe, learned weaving from the Pueblo peoples and took the art to new heights. Among the agricultural Pueblo groups, the men not only did the farming and hunting, but they also practiced such crafts as weaving – work often done by women in other societies. In early times, the principal material for weaving was a type of native cotton, supplemented by wool after sheep were introduced by the Spanish. Kilts, belts, and sashes were woven for ceremonial dances, which occupied a great deal of time and energy in an agricultural economy that depended upon infrequent rain for its survival. Hopi men traditionally made the wedding costumes for their brides.

Most Pueblo designs consisted of transverse stripes that were characteristic of basket-weaving, but they were also worked into complex twills of diamond and herringbone patterns. The traditional white belt known as a rain sash is done by braiding: the strands become alternatively both warp and weft. Today, the Hopi are the principal producers of woven materials, centered at the villages of Hotevile and Shimopovi. They trade ceremonial clothing to other Pueblo groups, most of whom weave their own everyday clothing. Except among the Hopi, Pueblo women do all the embroidery.

The Navajo learned to weave from the Hopi and Zuñi more than 200 years ago, and their textiles have been evolving into more and more elaborate and skillful designs since that time. Their first work was done from hand-spun wool and cotton using native dyes. As trade increased, they acquired commercial cloth like English stroud in red (*bayeta*) and blue, which was raveled to produce more complex and colorful designs. Then came the introduction of commercially spun wool, called "Germantown" or "Saxony," and bright aniline dyes. The original lightweight clothing blankets were superseded by heavy rugs, eagerly purchased by traders and, more recently, by collectors and tourists.

During the 19th century, Navajo blankets were traded widely throughout the West, often by Ute and Apache middlemen. They were found on the site of the Wounded Knee massacre in South Dakota in 1890. White traders encouraged the Navajo textile industry, and copies of Navajo designs were commercially manufactured. In recent times, Navajo women have revived the use of native dyes for their work and the "border blanket" has become popular. Recent fashion trends have made Southwestern designs in clothing and housewares widely known and appreciated, although, inevitably, commercialization has brought problems of its own.

Ceremonial and religious objects, including *kachina* masks and dolls, are among the most important products of the Pueblo craftsmen. The word *kachina* refers to supernatural beings personated by men, to the masks, dolls, and regalia proper to such personation, and to the ceremonies themselves. As a rule, *kachina* masks are the property of individual clans that have the exclusive right to personate the spirits involved. *Kachinas* may "die out" as the clans who own them become extinct, although the masks may also be inherited by other clans.

Below: This rare double weave Cherokee basket from eastern Tennessee dates from the late 18th to early 19th century. (*Frank H. McClung Museum, The University of Tennessee, Knoxville/W. Miles Wright*)

Bottom: The art of basket coiling is becoming increasingly rare. This craftswoman begins a new work of art at the Santa Fe Indian Market. (*Mark Nohl/New Mexico Magazine*)

Masked ritual was most highly developed in the western Pueblos, especially at Hopi and Zuñi, where non-Indians are sometimes allowed to witness masked dances. Other communities prohibit spectators and maintain the secrecy of their rituals, long jealously guarded in their *kivas*, or underground chambers. Most *kachina* masks are made of heavy leather or rawhide in a variety of shapes, some of which cover only the face, others, the entire head. These masks are repainted with appropriate designs before each dance, with appendages like ears, nose, and mouth made of fur, cotton, or feathers. Ruffs are made from the same materials, and from evergreen branches. Very few *kachina* masks were collected, or even seen, by non-Indians before the turn of the century, but some are being made for sale now that have never been used ceremonially. Intermarriage between men and women of different tribes has also lifted some of the religious taboos on the sale of such objects.

The Hopi are the principal producers of *kachina* dolls, which were introduced in the 19th century, both as playthings and to teach children about their religion. Originally, they were flat and boardlike, lacking hands and feet. More recently, detailed carvings with natural bodily proportions have been produced, most of them made from the soft root wood of the cottonwood tree. Many Zuñi dolls have arms movable at the shoulders and are dressed in cloth, while Hopi designs tend toward painted clothing. The demand for such dolls has increased their production, and a limited number are also made for sale at Acoma and Laguna. The latter pueblos are better known for their impressive wooden war god images. Such fetishes, in wood and stone, have a long history in Pueblo religion, and the animal fetishes carved in hart stone are among the most impressive Indian artworks of historic times. Wooden shrine figures carved for the Hopi and Zuñi *kivas*, dance wands, and other objects associated with the Pueblo rituals are also highly valued.

Some of the Pueblo *kivas* contained sand paintings, which were destroyed at the end of every ritual. They were symbolic reconstructions of universal order, which had power to restore order in the world. Such paintings are part of many Navajo healing ceremonies to this day. They are made by medicine men who sprinkle colored sand on the floor of a ceremonial hogan in designs passed down in Navajo cosmology from the Holy People. The sand is tinted by earth, ground shell, charcoal and pollen. When the sand painting is complete, the patient sits on it to receive healing, restoring harmony and well-being. The picture must be completed between morning and night and then destroyed. Many of the sand-painting designs are drawn from *kiva* wall art and recur in pottery and textiles.

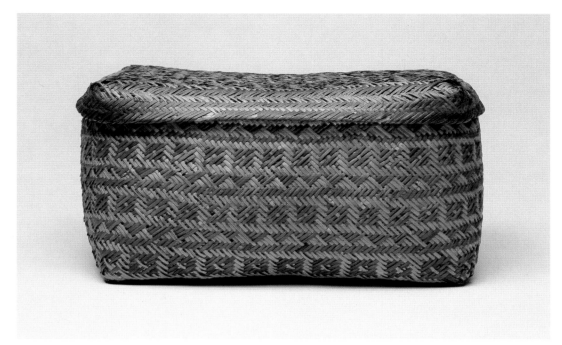

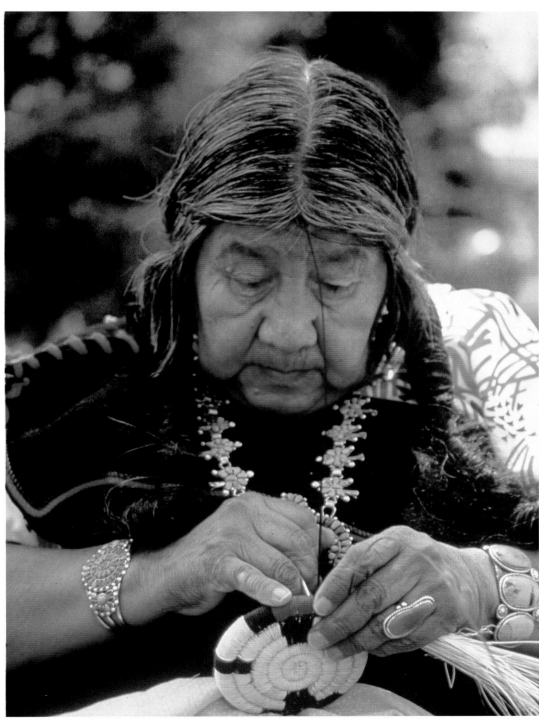

13

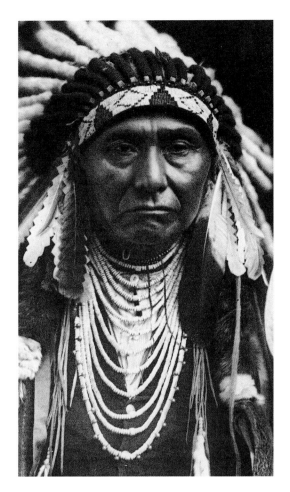

Like the Navajo, the Apache are an Athapaskan-speaking group believed to have migrated south from Canada and Alaska during the prehistoric period. "Apache" is a general term for several related tribes that once roamed over much of southern and central Arizona, eastern New Mexico, and parts of west Texas. The Jicarilla, in northern New Mexico, were much influenced by the Plains tribes, including the Ute, as seen in their elaborately beaded leather garments. The Mescalero and Lipan tribes also showed much influence from the Plains, while the San Carlos and Fort Apache groups, whose best-known art is basketry, were closely connected to the desert. The principal religious celebration is the Mountain Spirit Dance, in which the male dancers wear elaborate slat crowns above cloth or leather hoods. Other Apache artifacts include rawhide playing cards modeled on the playing cards introduced by the Spanish, painted leather bags and fetishes, cut-leather saddlebags, and painted deerskins depicting tribal history and mythology.

The Indian peoples of California and the Great Basin – between the Rocky Mountains on the east and the Sierra Nevada on the west and including the deserts of Utah, Nevada, and southern Oregon – shared many cultural traits. Theirs was primarily a subsistence economy based on acorn- and seed-gathering supplemented by hunting of small game and fishing, especially on the California coast. Weaving was unknown among the California tribes, but they produced fine baskets from native fibers by a type of knot netting. Feathers and shells were frequently incorporated into Pomo designs, which were – and are – known as "gift baskets" from their use in ceremonial exchanges. In the south, members of some tribes that are now extinct made coiled baskets in reddish earth tones, often incorporating rattlesnake designs. Pre-contact carvings from this region include soapstone animal effigies of high quality, some inset with shell beads, and sandstone bowls. Southwestern influences were seen in simple sand paintings made for male puberty ceremonies, which involved the use of the narcotic called "Jimson weed."

Central California tribes produced no pottery and little woodwork, but elegant baskets are still made in this region, using both the coiled technique of the south and the twined techniques of the northern part of the state, which was influenced by Pacific Northwest tribes. Here plank houses, dugout canoes, rod-and-slat armor, and basketry hats were produced, as well as baskets. The Yurok and Karok were well known for their variously shaped baskets with knobbed lids, some decorated with yellow porcupine quills and maidenhair fern stems. Elk antler carvings of fine quality are also characteristic of this region.

Some northern and interior tribes had almost

no white contact until the Gold Rush of 1849 and maintained their aboriginal way of life into the 20th century. In fact, an Indian who had never seen a white person and who was still making stone arrowpoints was found in California as late as 1911. Similarly, the scattered groups of Paiute and Shoshone living in the Basin area maintained a relatively primitive way of life. Basin groups lived in simple brush shelters and produced a limited number of tanned hides and beaded baskets or bottles like those made by the Paiute.

The Ghost Dance religion was originated by the Paiute prophet Wovoka on the Pyramid Lake reservation at Dixon, Nevada, in 1889. As Norman Feder points out in *American Indian Art* (Harry N. Abrams, 1965), it had little cultural effect in the Great Basin, but was eagerly adopted on the Plains. Wovoka foretold that if the Indians performed the Ghost Dance, refrained from

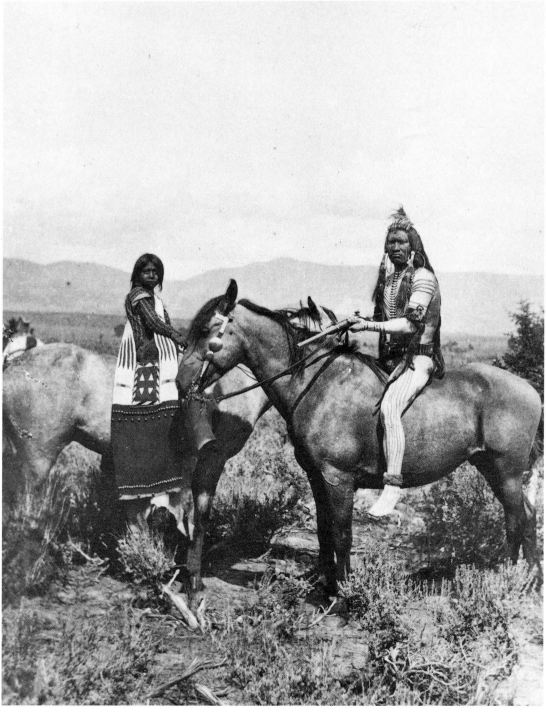

military. Indian participants at the Battle of the Little Bighorn, including Sioux chief Red Horse, made pictographic records of the engagement, showing captured horses wearing military saddles and slain tribesmen who were readily identifiable by details of their dress and war paint. Signatures, too, were pictographic: the sign of a running antelope identified a Sioux chief who waged war on the Arikara for 20 years during the mid-19th century. In general, the older historic artworks, like those of the paleo-Indians, depicted both humans and animals as stick figures; dashes or hooks stood for feet and hooves. Gradually, a more naturalistic style evolved. On the Northern Plains, this took the form of solidly colored silhouettes without internal detail. The Central Plains tribes moved toward simple outline drawings with considerable detail. Southern Plains peoples, including

fighting, and harmed no one, the buffalo would return, the white man would disappear, and the dead would return to life. Among the Sioux, Cheyenne, Kiowa, and Arapaho, specially painted shirts were designed for the dance and believed to be impervious to bullets. The shirts were painted with bird and animal designs, including that of the turtle, which is hard to kill, and ornamented with stars, fringes, and feathers. Sadly, the hope engendered by this religious revival was short-lived. By this time, most of the Plains Indians had been confined to reservations for almost 30 years.

During the period of westward expansion, it was the Plains tribes who became synonymous with the term "American Indian" both at home and abroad. Their way of life was dependent upon the buffalo, although some agriculture was practiced in the region, and the horse was a preeminent part of their nomadic existence. Warfare, as a means of gaining prestige and material goods, was a salient part of their culture, and the Sun Dance and vision quests were central to their religion. With regional variations, they produced feather bonnets and bustles for ceremonial use, skin tepees and clothing painted with pictographic designs, carved stone pipes, skillful beadwork and quillwork, painted shields, some metalwork, and painted rawhide containers known as *parfleches*. During the pre-contact period, bird quills were used extensively for ornamentation, but few quilled artifacts earlier than 1850 have survived.

The buffalo-based Plains economy was disrupted by the introduction of such trade goods as guns, liquor, and manufactured items. White traders sought buffalo hides in exchange for these goods, and the resulting slaughter of once-numberless herds was catastrophic within a few generations. Other trade goods were adopted and put to traditional uses, like the pony beads

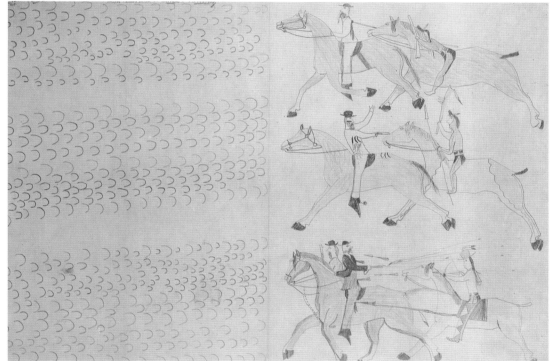

and the smaller "seed beads" of colored glass. The traditional pictographic designs worked in these materials were often similar to the signs employed in the region's sign language, by which the diverse tribes could communicate. Similarly, buffalo robes were painted as a record of tribal history, like the famous "winter count" robes.

Young men of the Plains tribes sought their guardian spirits in vision quests and bore emblems that invoked the power of their totemic animals, such as bear-claw necklaces and hawk-feather war flags. They also adapted such trade goods as tubular hair pipes, introduced as hair ornaments, to other purposes like the production of breastplates fringed with leather.

The designs painted on tepee covers and liners might be historic, symbolic, or dictated by visions. Much historic pictography recorded battles with other tribes and, later, with the U.S.

the Kiowa and Comanche, painted hides with bordered hourglass designs. The Kiowa eventually developed a style that included the use of perspective and minute detail.

Painted shields, like ritual shirts, were considered "medicine" for their bearers. Most shield designs were dictated by visions. Often, the form was cut from the thick skin of a bison's neck and shrunk to a convex shape. This rawhide circle was usually fitted with a painted buckskin – sometimes muslin – cover. The Crow Indians produced many shields, most of which show an animal in profile with rows of zigzags representing bullets. The Cheyenne made a special type of shield in which crosshatched lacing took the place of rawhide: clearly, it was designed as a form of magical protection rather than a defense against arrows or bullets.

Raw, or untanned, hide was widely used for

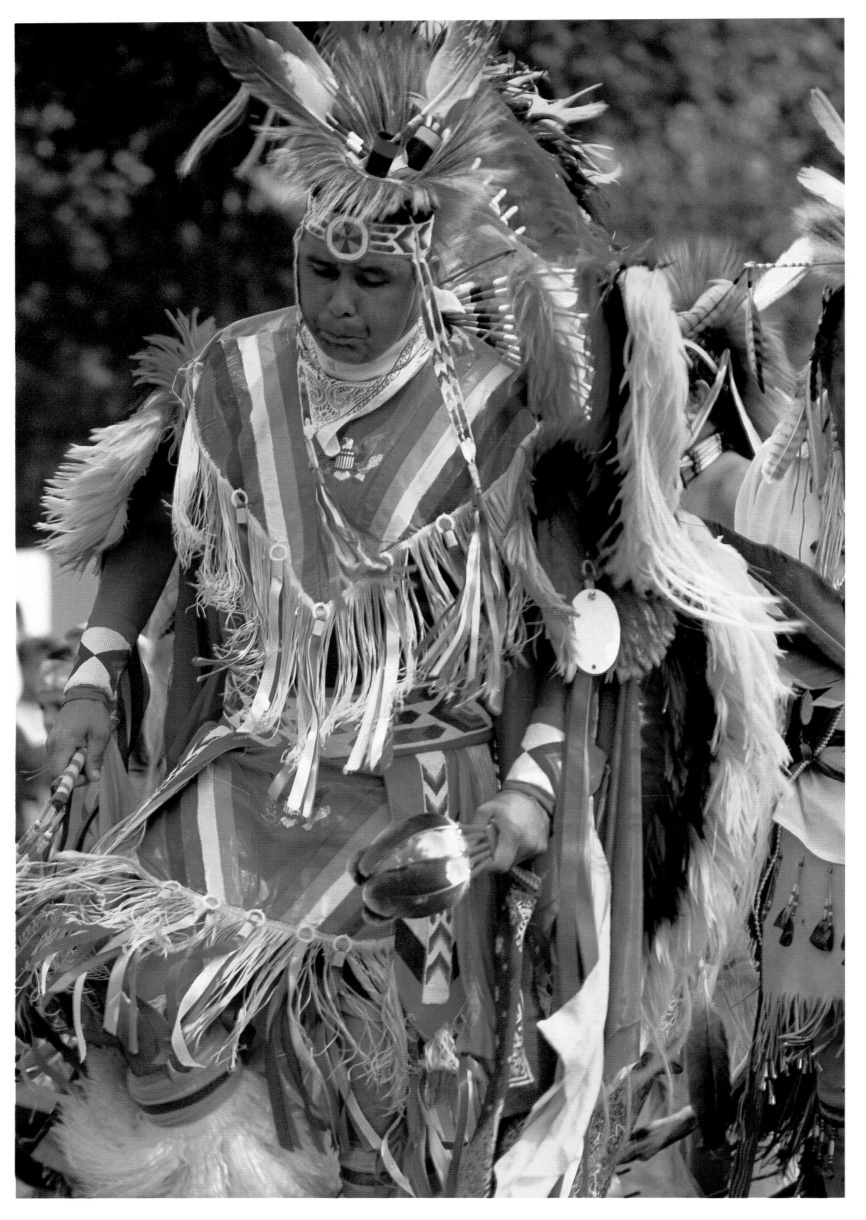

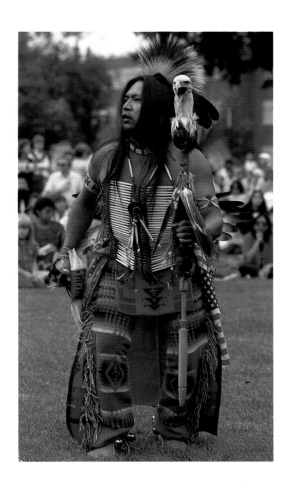

mountain tribe that lived by deer and elk hunting, with periodic forays onto the Plains to hunt bison. Then the pressure of Kiowa and Comanche raiding forced both groups west of the mountains, where they were influenced by the neighboring Cheyenne and by the Crow and Shoshone to the north. Unlike most other Plains tribes, the Ute and Jicarilla produced a type of coiled basketry similar to that of the Paiute, Navajo, and Pueblo groups at Jemez. They decorated their moccasins with Cheyenne

designs, and their beading on horse trappings and pouches resembles the Crow style with its multi-colored geometric designs outlined in white.

The Mandan, Hidatsa, and Arikara of the eastern Plains were more typical of the Plains groups in the prehorse period. They lived in earth lodges most of the year, hunting bison only seasonally, and produced some pottery and basketry. Their quill- and beadwork designs were heavily influenced by the Northern Plains tribes, but they

ceremonial rattles, burden straps, and lacing thongs. It is most frequently seen in the *parfleche*, which was usually painted with geometric designs formed with willow-stick rulers. These carrying cases were in daily use by the nomadic Plains people until the reservations were set up. In pre-contact times, painting was limited to a variety of natural pigments, including red and yellow ochres, brown lignite, and a few blues and greens. With the introduction of mercury vermillion from China by trade, red became a prominent color in Plains painting on a variety of objects. Later in the 19th century, a growing number of commercial pigments became available through trade.

During the initial reservation period, and occasionally among tribes living close to white communities, pictographic painting in notebooks – "ledger art" – was introduced, done in trade-colored inks and pencils. Originally, this work was done for Indian use, but it had been commercialized by the late 19th century and the style was used to paint small deerskins or elkhides for sale to non-Indians. These artifacts often employed the two most prominent Plains designs: a sunburst of concentric circles comprising featherlike elements, often called the "black bonnet" design, and the box-and-border design historically worn by Plains women.

White contact was by no means the only factor accounting for regional differences in styles of quillwork, beadwork, and other ornamentation. In the southwestern Plains, for example, the Ute and the Jicarilla Apache had a strong influence on one another. The Ute were originally a

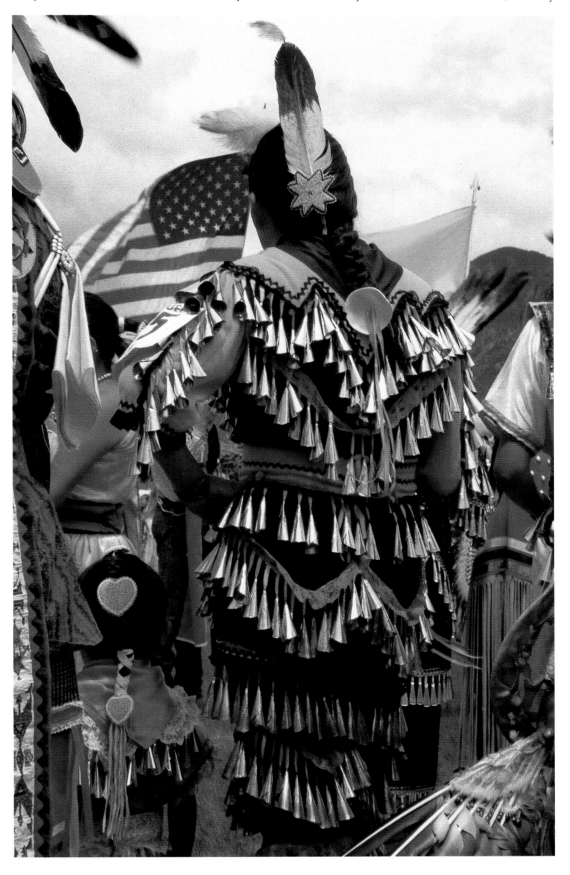

developed a mixed style due to the influence of related tribes. For example, the Hidatsa and the Crow – a single tribe in the prehistoric period – still speak closely related languages, visit one another, and intermarry. Similarly, the Arikara and the Pawnee share much in common from their origins as a single tribe. Norman Feder believes that a style center developed in the early reservation period around southeastern Nebraska and northeastern Kansas. Here the Iowa, and Sauk and Fox, of the Nemaha reservation developed a rich style of abstract floral decoration in combination with the Oto-Missouri peoples.

The best known form of Plains sculpture is the carved stone pipe, most frequently made in red pipestone (called catlinite), but also in shales, soapstones, limestone, and other native stones. Since prehistoric times, animal and human figures have been carved on the stems of these effigy pipes, used for ceremonial purposes, including gift-giving and treaty-making. The calumet (peace pipe) was often decorated with feathers from the golden eagle. Some of the finest work was produced by the Iowa and Oto-Missouri tribes during the historic period. The pipestems were usually wrapped in quill plaiting and

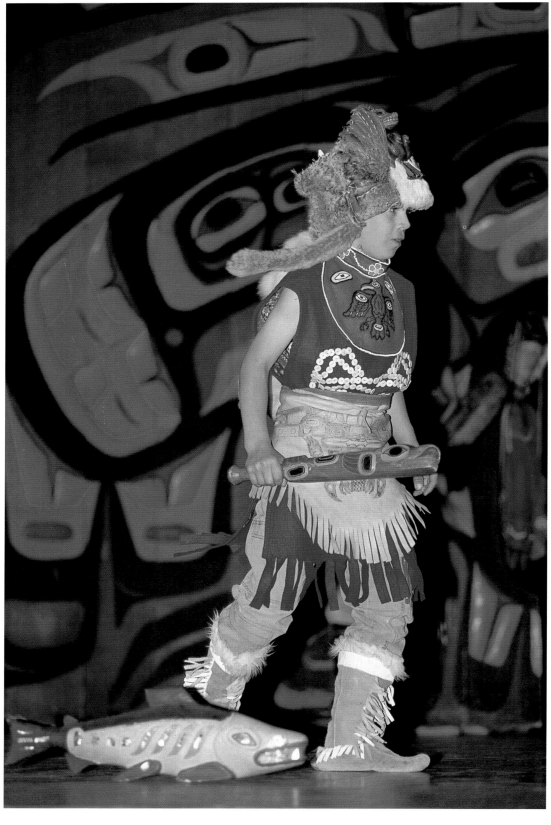

decorated with horsehair, woodpecker beaks, feathers, and other objects. The Sioux believed that the White Buffalo Calf Woman had brought the sacred pipe to their tribe. They decorated their pipes with elaborate beads and quillwork and kept them in fringed and beaded pipe bags. The sacredness of these objects among the Plains Indians inspired some of their most beautiful artworks. Tobacco was usually made from the inner bark of the red willow, and prayers were sent through the smoke. Sometimes the pipes were carved of green ash wood, although wood carving is more characteristic of the Eastern Plains area due to the Woodlands influence there.

Wooden war clubs with animal forms were carved by many tribes, including the Oto, as were mirrored frames and dance sticks used in such ceremonies as the Horse Dance. Grass Dance whistles were sometimes carved into bird forms, and many of the eastern Sioux made carved cradleboards, as did the Osage and Pawnee. Doll-like wooden fetishes included the Santee Tree Dweller dolls, the Prairie Potawatomi love dolls, and dolls carved for Crow medicine bundles. The Teton Sioux still make wooden pipes with shallow relief carvings of deer, turtles, sheep, elk, and dragonflies. The Santee Sioux carve their pipestems into graceful spiral forms.

The Plains Indians produced only a limited amount of metalwork, much of it in the form of silver horse trappings. The Sioux adopted heavy silver chest decorations in the shape of eagles and other symbolic birds; silver rings were suspended from them. Metal bells and tin cones were used to decorate ceremonial regalia, and shamans sometimes wore silver ornaments on their medicine shirts. Apache tradition demanded that the buckskin for these shirts be taken from a stranded animal that was strangled to death rather than shot.

Medicine and war shirts bore such designs as the sun, moon, and stars; lightning; smoke clouds; centipedes; snakes; and tribal gods. Bandolier bags suspended from straps across the chest were used as carryalls on the Plains, as they had been among Woodlands tribes like the Delaware. Worn into battle, they were decorated with the symbols of war in colored quills or beads. The accoutrements of warfare, in addition to painted shields, included the famous full-length warbonnets originally worn only by chiefs as a sign of leadership. Warbonnet featherwork was primarily of tailfeathers from the immature golden eagle, awarded one at a time for bravery in battle and for generosity. It took 36 of these feathers to make a full bonnet. Bartering played a part as well: one bonnet could be traded for two or three good horses.

Among the Northern Plains and Columbia Plateau tribes, the split-horn bonnet, made of bison horn and strips of ermine, was highly

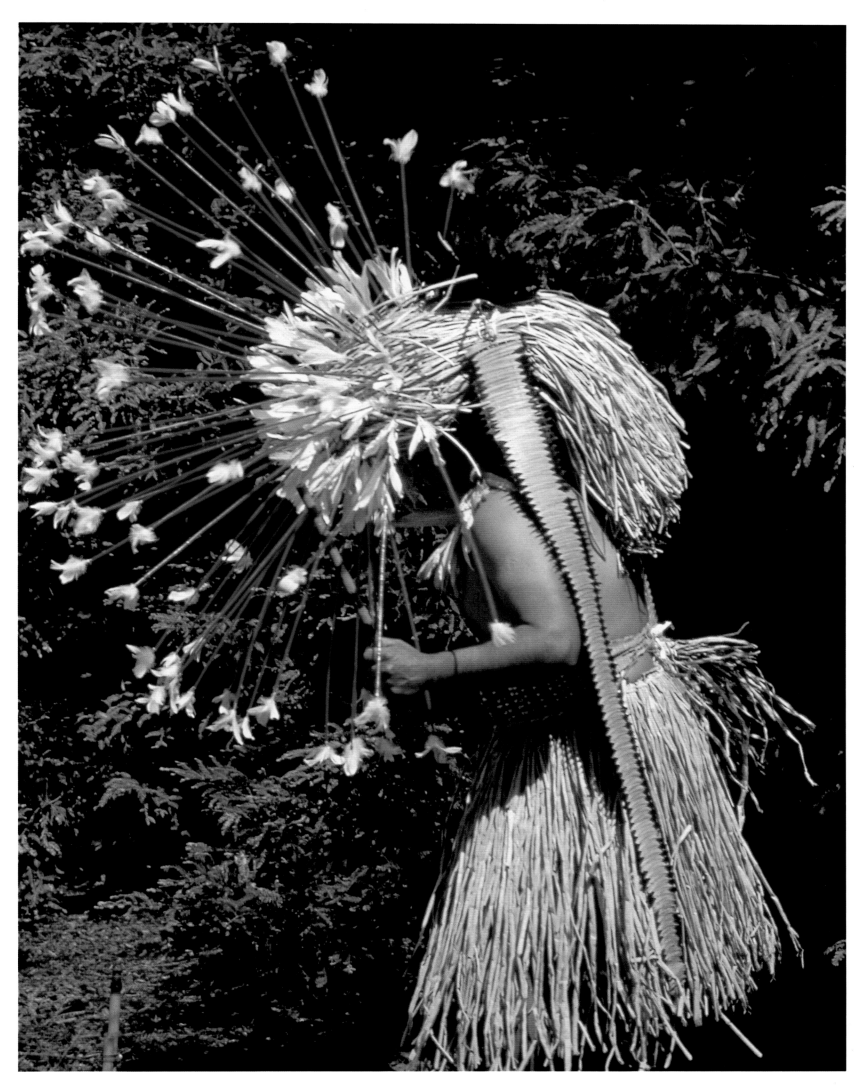

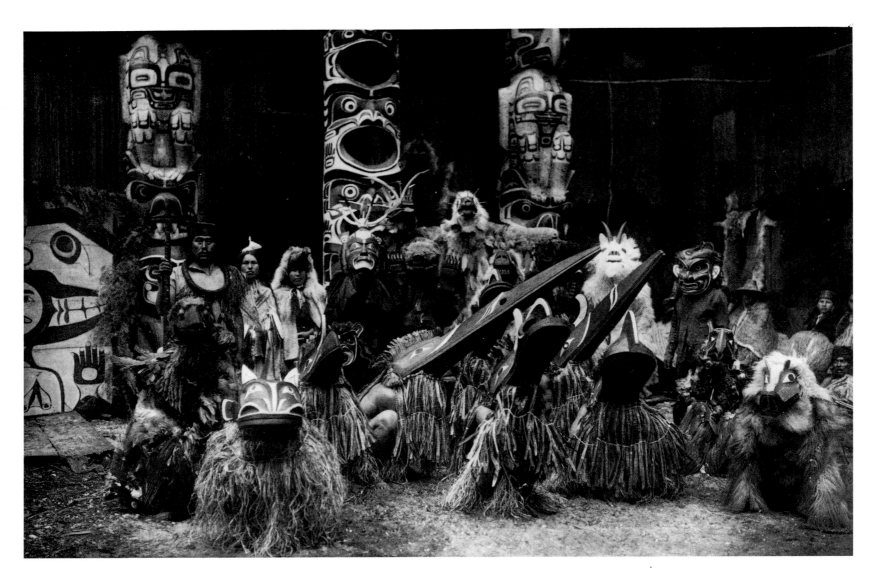

prized. Eagle, hawk, or owl feathers might be attached to the horns. Weapons included the traditional bow and arrow, lances, tomahawks, and coupsticks, used to touch the enemy in battle as an act of bravery. The Flathead decorated their knife sheaths with brass tacks; most Plains tribes used seed beads and porcupine quills. Lance cases, quivers, and quirts were similarly adorned. A head ornament common to the Plains, Woodland, and Columbia Plateau tribes was the roach: a headdress made of guard hair from the porcupine attached to red-dyed deer tail. (The color red symbolized protection and all that was good in the world.) Such headdresses may be seen in the earliest depictions of European contact along the Atlantic seaboard.

As beadwork began to replace the original quillwork tradition, beginning in the 1830s, distinct styles evolved throughout the Plains region. On the Northern Plains, including parts of southern Canada, beadwork was done in bold geometric designs in four or five colors. The beads were applied in an overlay stitch in straight lines, often formed by solid rectangles joined from corner to corner. The Sioux living in North and South Dakota favored large blocks of beadwork in relatively few colors including black, white, and blue.

The Central-Plains groups, including Sioux, Arapaho, and Cheyenne, sewed beads in the lazy-stitch and geometric designs, while the Southern Plains tribes developed a light and delicate bead-trim style, covering smaller areas in few colors. Crow beadwork, by contrast, might use up to 20 colors. Its geometric designs are similar to those painted on crow *parfleches*. A central motif is outlined in white beads running in a different direction from that of the background beadwork. The Nez Percé of Idaho seem to have adopted this style, and it was borrowed from them, in turn, by such Plateau groups as the Yakima, Umatilla, and Walla Walla.

Overlay beadwork in a floral motif, introduced some time before 1900, spread west across the Northern Plains with the widely traveled Plains Cree and Plains Ojibwa tribes, even reaching the Athapaskan peoples of interior Alaska. The Kiowa also used abstract floral designs worked in an overlay technique and developed a form of bead netting that became known as the gourd or peyote stitch, now widely used to decorate the fans, staffs, and gourd rattles used in the Peyote ceremonies of the Native American Church.

The Pacific Plateau comprises parts of Idaho and Washington east of the Coast Range, inland British Columbia, and northern Oregon. Two waterways make this region more accessible than the Great Basin – the Columbia and Fraser rivers. Since prehistoric times, the native peoples have fished these rivers for salmon. They also gathered roots and berries and lived in semi-subterranean houses before adopting the Plains tepee type of dwelling, sometimes covered with cattail mats. They made no pottery, but basketry was a fine art. Twining was used for soft bags and hats, coiling for large storage containers. The coiled baskets, made of grasses and corn husk, were often decorated by a technique called imbrication – sewing decorative elements on the outer surface. Such baskets were made by the Yakima, Lillooet, Shuswap, Chilcotin, and Klickitat tribes, among others.

The Plateau peoples were influenced in many ways by the Plains tribes. The Nez Percé and Cayuse bred horses and decorated their trappings in the Crow style. Beadwork in this region used geometric motifs until the turn of the century, when floral designs came into common use. Inland British Columbia was influenced largely by the Northwest Coast culture. The Lillooet and Thompson tribes made totems for use as grave monuments, carved stone bowls, and made blankets of dog hair and wool from the mountain goat. The Shuswap produced birch bark baskets similar to those made by the Great Lakes tribes.

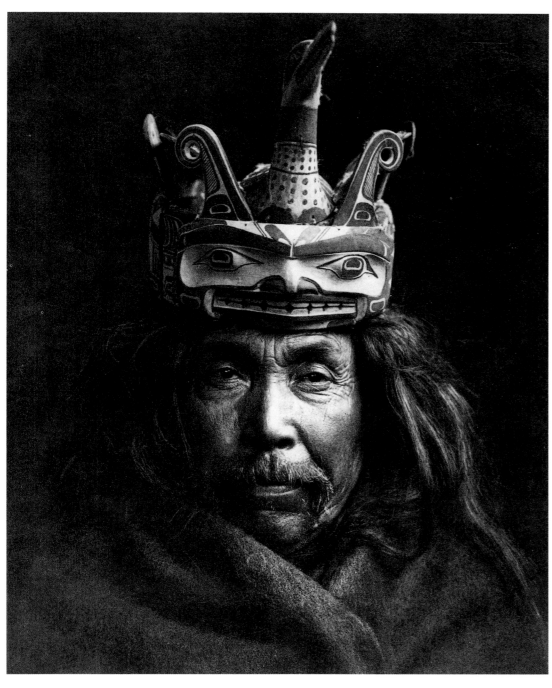

of their houses, clothing, utensils, and, most characteristically, totem poles. Gold and silver were mined locally and used to make jewelry and other ornaments. Blankets, carvings, storage chests, and other forms of wealth were exchanged at the *potlatch*: the ceremony that validated one's claims to ancestral privilege. Membership in secret societies also played a role in this process among the Kwakiutl and their neighbors, who were known for lavish feasts, gift-giving – even the destruction of stockpiled property as a symbol of status.

Animal carvings and designs from the Northwest Coast are usually conventionalized by combining several parts of the body, like a beak and a tail, to represent the whole. Many depictions are drawn from local mythology: for example, a sea wolf, shown as a wolf's head and a pair of seal-like flippers. Eyelike elements are often found throughout the design, which tends to fill the area being decorated. Sometimes faces appear within a larger form. The results are striking and unmistakeably the work of Northwestern artists.

Carved wooden masks were especially important in this area. They served to display personal emblems, to frighten enemies in warfare, and to personate supernatural beings in religious rituals and shamanic rites. Shamans had the right to carve their own masks, rattles, and other regalia for ceremonial use. Among the Tlingit, the shaman was especially powerful. Some

The tribes of the Northwest Coast, from the Columbia River to the Alaskan Panhandle, produced an unusually rich, distinctive art style for a hunting-and-gathering economy. They practiced almost no agriculture, but the region's warm climate, a result of the Japan current along the Pacific coast, and abundant fish, shellfish, and water mammals in the rivers and sea allowed leisure time for cultural pursuits. The Tlingit and Tsimshian tribes crossed the Coast range for trade with the Athapaskan groups of the interior. The Haida also lived in the northern part of this region and developed a similar style. Wood carving was the principal art form, and native cedar and spruce were used for houses, canoes, storage boxes, food bowls, and other artifacts of everyday life. Spruce root was widely employed for making baskets. The central Pacific coast was populated by the Kwakiutl and Bella Coola tribes, while the Coast Salish, Nootka, and lower Chinook tribes occupied the southern part of the region.

In these societies, rank was based primarily on ancestry and carried certain privileges, titles, and rights to various dances, rituals, and animal crests. Ancestral prerogatives derived from animal mythology, and art was basically totemic. People expressed their close relationships to mythological animals in the elaborate decoration

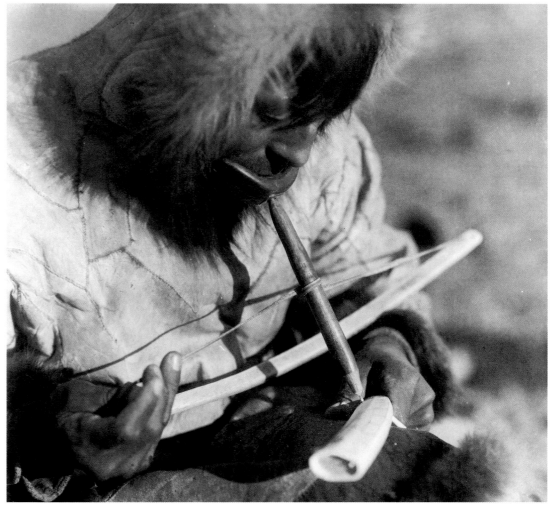

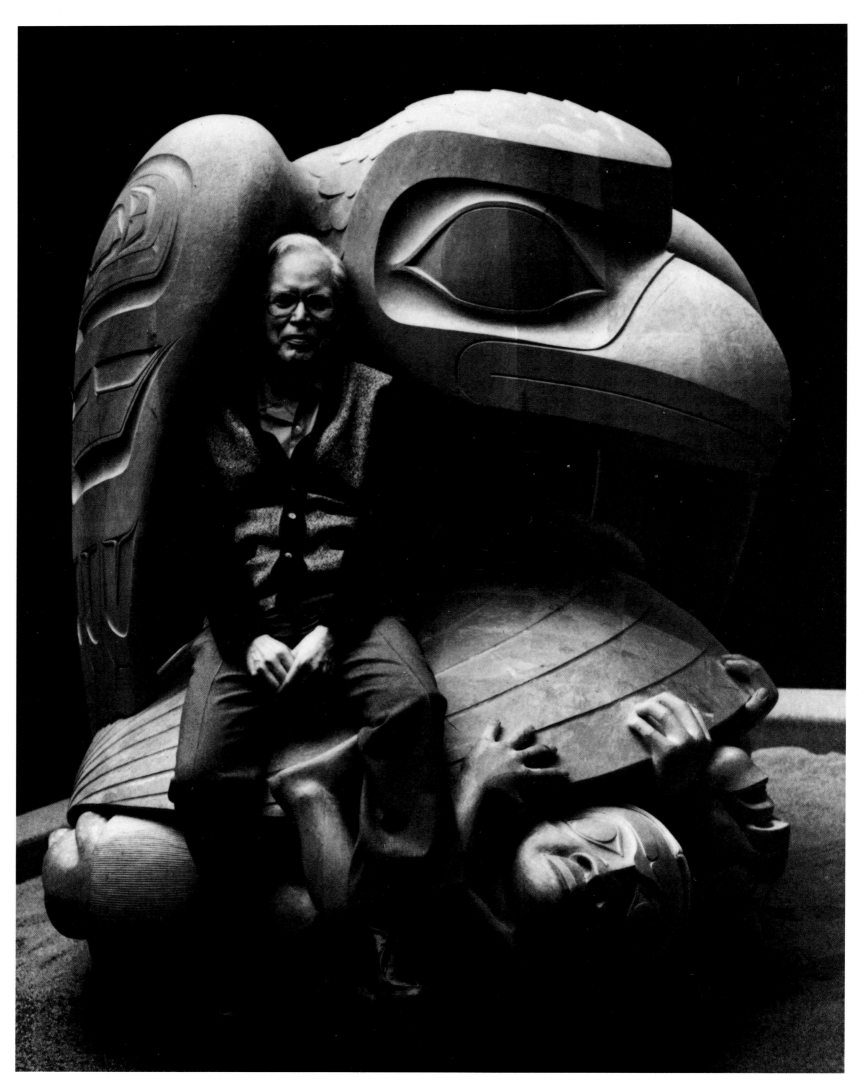

Northwestern masks have movable lower jaws, or inner masks concealed by the outer. They may be painted and adorned with wool, feathers, human hair, abalone shell, or opercula – snail shell, frequently used to form teeth. The Kwakiutl carved frightening masks of such mythological figures as the Wild Man of the Woods and Tsonoqua, the Cannibal Woman.

Despite the general similarity in the Northwest Coast style, due to frequent travel and raiding as well as comparable life styles, tribal and regional differences can be identified. The northern group – Tlingit, Haida, and Tsimshian – shows a more refined sculpture style than the other groups and hews closely to the original form of the wood. On their totem poles, the carved figures are wrapped around the cylindrical surface, while in the south elements added on, such as arms, project from the surface.

Pail-shaped twine baskets were produced by all the northern groups, as were basketry hats and mats. The Tsimshian and the Tlingit adopted many cultural traits from the Athapaskan tribes of the interior. They did porcupine quillwork, beadwork in floral designs, and blanket-weaving from mountain goat hair and shredded cedar or spruce bark. For some time after European contact, these arts flourished and took new forms from trade goods like cloth, buttons, and copper. Carving was enhanced by the introduction of metal tools, and the Haida of the Queen Charlotte Islands specialized in carving native argillite into miniature stone totem poles and other objects for sale to non-Indians. The Chilkat Tlingit were especially well known for their blankets and wall screens. Contemporary Haida artist Bill Reid trained himself in the wood-carving tradition of his people and has produced memorable work, including a house and totem poles at Vancouver's University of British Columbia.

The central Northwest Coast is still home to the Kwakiutl and Bella Coola tribes, whose sculpture is bolder and more colorful than that of the northern groups. Carvings from this area may be identified by rounded, projecting eyes with a flattened pupil. Bella Coola masks are often painted bright blue, and both tribes used masks with interchangeable parts to change characters in the course of a dance. The Kwakiutl carved dramatic four-headed masks to use in dances of the Cannibal Society, which was outlawed during the 19th century. For some time, all native religious practices were forbidden, and ceremonial masks and other objects were confiscated by the government.

The Salishan-speaking peoples of the southern Northwest Coast included the Cowichan, Puyallup, Suquamish, Tillamook, and Nanaimo. The Nootka and lower Chinook also inhabited this area, depending upon vegetable food and seafood. The Nootka hunted whales in their dugout canoes, and the whale is a frequent emblem in their art. They also made distinctive basketry hats, sometimes crowned by an onion-shaped dome, in the twined technique. The Salishan tribes used the coiled technique with imbricated designs; some of them also wove blankets of dog's hair.

In general, carvings from this area are less refined and more brightly painted than those of the northern groups. Hand-hewn canoes are still made by tribes including the Suquamish, although today they are primarily for display and for racing. Guardian spirit figures are still carved among the Coast Salish and carried in traditional dances. Other traditional crafts, such as the carving of horn charms and objects, are little practiced today.

Contemporary Northwest carvers of distinction include the Kwakiutl artists Charlie James, Mungo Martin, Henry Hunt, and Doug Cranmer, to mention only a few. These men served apprenticeships with master craftsmen in the traditional way. Alaskan artists who have done fine Tlingit work include Lincoln Wallace of Sitka and Amos Wallace of Juneau. Nathan Jackson has helped revive Chilkat carving and bring it into the present with no sacrifice of quality. Collectors have created such a demand for Northwest Coast carvings that miniature totem poles are being created by Seminoles in the Everglades for sale to tourists! However, they are not meant to deceive anyone: it's a question of supply and demand.

On Alaska's Arctic Coast, the Inuit (Eskimo) comprise a distinct ethnic group relatively new to North America. Their ancestors came from parts of eastern Siberia some 2000 years ago, and their culture still bears affinities to that region. They make seasonal migrations to hunt caribou and musk ox during the short summer months and spend winters near the sea, hunting seal and walrus through their breathing holes in the ice. The Inuit are especially well known for their carvings in marine ivory – walrus and narwhal tusks. Long, dark winters in this region created leisure time in which to create such objects as animal carvings, headbands, toys, jewelry, and warm clothing of skins and furs.

The Inuit way of life is communal, with each family sharing food and shelter in the knowledge that its own survival might depend on that of others. Religious practices evolved around the mythology of animals that were hunted, and shamans were revered as healers, controllers of the weather, and ensurers of an adequate food supply. In some areas, there were annual gatherings for ceremonies in which masked dancers personated gods and spirits. The masks produced for these ceremonies are among the region's most distinctive artworks. Some were made of driftwood painted in polychrome; others were carved from native wood where it was available. Most depict a human face, or a grotesque variation thereof, and are encircled by such appendages as clamshells, feathers, carved hands and feet, and sprigs of dried plants. Tiny "finger masks" were also produced for ceremonial dances, in designs so old that their original meanings have been forgotten.

Many masks depict the *inua*, or spirit, of local animals, including salmon, hair seal, walrus, waterfowl, and sea parrots, or oystercatchers. Others represent the *tunghak* – a being that controlled the supply of game. Occasionally, a representational mask showed a human face without distortion of any kind, perhaps with traditional tattoo marks and a winter hood attached.

Recurrent designs in Inuit art since prehistoric times include both realistic and mythic animals, sometimes a combination of the two. Ivory carvings from this region range from toy dogs with a sled to seals with a mouth like a lamprey and a creature that is half whale, half polar bear. Slate and stone were also used for carving, and wristlets for ceremonial dances were made from sealskin. Dolls were made for children's play rather than ritual use, sometimes carved in ivory and dressed in traditional fur costumes. Native copper was used to make ornaments, and household utensils were carved from ivory and wood, sometimes with pierced handles and incised designs. Considering the harshness of this region, it is astonishing to find such a rich cultural heritage, which is being preserved and enhanced by new materials and techniques. These include carvings in soapstone and prints made from soapstone blocks or skin stencils.

In recent years, paper, canvas, and other nontraditional media have been employed by some native artists. Some of this work has obvious origins in Indian art of the past, while some is nontraditional. T. C. Cannon, for example, used contemporary pop art to express his cultural heritage, thus joining a long line of native artists who adopted innovations they found useful. Jaune Quick-to-See Smith is creating similar integrated artworks in her painted abstractions. Strong regional centers of Native American art now exist in major cities like Los Angeles and Phoenix, in addition to Santa Fe, to foster the work of painters like Fritz Scholder, Kevin Red Star, Bill Soza, Earl Biss, and Emmi Whitehorse. Several Native Americans are well known as both artists and writers, for example, N. Scott Momaday and Michael Kabotie.

It is heartening to know that men and women of great talent have emerged across the whole spectrum of Native America to affirm the vitality and importance of their cultural heritage. Today, as throughout its history, Native American art forges a physical link between the physical and spiritual worlds, opening the doors of perception to a deeper reality.

WEAVING AND BASKETRY

Prehistoric Southwestern farmers cultivated cotton and wove cloth from it for centuries before European contact. When the Spanish introduced sheep to the region, Pueblo descendants of the Anasazi and Mogollon learned how to make yarn and weave wool. They taught this skill to the Navajo, who became eminently proficient at it. During the 19th century, Navajo blankets were eagerly sought by traders to meet demand; the traders, in turn, had their influence on the work in supplying materials and proposing designs.

Both Pueblo and Navajo women wore horizontal blankets folded in half and sewn along the side to form a dress or *manta*. They were woven primarily in black, indigo, and red hand-spun wool, with traditional designs including diamonds and zigzag outlines. The beauty and durability of Navajo "wearing blankets" made them popular with other tribes, and some of the Southern Plains people adopted them in place of the buffalo robe. What came to be called the chief's-style blanket evolved through three distinct phases during the 19th century. Originally characterized by broad horizontal stripes, the Classic style added elongated rectangles; then half, quarter, and whole diamond shapes were balanced against the horizontal stripes. Other innovations included the use of commercially spun and dyed yarns from Germantown, Pennsylvania, to make the brightly colored pictorial blankets of the late 19th century.

The early 20th century saw a return to pictorial and geometrically designed blankets and rugs in natural vegetal-dyed colors, made from homespun Marino and Rambouillet wool. Navajo weaving has long since been highly regarded as an art form, and collectors are eager to acquire the work of such contemporary weavers as Lillie Touchin, Charlotte Yazzie, Cecilia George, Marian Nez and Julia Jumbo as well as the work of contemporary Hopi weaver Ramona Sakiestewa.

Closely related to weaving is the ancient art of basketry, widely practiced throughout North America in a variety of forms and materials. Elegant twined baskets with delicate featherwork and shellwork are characteristic of such northern California tribes as the Pomo, Hupa, Washoe, and Yurok. These tribes and others who lived primarily by gathering seeds and nuts, rather than by agriculture or hunting, became famous for their basket-making, even developing watertight baskets to meet their needs. Geometric and pictorial designs handed down through the centuries characterized the work of the various tribes. In central California, the Chumash made fine coiled baskets. Northwest Coast tribes including the Haida, Tlingit, and Makah made basketry hats and lidded baskets of great complexity and beauty.

In the Southeast, reeds and cane were used to weave baskets for storage, gathering, and a variety of other uses, including cradles. Southwestern tribes, including the nomadic Apache, made strong, wide-mouthed basketry jars and trays, and the Pueblo people used baskets to raise and lower supplies to their mesas, as well as for farming and storage.

***Navajo Textile – Teec Nos Pos
Style,*** c. 1993
Marian Nez
Commercial wool
88 × 111 inches
Courtesy of the Santa Fe Collection and
Cristof's, Santa Fe, New Mexico
Photography by Mark Nohl

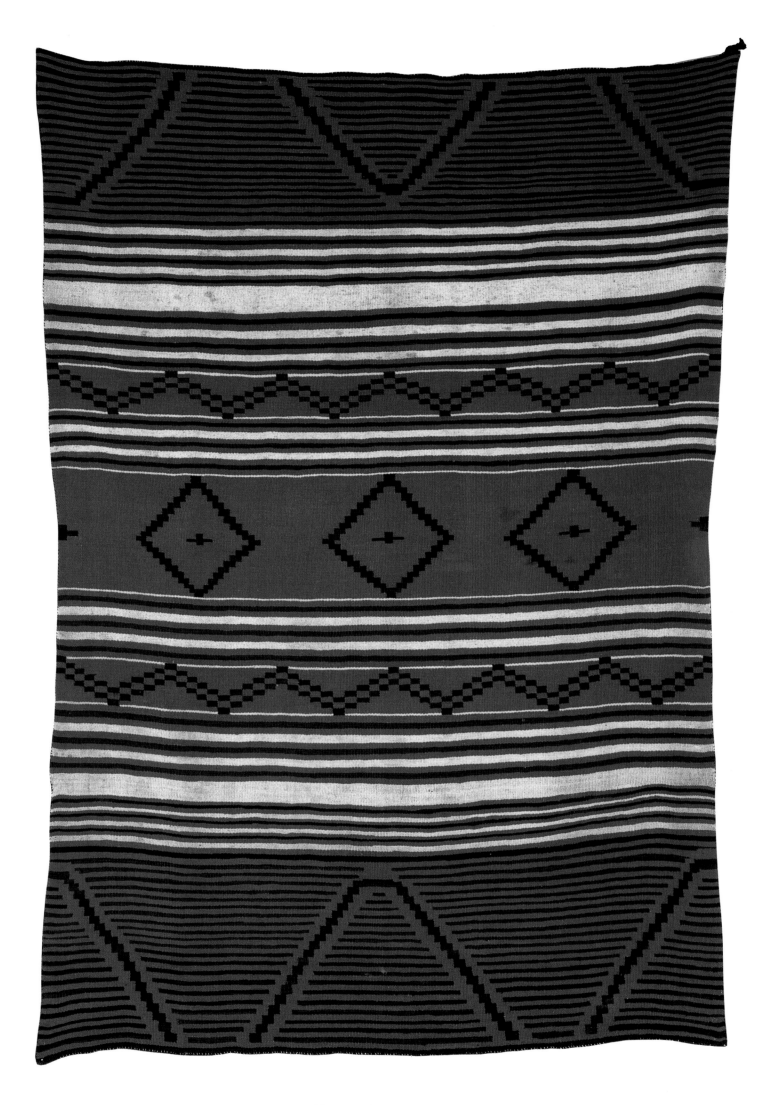

Navajo Classic Serape, 1850-60
Red bayeta with homespun white and indigo
yarn
67 × 43 inches
Courtesy Morning Star Gallery, Santa Fe,
New Mexico
Photography by Addison Doty

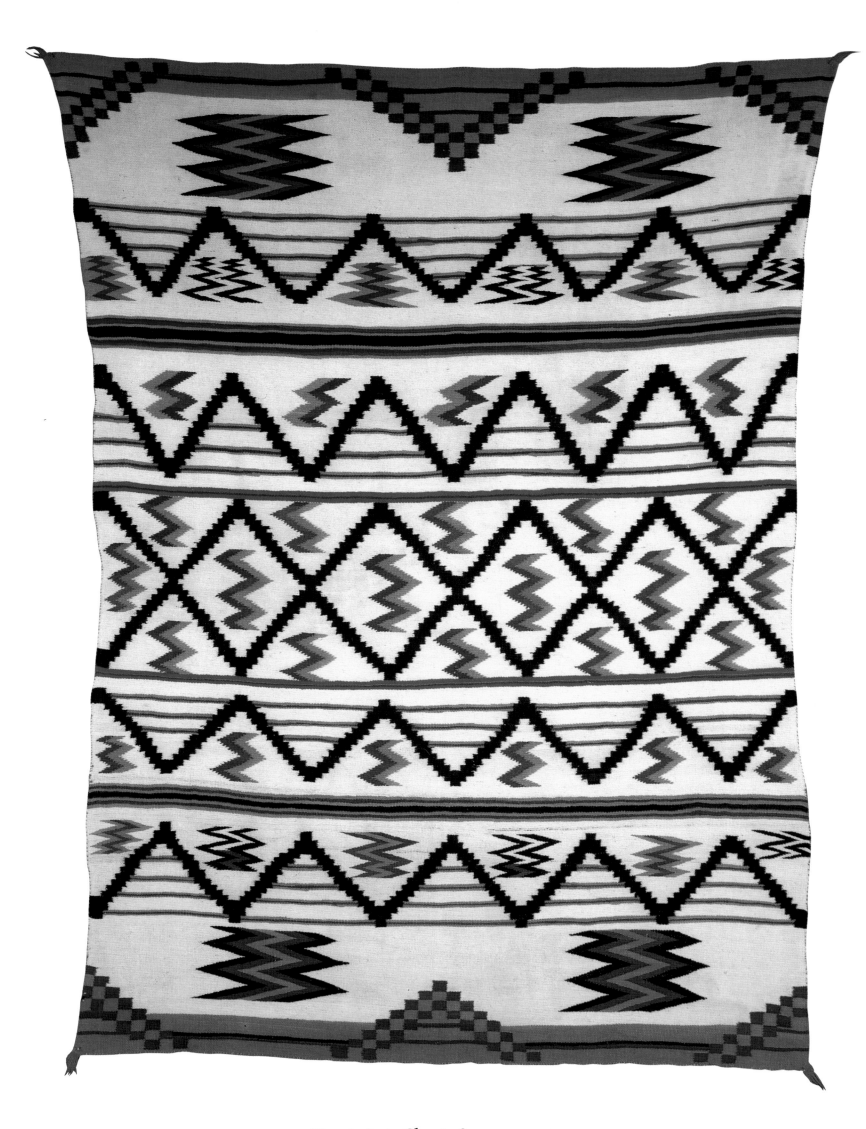

Navajo Late Classic Serape, c. 1870
Homespun wool
68 × 50 inches
Courtesy Morning Star Gallery, Santa Fe,
New Mexico
Photography by Addison Doty

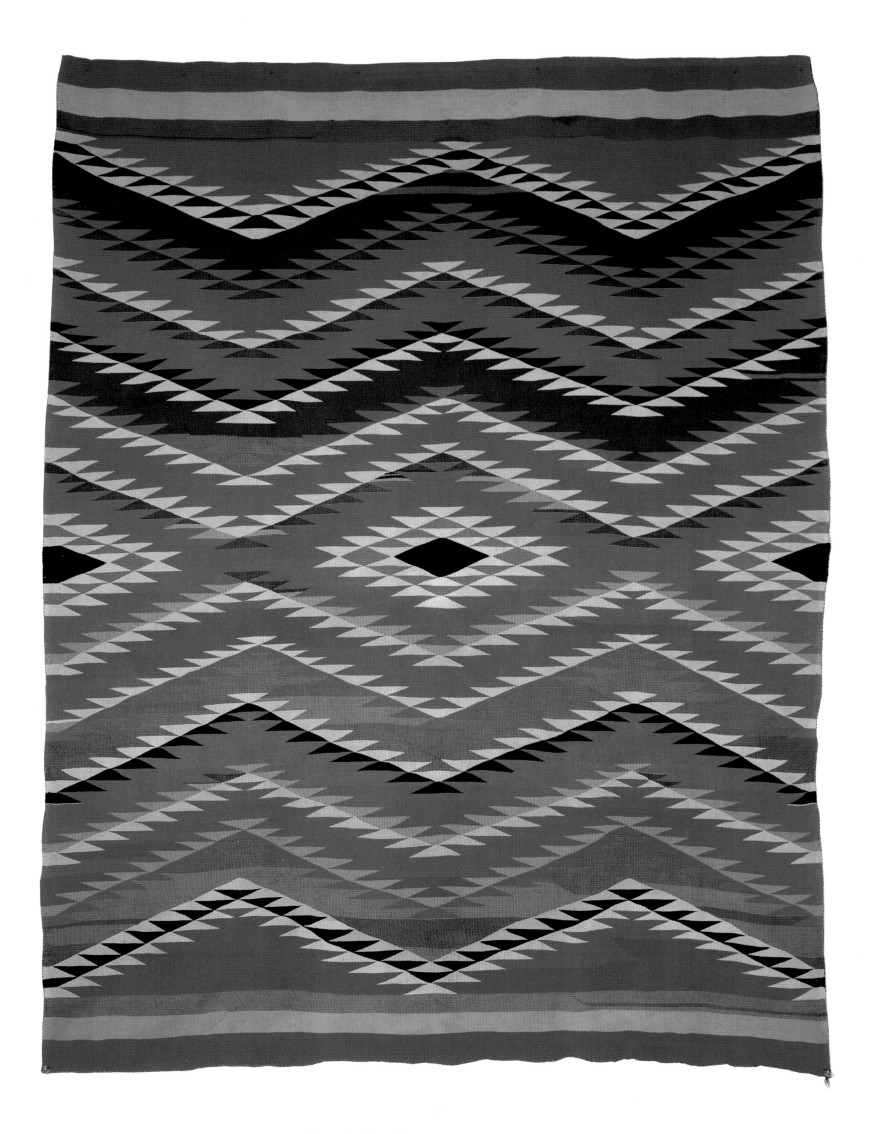

Navajo Textile, 1880-90
Four-ply Germantown yarn
79 × 62 inches
Courtesy Morning Star Gallery, Santa Fe,
New Mexico
Photography by Addison Doty

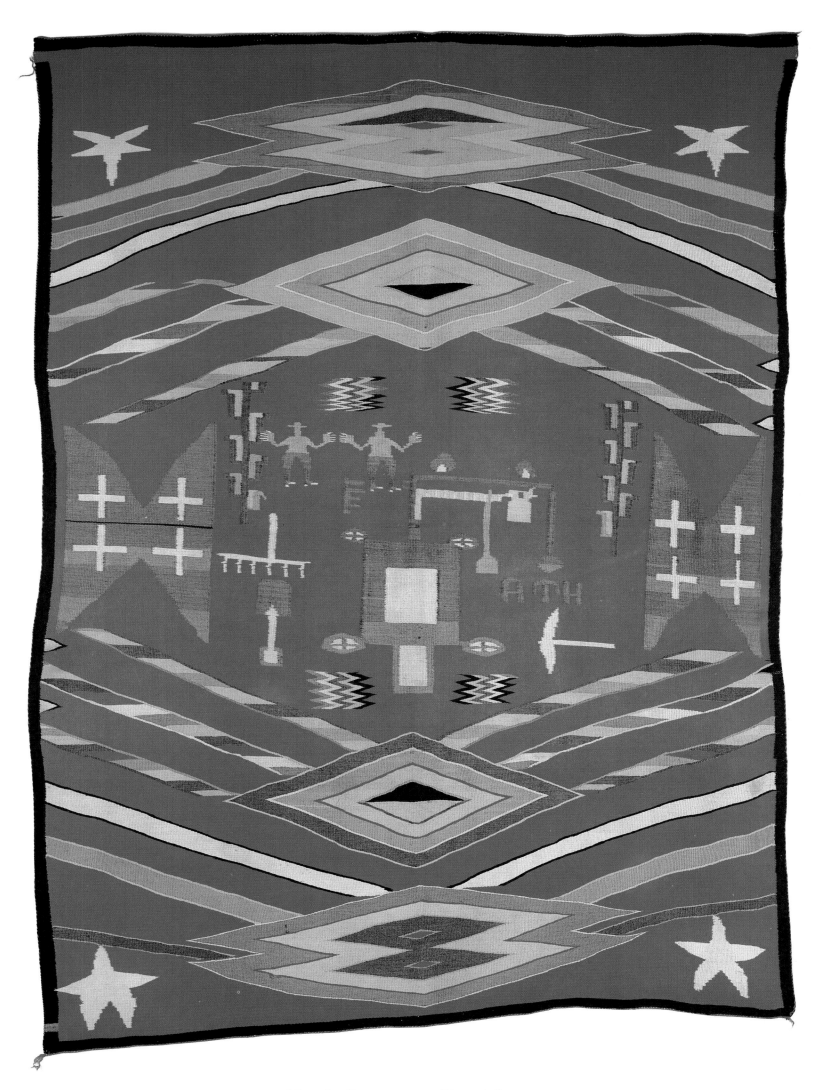

***Navajo Germantown Pictorial
Blanket,*** c. 1890
Germantown yarn
77 × 55 inches
Courtesy Morning Star Gallery, Santa Fe,
New Mexico
Photography by Addison Doty

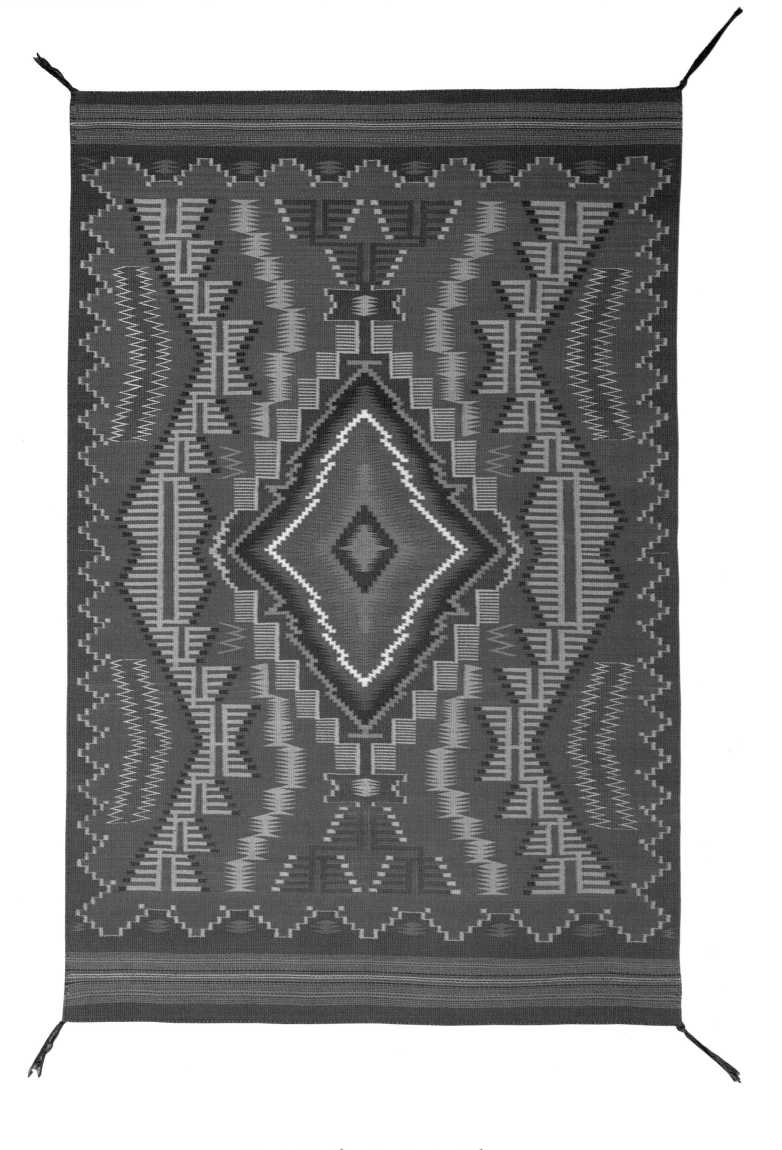

Navajo Textile – Burntwater Style,
c. 1991
Charlotte Yazzie
Vegetal and analine dyed respun commercial
wool
Courtesy Christof's, Santa Fe, New Mexico
Photography by Mark Nohl

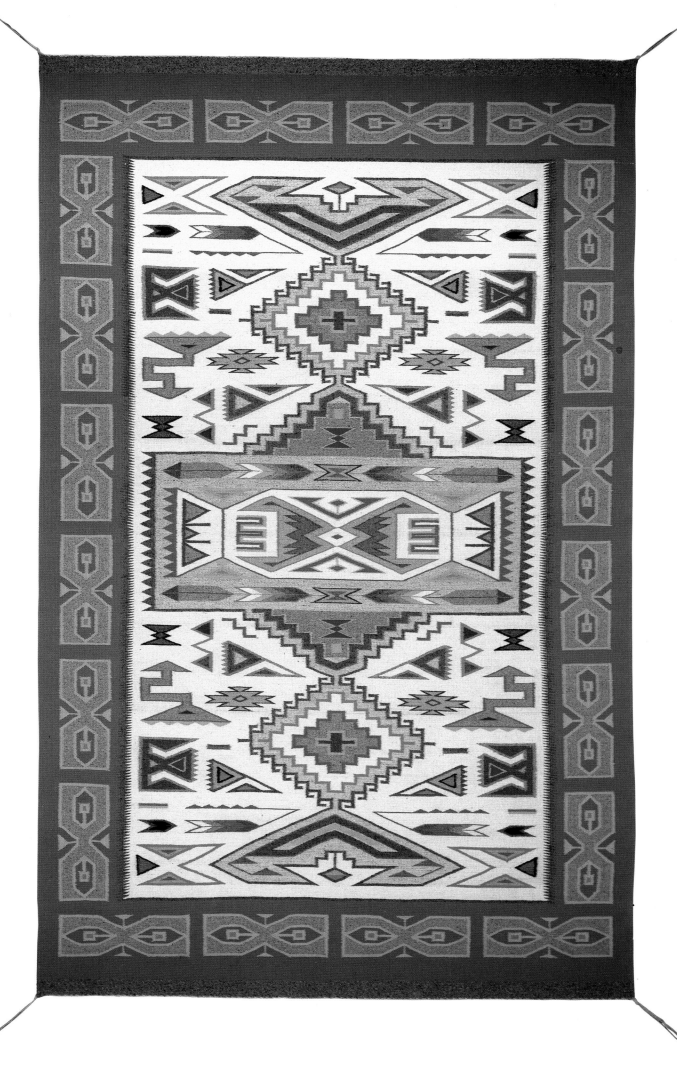

Navajo Textile – Teec Nos Pos
Style, c. 1990
Cecilia George
Commercial wool
50 × 79 inches
Courtesy Cristof's, Santa Fe, New Mexico
Photography by Mark Nohl

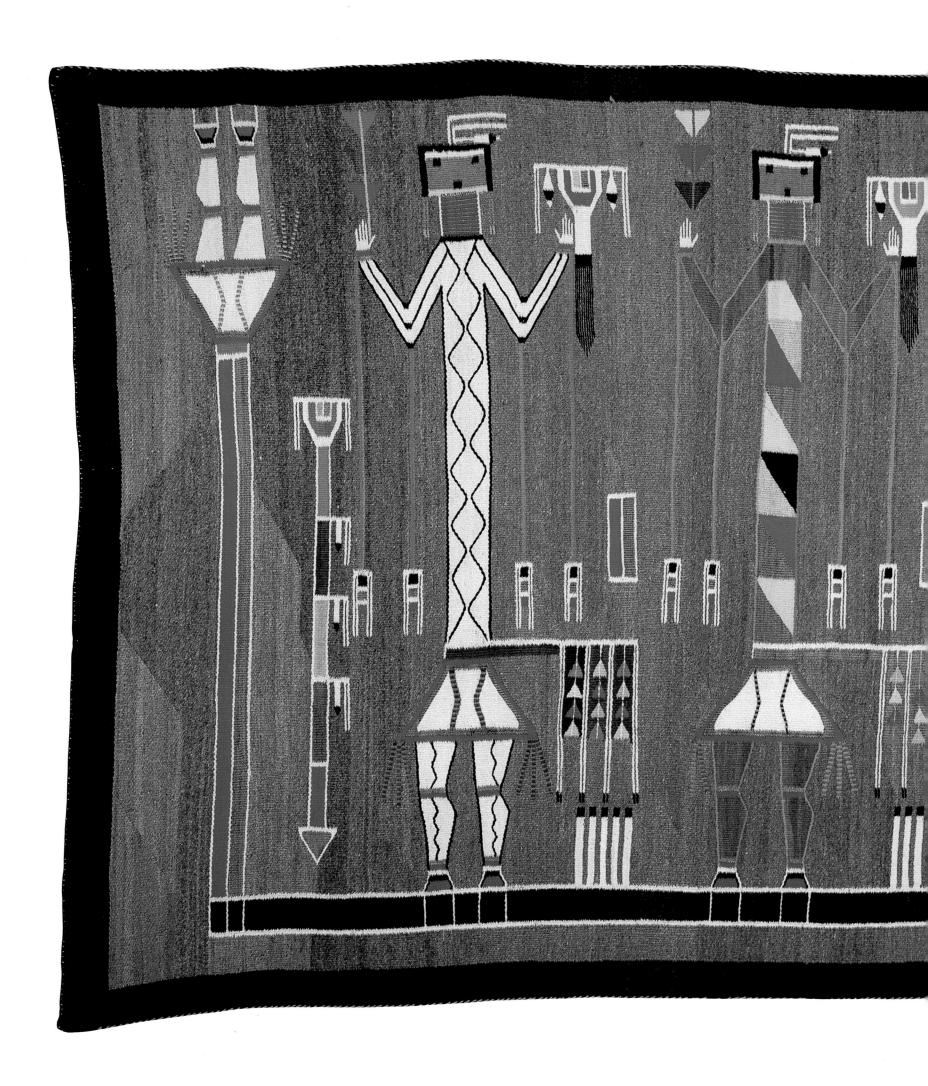

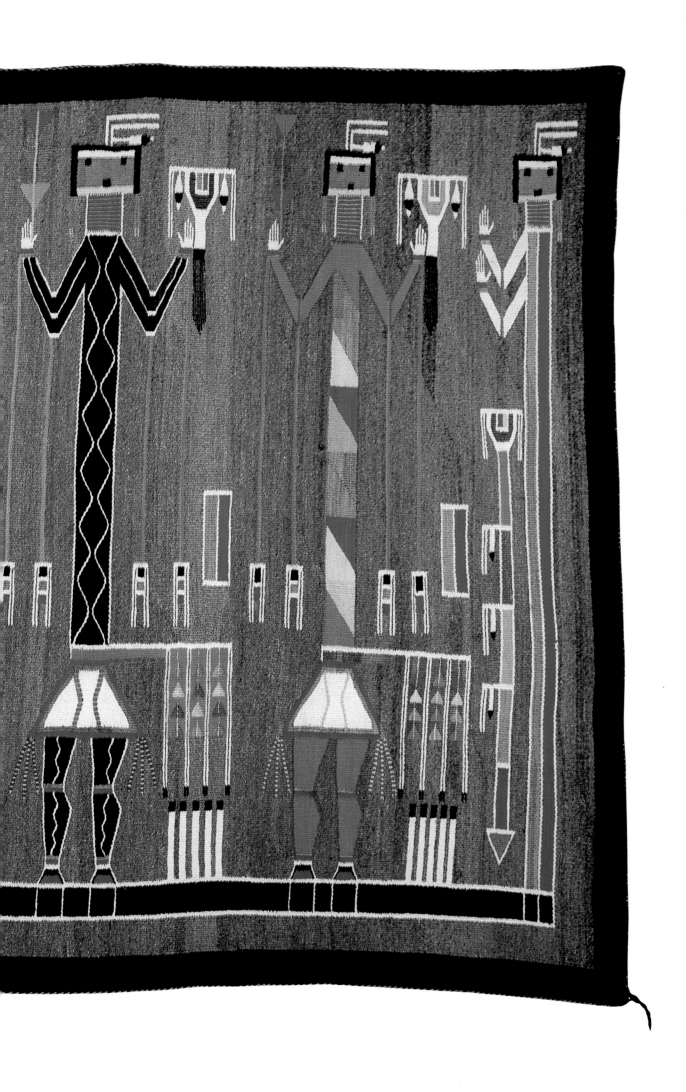

Navajo Yei Rug, c. 1930
Homespun yarn
57 × 96 inches
Courtesy Morning Star Gallery, Santa Fe,
New Mexico
Photography by Addison Doty

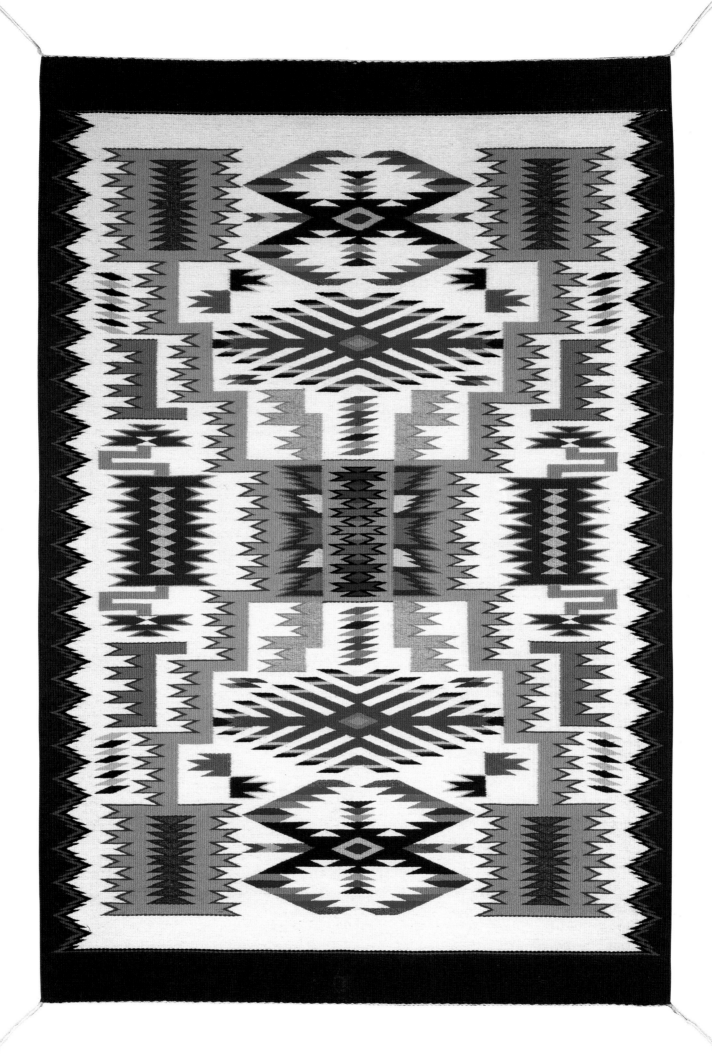

Navajo Storm Pattern Weaving,
c. 1991
Lillie Touchin
Natural and aniline-dyed wool
49 × 34 inches
Courtesy Christof's, Santa Fe, New Mexico
Photography by Mark Nohl

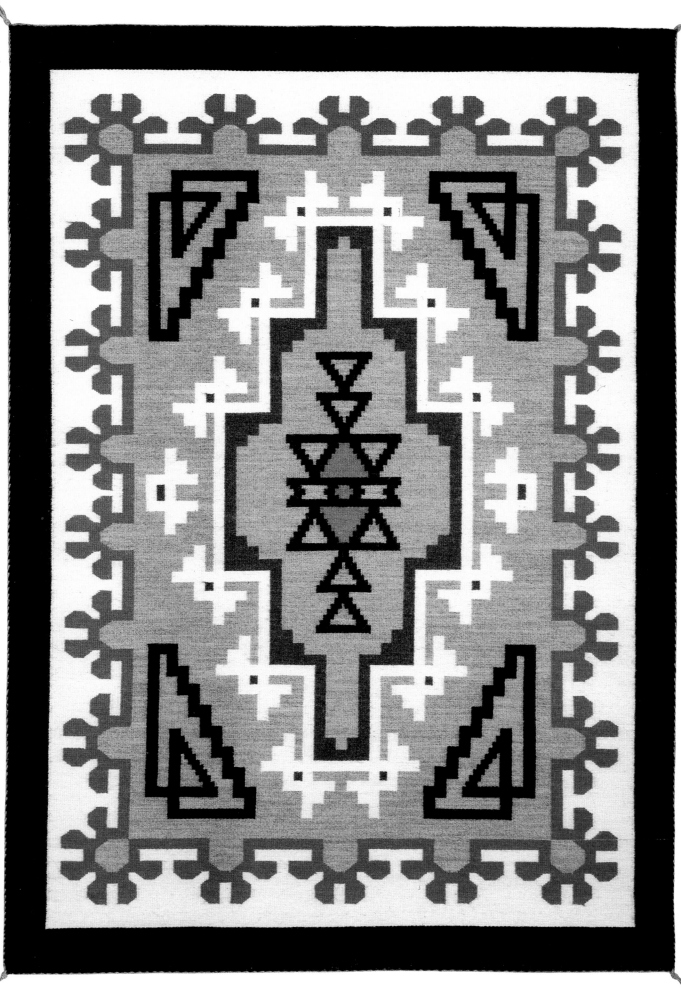

***Navajo Textile – Two Grey Hills
Tapestry,*** c. 1979
Julia Jumbo
All natural handspun wool
21½ × 30 inches
Courtesy Christof's, Santa Fe, New Mexico
Photography by Mark Nohl

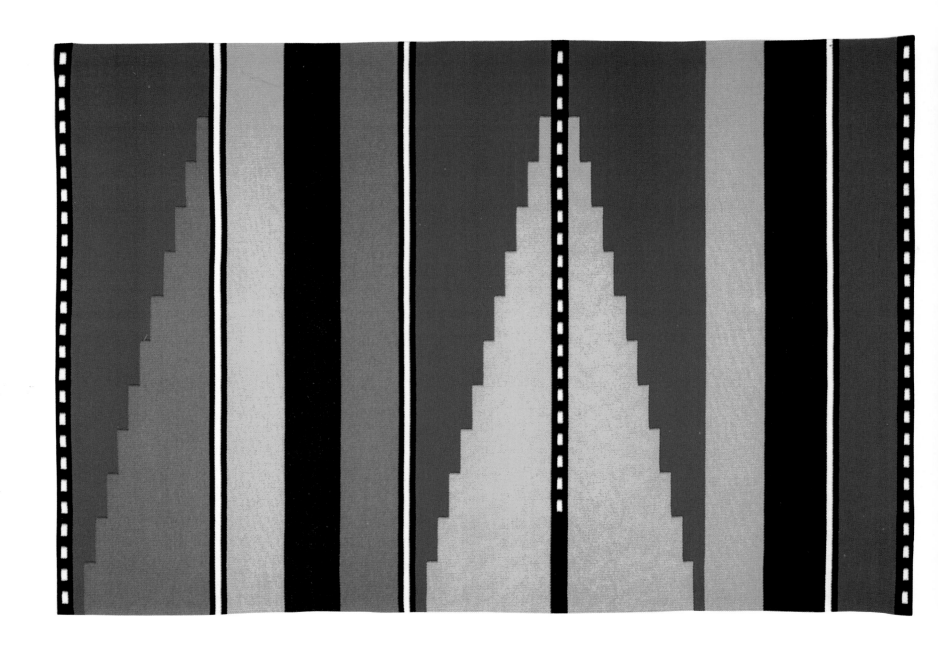

Basket Dance, 1991
Ramona Sakiestewa–Hopi
Hand woven wool
50 × 73 inches
Courtesy Lew Allen Gallery, Santa Fe,
New Mexico

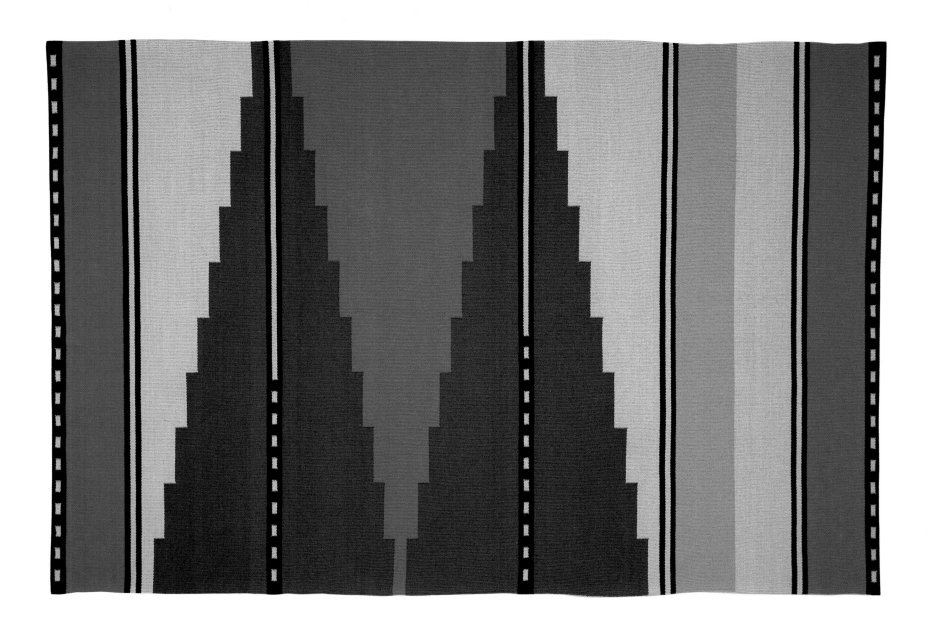

Basket Dance, 1992
Ramona Sakiestewa–Hopi
Hand woven wool
50 × 75 inches
Courtesy Lew Allen Gallery, Santa Fe,
New Mexico

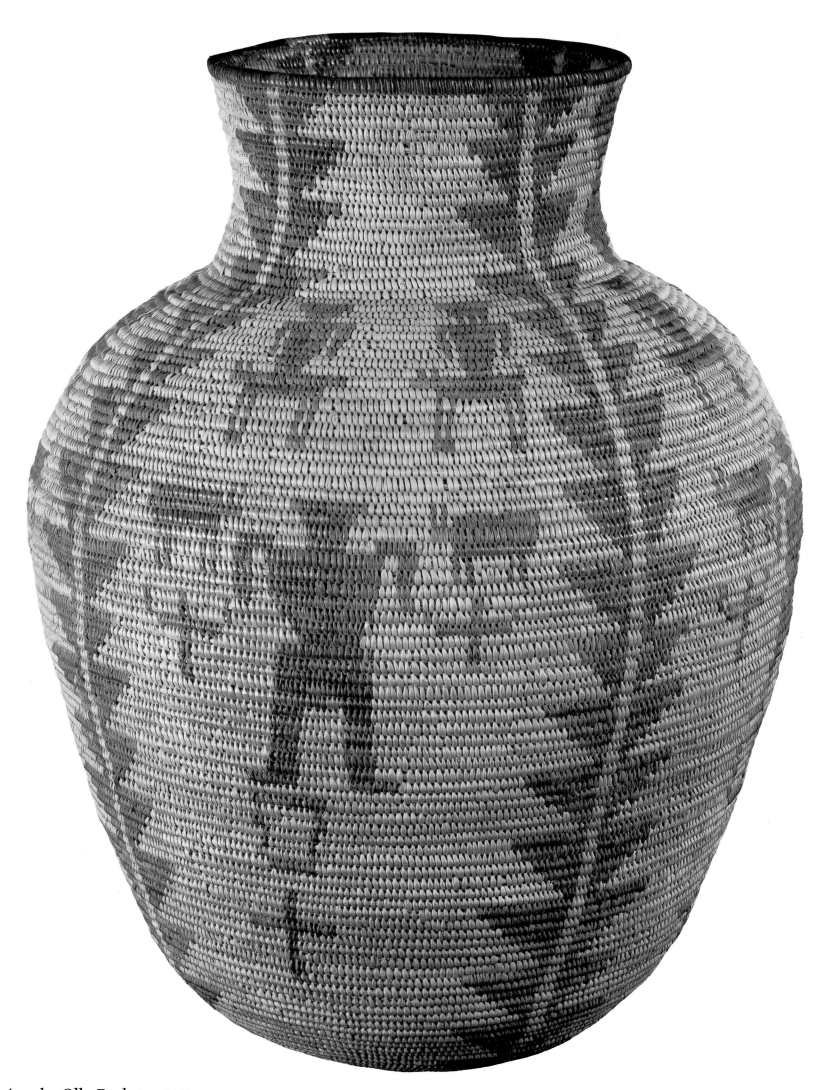

Apache Olla Basket, c. 1900
Willow and devil's claw
Height 17 inches
Courtesy Morning Star Gallery, Santa Fe,
New Mexico
Photography by Addison Doty

40

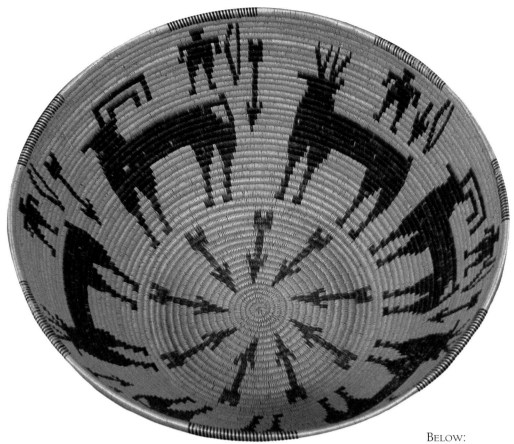

ABOVE:
Paiute Panamint Style Basket,
pre-1915
Rosie – Owens Valley Paiute
Woven reeds (40 stitches per inch)
Diameter 7½ inches
Gift of the Artist
San Diego Museum of Man, California
Photography by Ken Hedges

BELOW:
Kumeyaay Coiled Basket, Campo,
California, 1935
Marie Menas Chappo
Bunch grass, three-leaf sumac, and devil's claw
18½ × 15½ × 1½ inches
Mrs. J. D. Zaucha Purchase
San Diego Museum of Man, California
Photography by Ken Hedges

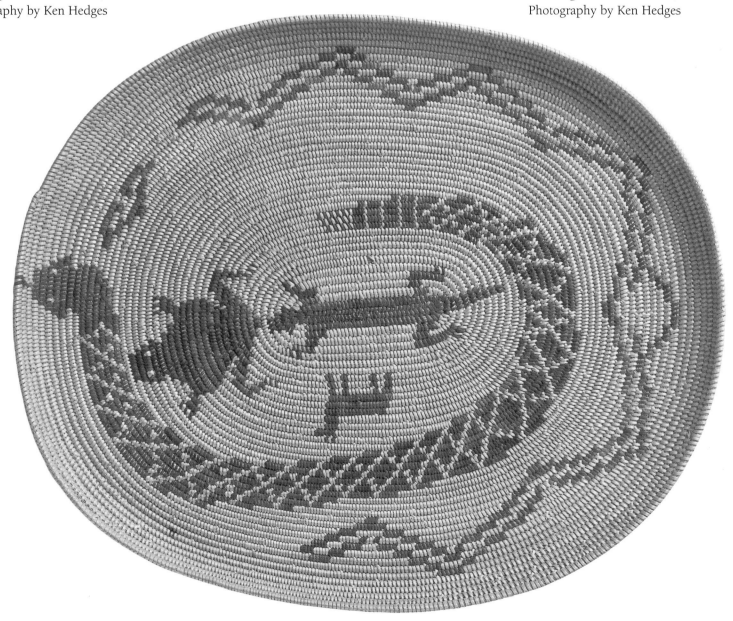

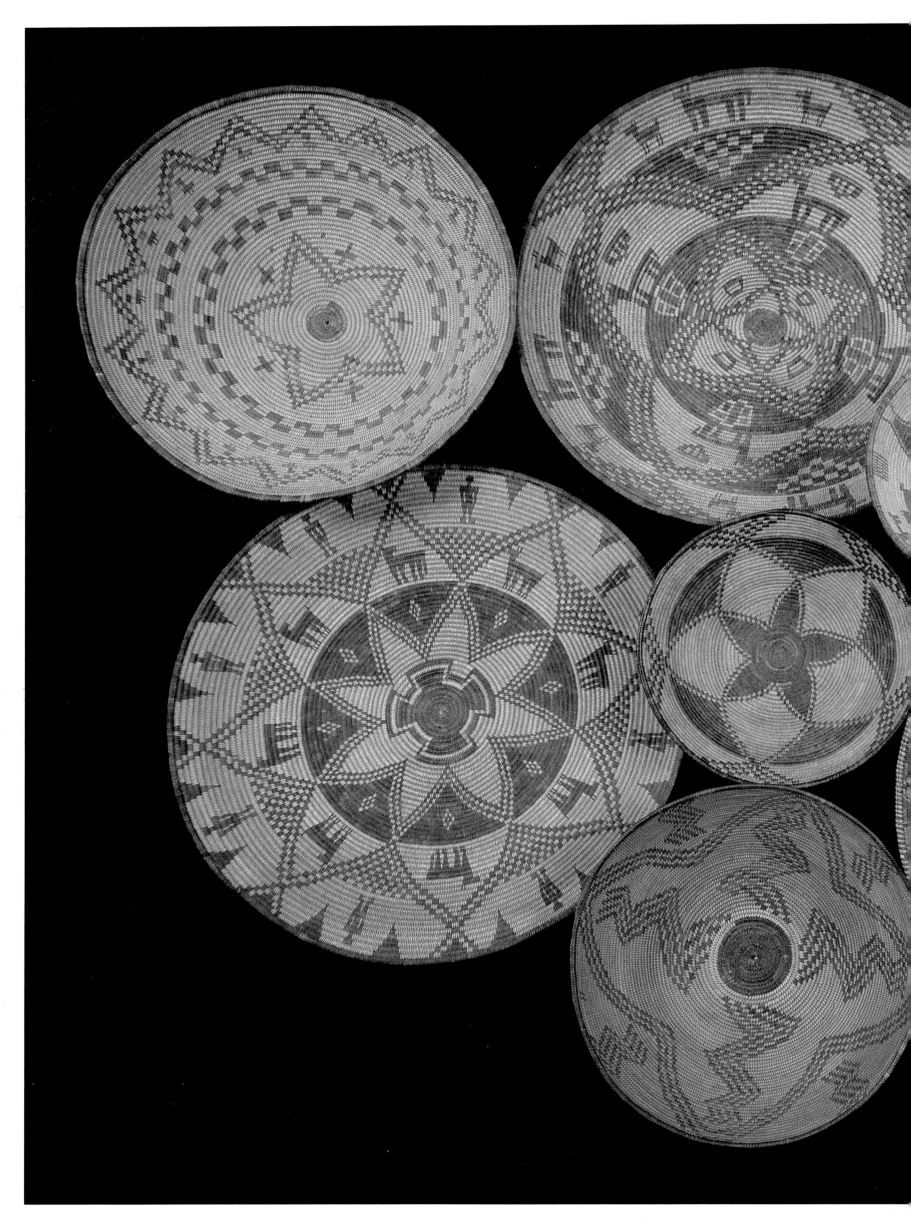

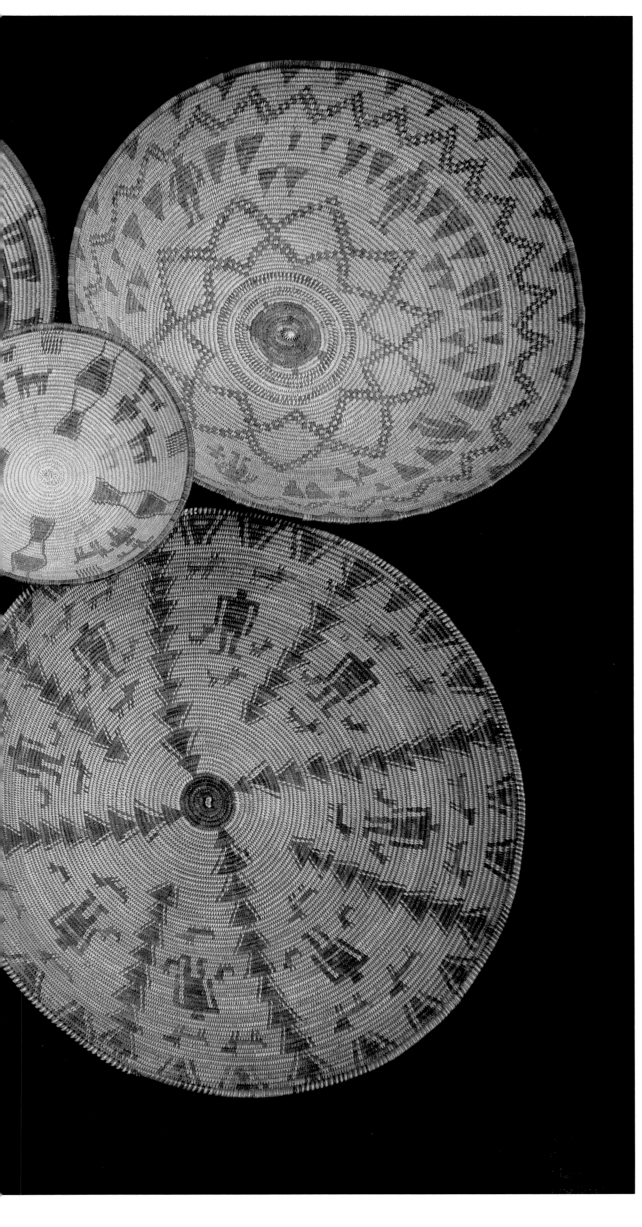

Apache and Yavapai Basket Trays, 1900-10
Cottonwood and devil's claw
Diameter 10½ – 22 inches
Courtesy Morning Star Gallery, Santa Fe,
New Mexico
Photography by Addison Doty

43

Yokuts (Fort Tajoen) Basket, 1890-1910
Willow and bracken fern
Diameter 20½ inches
Courtesy Morning Star Gallery, Santa Fe, New Mexico
Photography by Addison Doty

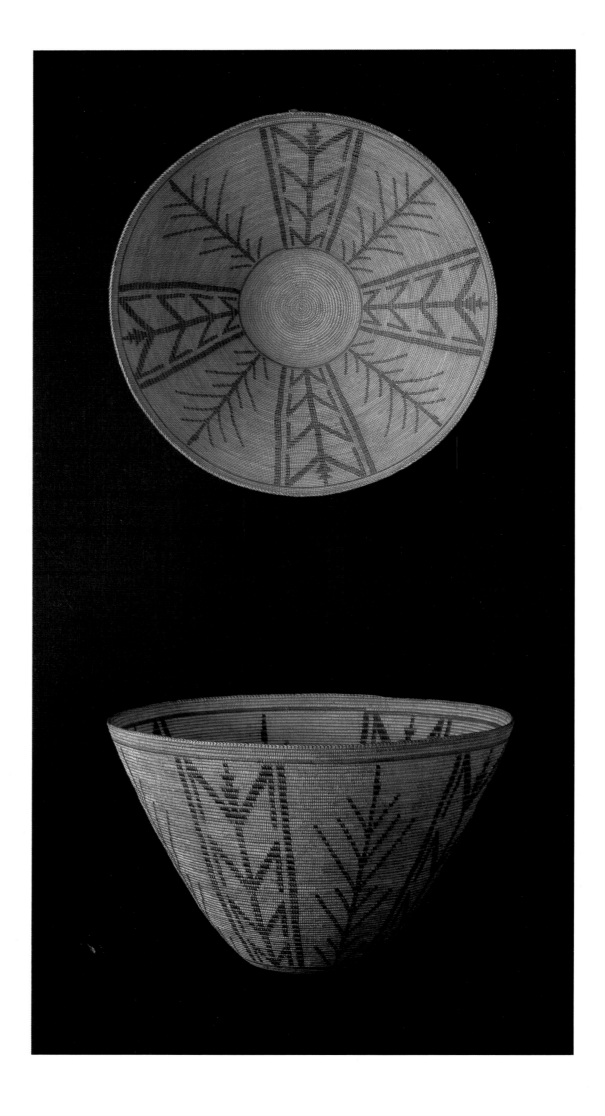

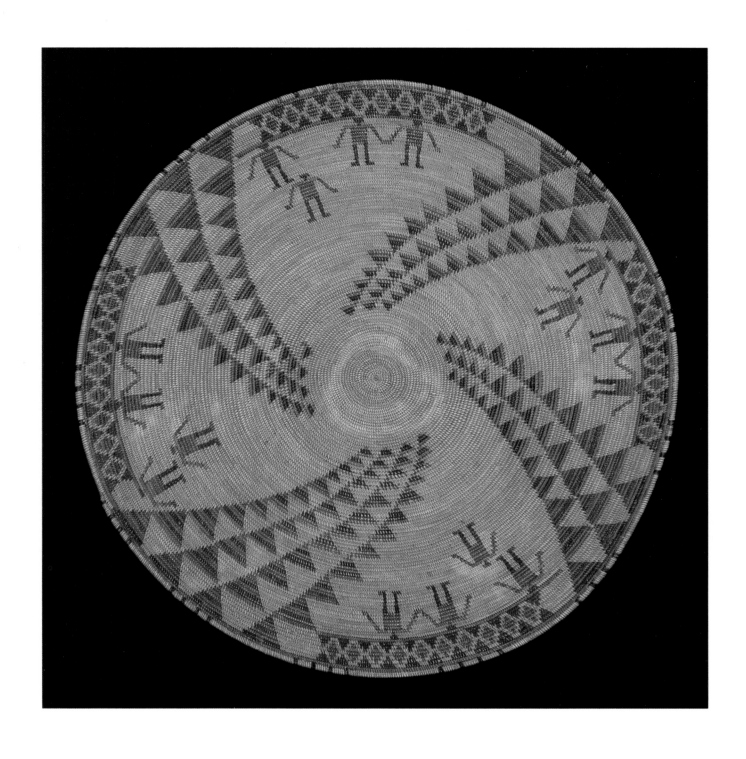

**Yokuts Polychrome Gambling
Tray,** c. 1920
Willow, bracken fern and redbud
Diameter 26 inches
Courtesy Morning Star Gallery, Santa Fe,
New Mexico
Photography by Addison Doty

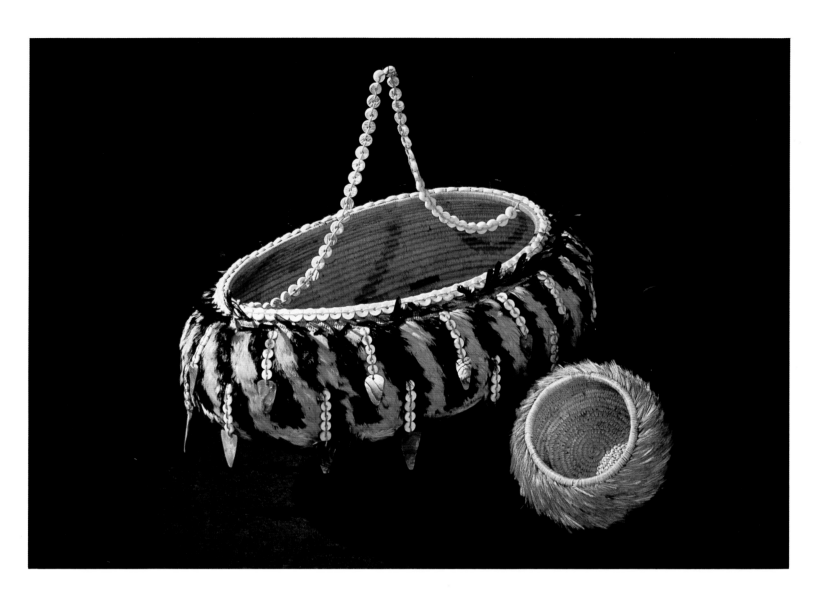

ABOVE:
Pomo Gift Basket, California, c. 1890
Woven reeds, shells, feathers
Diameter 10⅜ inches
National Museum of Natural History
Smithsonian Institution, Washington, D.C.

BELOW:
Yokuts Basket, Tule River, California,
pre-1936
Woven reeds, California quail feathers
5 × 6½ × 3½ inches
Loaned by Edith Williams
San Diego Museum of Man, California
Photography by Ken Hedges

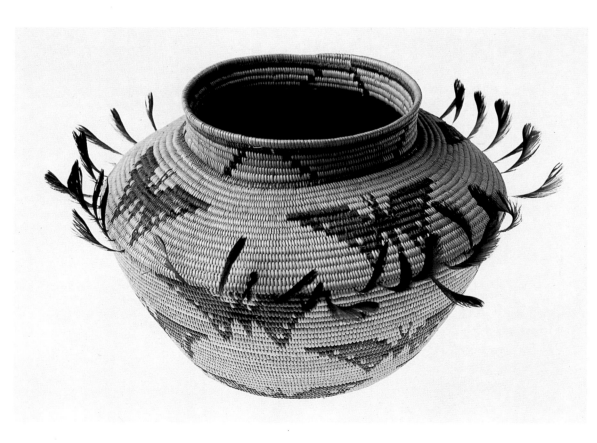

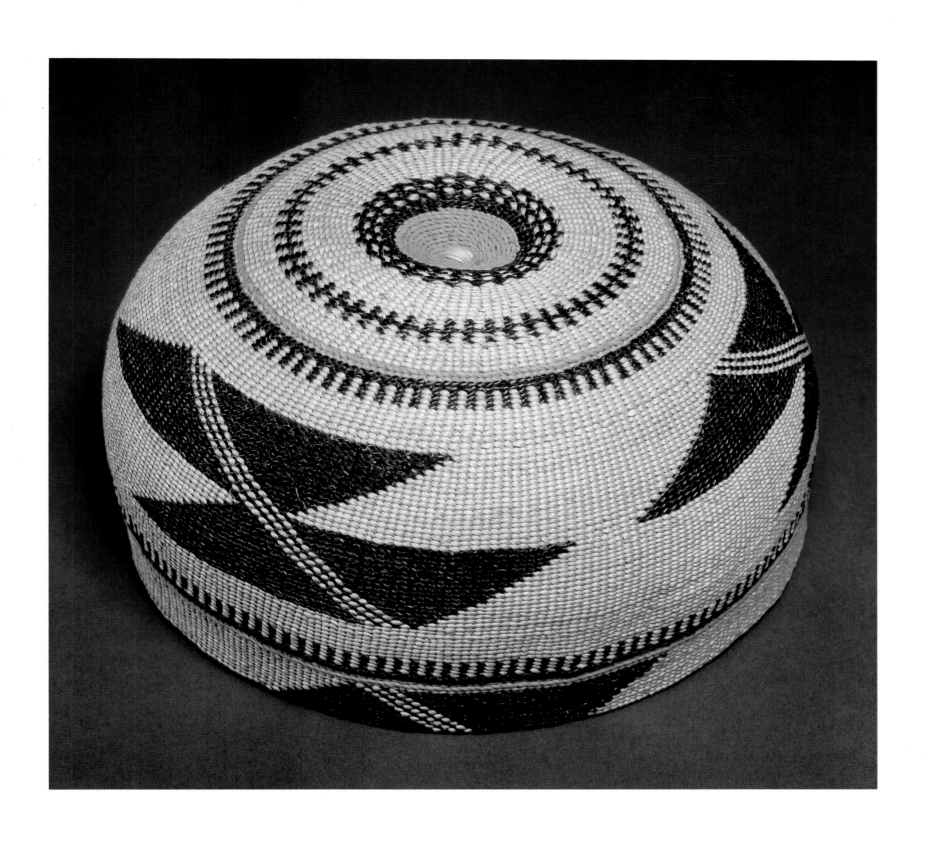

Karok Basket Hat, California
Gift of Mrs. Russell Sage
National Museum of the American Indian
Smithsonian Institution
Photography by David Heald

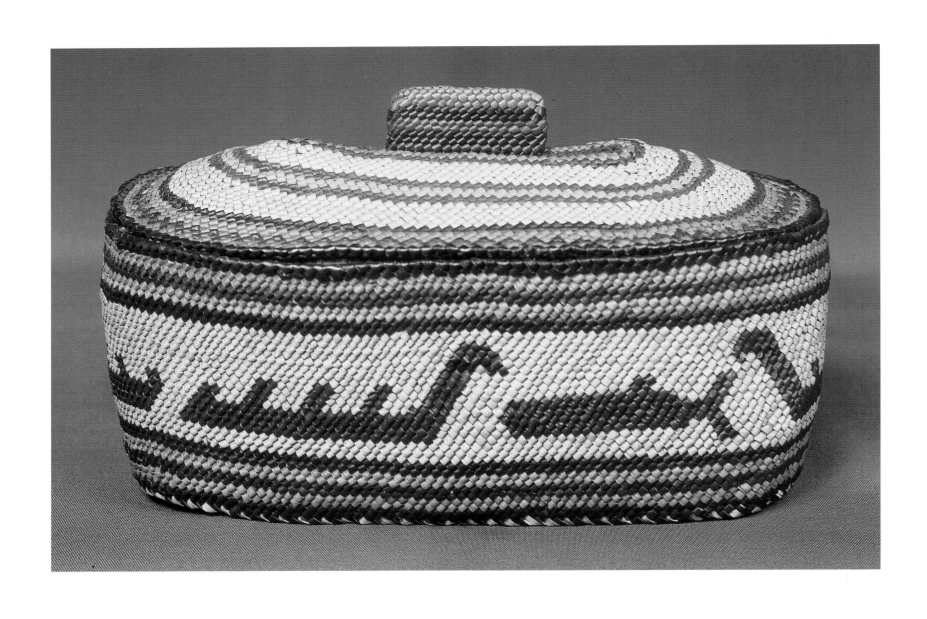

Makah Oval Basket and Cover,
Washington
8 × 4½ inches
National Museum of the American Indian
Smithsonian Institution

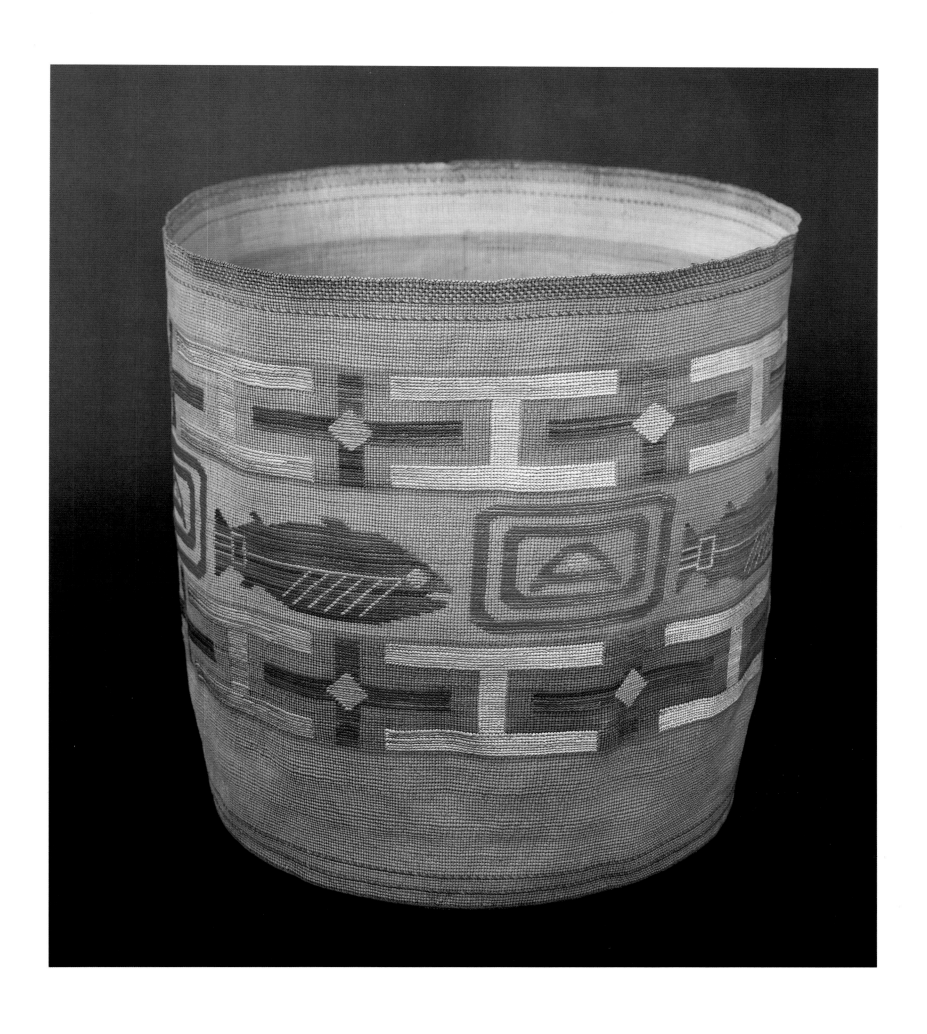

Tlingit Basket, c. 1900
Spruce roots, grasses
13½ × 15⅜ inches
Alaska State Museum
Photography by Lynn Armstrong

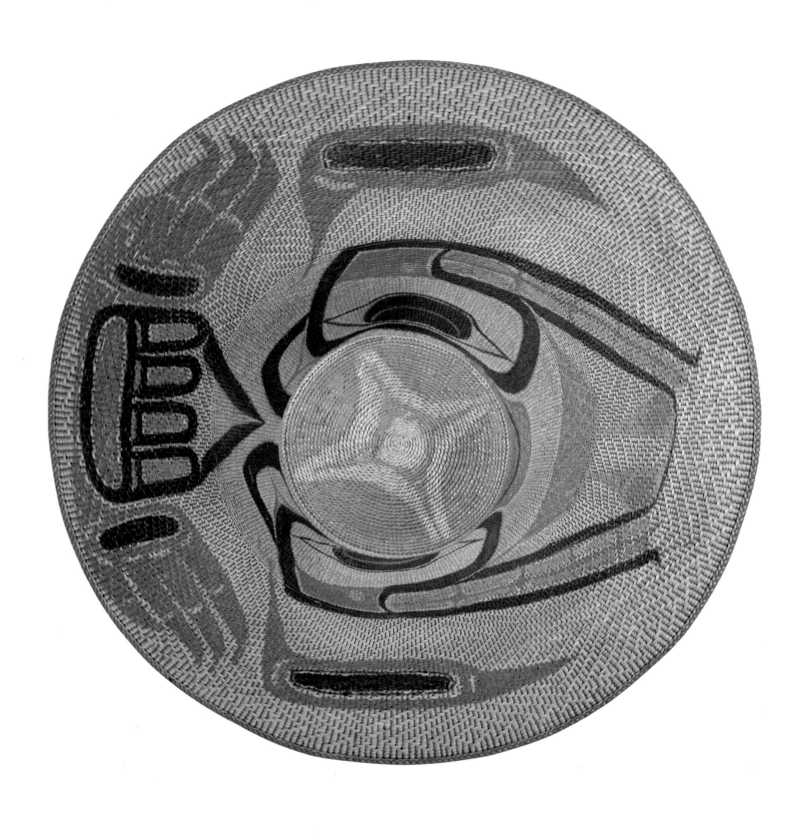

Haida Rain Hat, c. 1880
Woven spruce root
16½ × 7 inches
University of Kentucky, Lexington, Kentucky

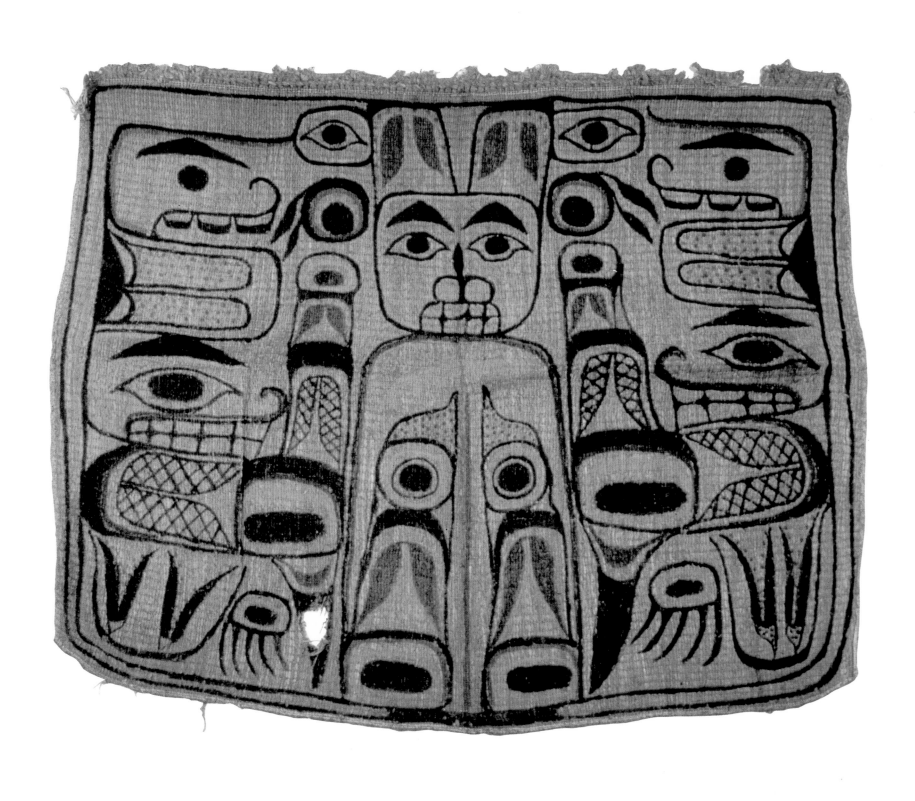

Kwakiutl Bark Blanket
Cedar bark
National Museum of the American Indian
Smithsonian Institution

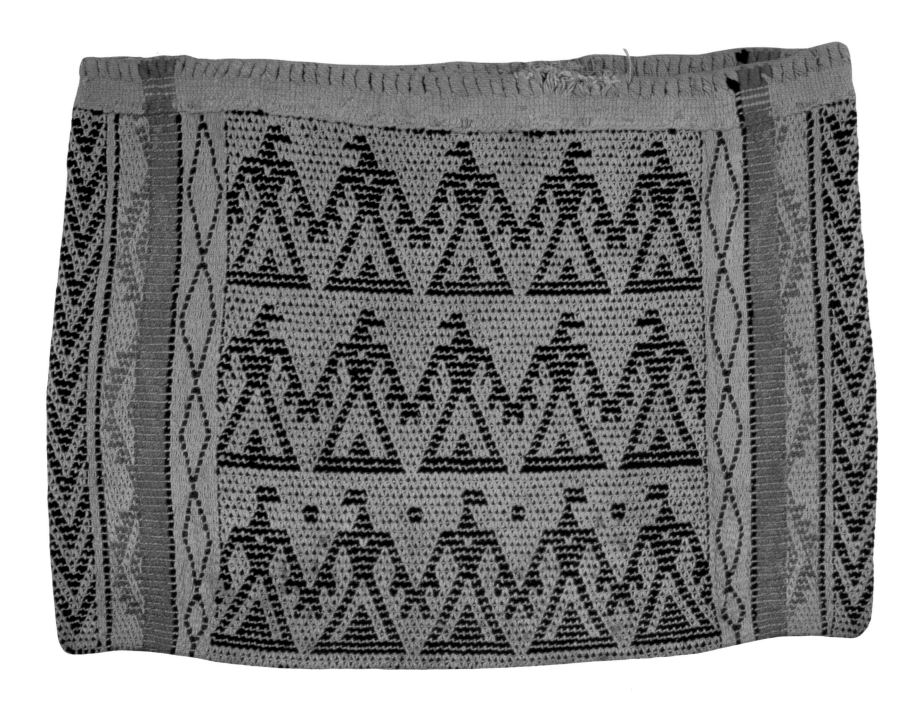

RIGHT, FROM TOP:
Menominee Yarn Bag, Wisconsin,
c. 1900
Potawatomi Woven Storage Bag,
c. 1900
David T. Vernon Collection
Colter Bay Indian Arts Museum, Grand Teton
National Park, Wyoming
Photography by John Oldencamp and Cynthia
Sabransky

ABOVE:
Fox Woven Yarn Bag, Iowa
National Museum of the American Indian
Smithsonian Institution

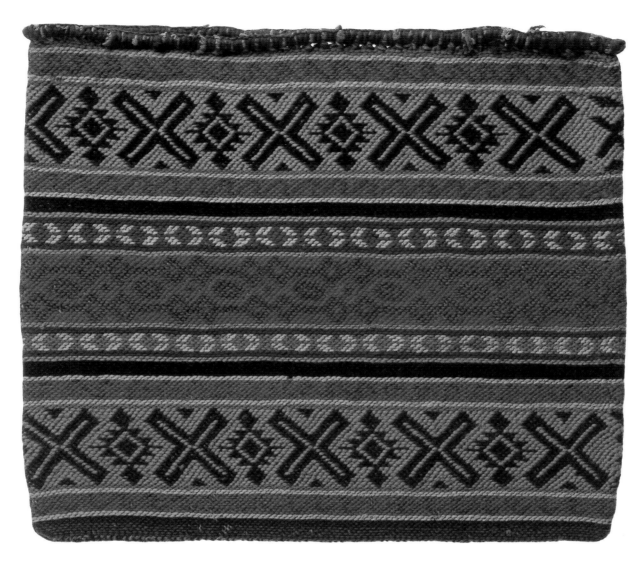

POTTERY

Durable pottery has provided us with many valuable clues to the prehistoric cultures of North America, including the Mound cultures of the eastern United States. Animal-shaped effigy jars and mortuary offerings with complex geometric designs that originated with basket-making were carried over to pottery long before European contact. Some of them are still seen today, especially in the Southwest. Here the Anasazi, ancestors of the Pueblo peoples, developed a distinctive firing technique that yielded vivid black-on-white colors on their ceramic works, whose decoration was nonfigurative and linear.

From about A.D. 200, Hohokam villagers of southern Arizona were making painted pottery, which soon became the dominant art form throughout the region. Mimbres artists of southwestern New Mexico made remarkable figurative paintings on their pottery between about A.D. 1000 and 1150, but most regional pottery adhered to the geometric style. Its striking effect was – and still is – primarily the result of complex linear patterns, whether painted or incised.

Over time, each pueblo developed a distinctive style. San Ildefonso and Santa Clara became known for their burnished red-and-black and black-on-black ware – a style revived in the early 1900s by Maria and Julian Martinez and carried on today by Maria's grandson, Tony Da. Double-spouted wedding vases and graceful storage jars are among the best known products of the potter's art at San Ildefonso. Santa Clara potters, including Grace Medicine Flower and Jody Folwell, have interpreted their traditional designs and techniques in vibrant forms and colors.

Taos and Picuris produce a tan pottery that glitters as a result of the high mica content in the local clay. At San Juan, the clay produces a distinctive dark red slip applied to large areas of utilitarian pottery as its sole decoration. The slip enhances the fluid curves of the object. Since the 1930s, incised decoration has been revived at San Juan as a result of prehistoric pieces unearthed at the nearby Otowi ruin.

Both Acoma and Zia make whiteware with beautiful plant and animal designs drawn from tradition and the natural surroundings. Birds are frequently depicted, as they are considered a link between heaven and earth and a symbol of spiritual aspiration. Thin-walled Acoma jars, painted with traditional Mimbres and Anasazi designs, have been much in demand since Lucy Lewis revived the style in modern times. Zia storage jars are often earth-colored with polychrome painting.

Zuñi potters are well known for their geometric designs and for the traditional deer with heartline running from mouth to mid-body. Hopi pottery has experienced renewal with the work of such artists as Al Qoyawayma, who brings an architectural quality to his art, in which relief elements are extruded from inside the pottery wall. Other techniques revived and combined in modern times include inlay, two-tone firing, and multiple colors of slip.

Cochiti has become well known for the clay storyteller figures developed by Helen Cordero, and Santo Domingo is still producing elegant black-and-cream ware with intricate geometric designs. The Navajo, better known for their weaving, also make a distinctive brown pottery that was barred from commercial sale by tribal taboos until recent times.

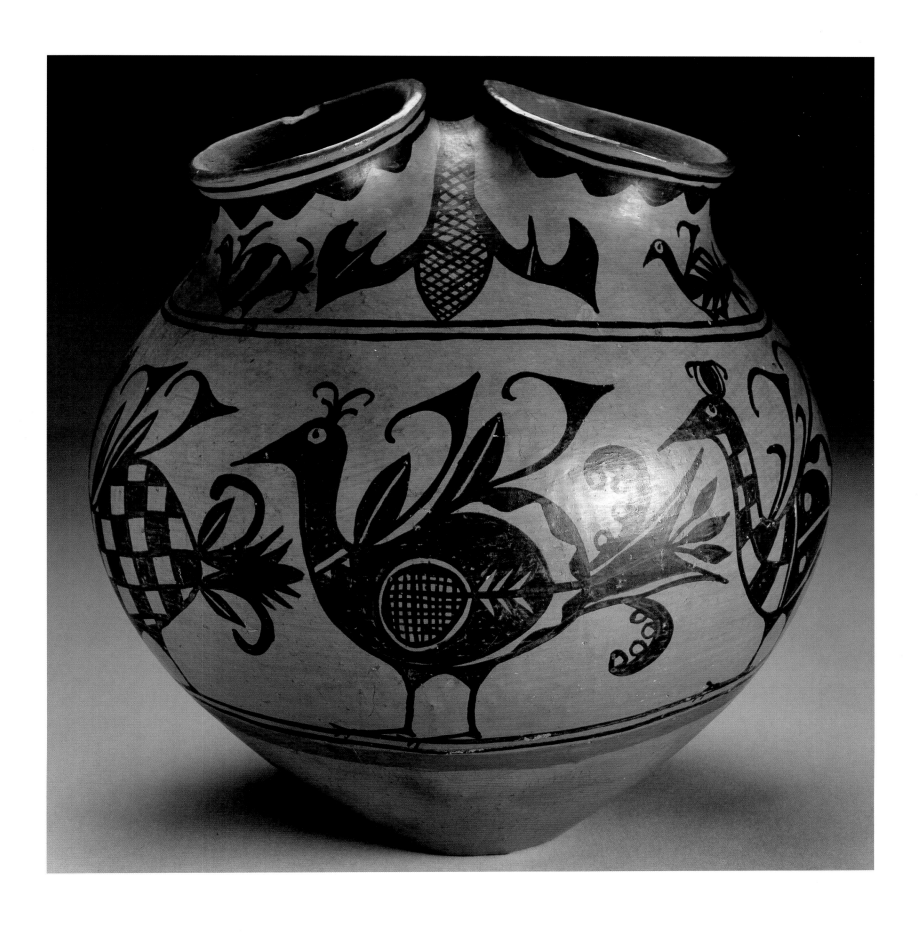

***San Ildefonso Pueblo Wedding
Vase,*** c. 1910
Black-on-red
Height 12 inches
Courtesy Morning Star Gallery, Santa Fe,
New Mexico
Photography by Addison Doty

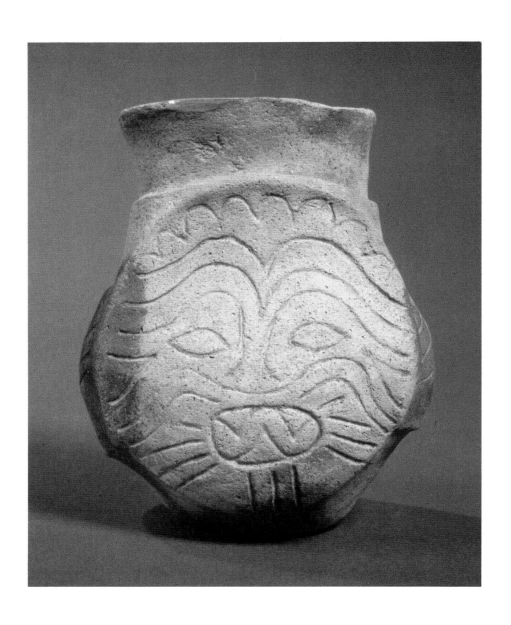

San Lazaro Polychrome Jar, Santa Fe Area, New Mexico, c.1450
Collection of Mr. and Mrs. Forrest Fenn
Photography by Addison Doty

San Lazaro Polychrome Jar with Bird Motif, Santa Fe Area, New Mexico, c. 1450
Collection of Mr. and Mrs. Forrest Fenn
Photography by Addison Doty

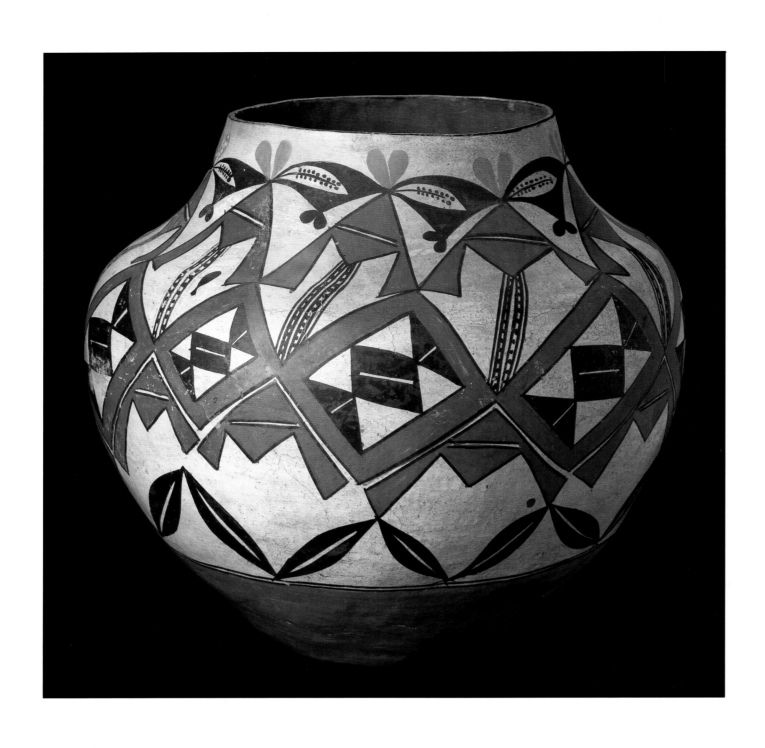

Laguna Pueblo Polychrome Jar,
c. 1880
Height 12½ inches
Courtesy Morning Star Gallery, Santa Fe,
New Mexico
Photography by Addison Doty

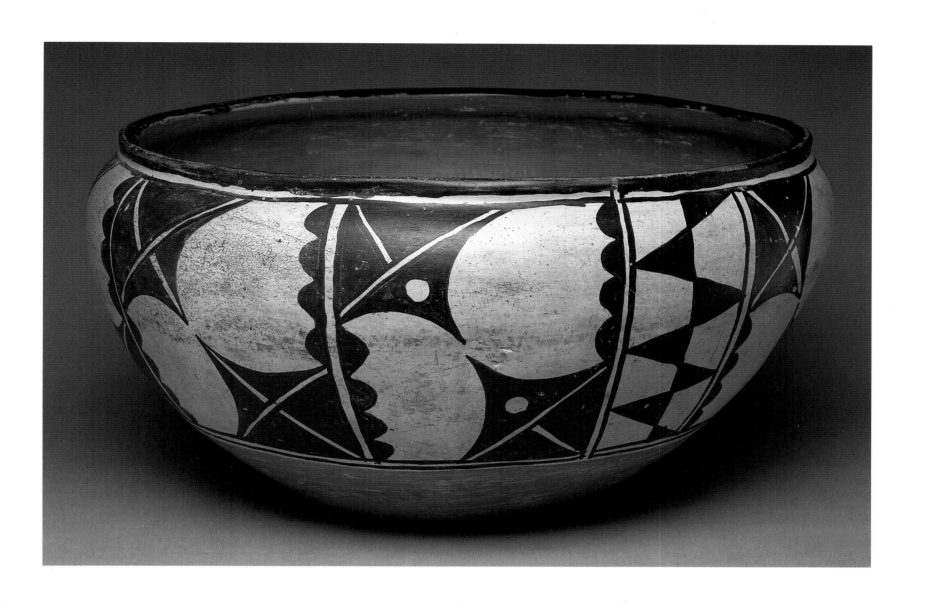

*Santo Domingo Pueblo Dough
Bowl,* c. 1930
Black-on-cream
Diameter 20 inches
Courtesy Morning Star Gallery, Santa Fe,
New Mexico
Photography by Addison Doty

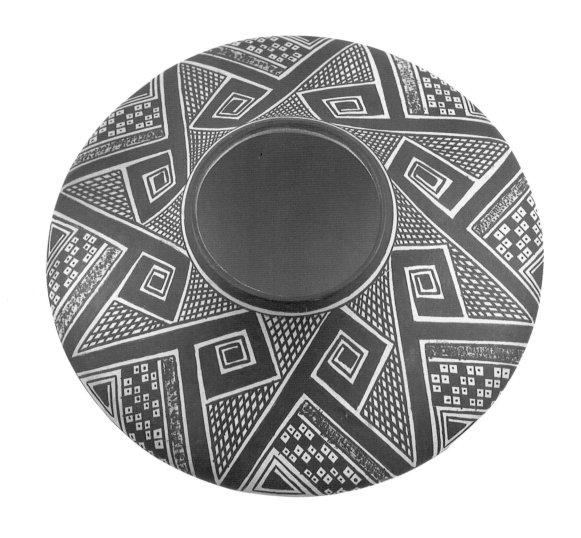

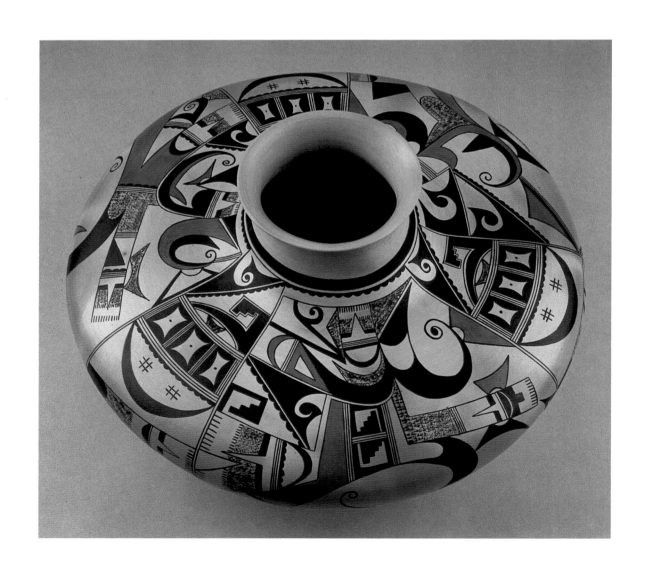

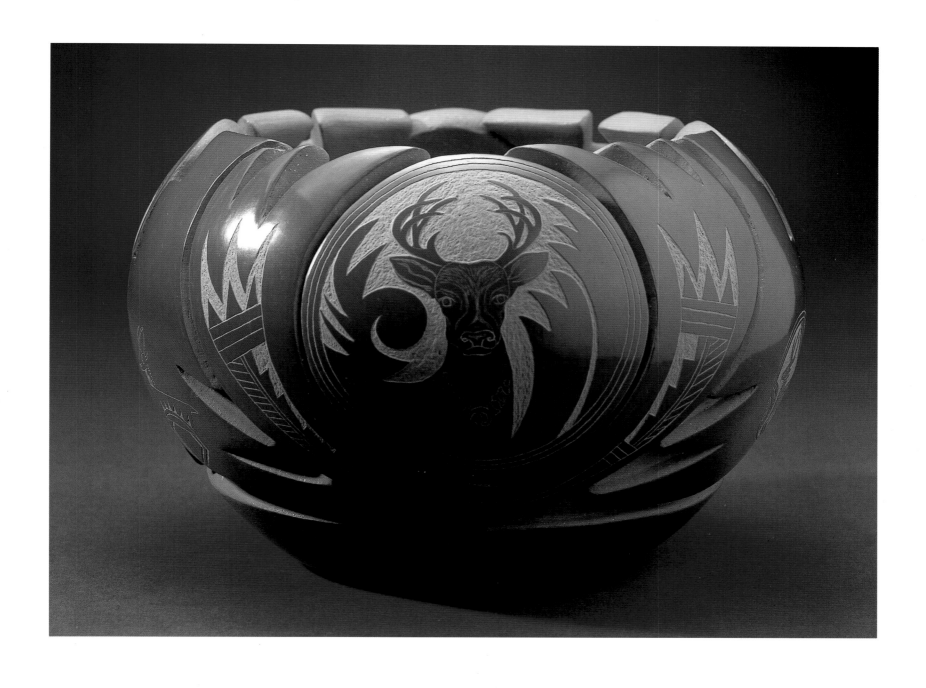

TOP LEFT:
Hopi Jar, c. 1990
Karen Abeita
Courtesy of the Artist

LEFT:
Hopi Jar, c. 1990
Karen Abeita
Courtesy of the Artist

Contemporary Red Carved Bowl
Grace Medicine Flower – Santa Clara Pueblo
4½ × 7 inches
Courtesy Gallery 10, Scottsdale, Arizona, and
Santa Fe, New Mexico

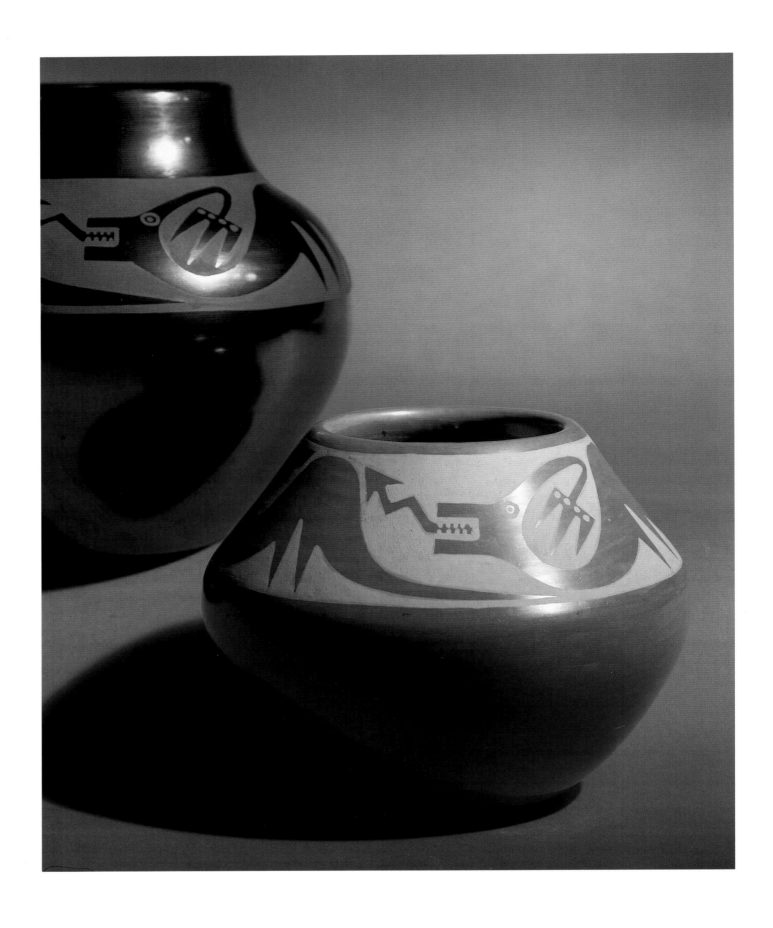

***Black-on-Black and Buff-on-Sienna
Pottery,*** c. 1965
Maria and Popovi Da Martinez – San Ildefonso
Pueblo
Earthenware with Avanyu (plumed serpent)
design
Height 6 inches (black-on-black) and
4½ inches (buff-on-sienna)
Courtesy Gallery 10, Scottsdale, Arizona, and
Santa Fe, New Mexico

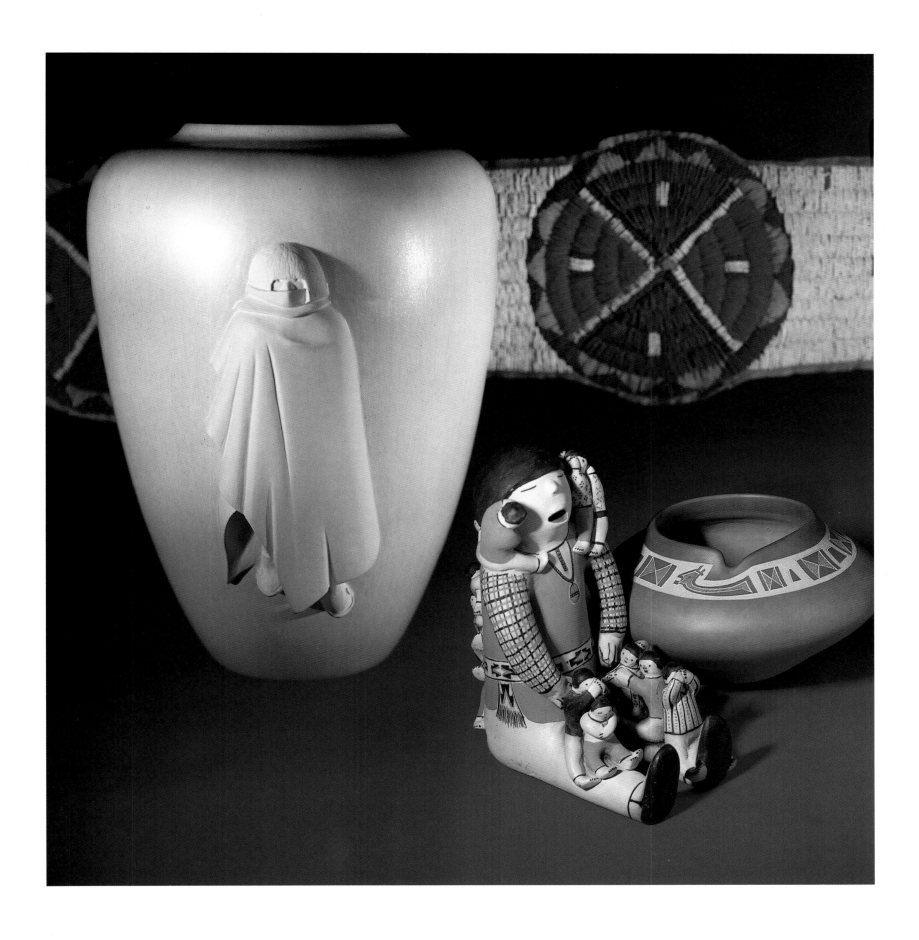

(Left to right):
Hopi Maiden Motif Pottery, c. 1980
Al Qoyawayma – Hopi
Hand-coiled ceramic with bas relief and
carving
Height 16 inches

Storyteller, c. 1970
Helen Cordero – Cochiti Pueblo

Clay slip and mineral pigment
Height 12 inches

Hand-Coiled Ceramic Bowl, c. 1985
Jody Folwell – Santa Clara Pueblo
Stone burnished polish with incised design
Height 7 inches
Courtesy Gallery 10, Scottsdale, Arizona, and
Santa Fe, New Mexico

SILVERWORK, JEWELRY AND ORNAMENTS

❖❖❖❖❖❖❖❖❖❖❖❖❖❖❖❖❖❖❖❖❖❖❖❖❖❖

Native Americans historically have had a wealth of natural materials with which to make both decorative and useful objects. These materials originally included shell, bone, feather, wood, stone and, later, silver, copper, and gold, colored glass beads, ribbon, and various kinds of trade cloth introduced by Europeans. Such materials were widely traded among the various tribes and across the broadly defined culture areas.

In the Northwest, blankets made of dark blue cloth were bordered in red and edged with small buttons in close rows, with larger buttons used to form the design. These blankets – actually worn as robes or capes denoting tribal status – were used for ceremonial gift-giving at the *potlatch*. Native artists of Alaska and the sub-Arctic made jewelry, small fetishes, and various ornaments from marine ivory – a tradition continued today in the work of Aleut artist Denise Wallace, who combines scrimshawed fossil ivory with silver, gold, and such stones as lapis lazuli and lace agate.

In the Southwest, the Pueblo peoples of prehistoric times made shell jewelry, often inlaid with turquoise and other native stones. They learned to work with silver from the Spanish and became renowned for their jewelry. Zuñi Pueblo produces channel and inlay work of great beauty in a mosaic style. Santo Domingo is known for its delicate *heishi* – finely crafted shell necklaces – and graceful strands of turquoise. Navajo jewelry of silver, shell, turquoise, coral, and jet has become synonymous with Southwestern art. Both the Navajo and the Zuñi are known

for their squash blossom necklaces, a symbol of fertility. The Navajo also produced *ketohs*, or bow guards, originally worn on the wrist by hunters to prevent being scraped by the bow string. The beautiful silver rectangles were often decorated with turquoise, and later were worn as a symbol of a warrior's hunter-gatherer prowess.

Mojave women of southern California and western Arizona made beautiful collars and aprons from glass beads and cotton thread. The example shown in this chapter has diamond-shaped interstices and is made entirely of transparent cobalt blue and white beads with a single edging of pink around the neckline. The circular collar is fringed in blue and white, with a large white bead at the end of each fringe.

The Modoc people of northern California did very little beadwork until the early 1900s, when they began to interpret their historic basketry designs and patterns in the form of aprons and necklaces. These were often made in vivid colors and fringed with abalone and other native shells, called *wampum*, as in the Eastern Woodlands.

The Woodlands and Great Lakes tribes made metal jewelry and such ornaments as hair ribbons with beadwork appliqué. The Chippewa, Menominee, Potawatomi, and Sauk and Fox were widely known for their ribbon appliqué on navy blue or red trade cloth. Their shirts and robes were edged with many rows of brightly colored ribbons worked into traditional designs, sometimes with metal ornaments.

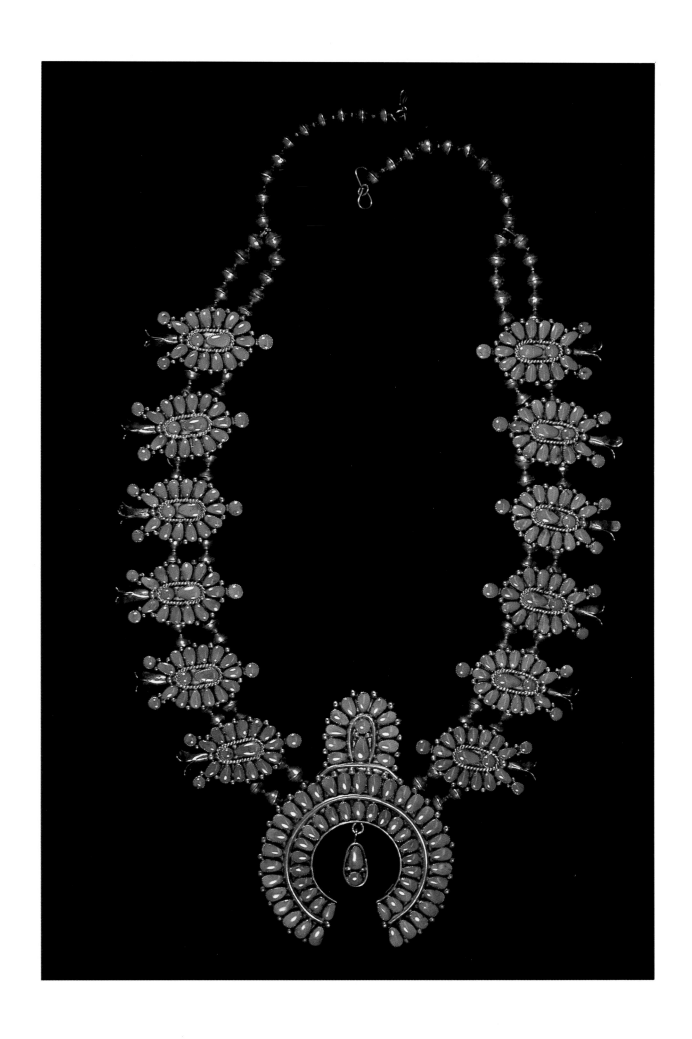

Zuñi Squash Blossom Necklace,
c. 1940
Turquoise, silver, commercial stringing wire
San Diego Museum of Man, California
Photography by Ken Hedges

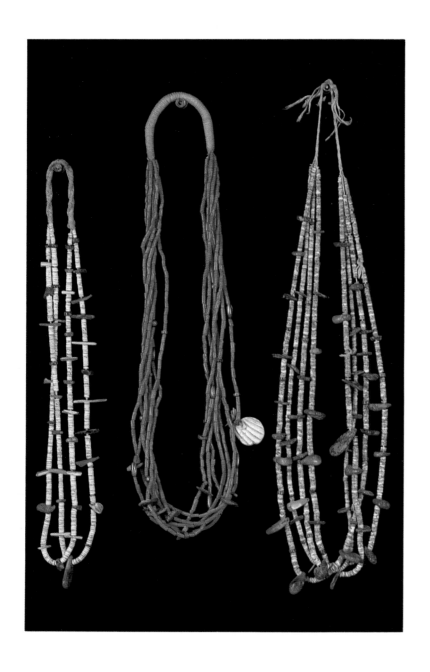

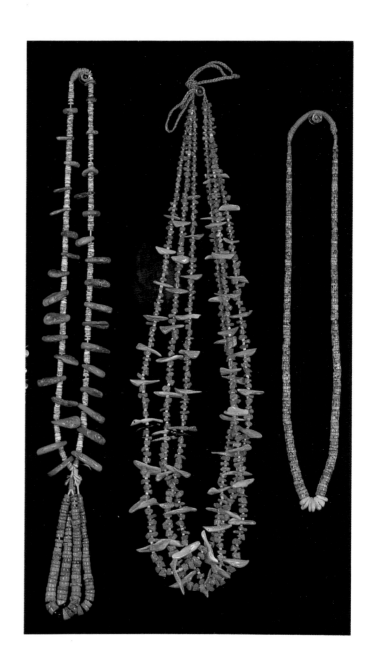

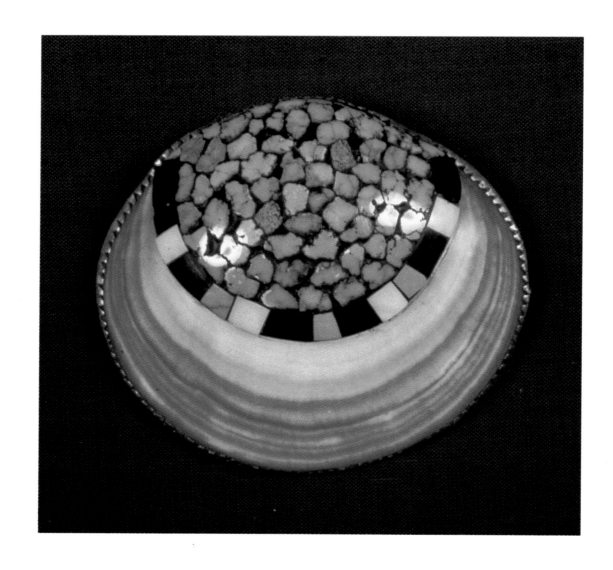

Group of Santo Domingo Pueblo Necklaces

(Left to right):

Fetish Necklace, c. 1930
White clam shell with hand carved turquoise, spiny oyster shell and coral fetishes, wrapped backing
Length 26 inches

Coral Necklace, c. 1930
Hand carved coral filament heishe with turquoise, sterling silver and white clam shell beads, wrapped backing
Length 28 inches

Turquoise and Heishe Necklace, c. 1920
Large nuggets of turquoise strung on clam shell heishe strands, tie-off wrapped backing
Length 30 inches

Clam Shell Necklace, c.1920
White clam shell heishe with turquoise nuggets, jaclaw drops, jet beads, wrapped backing
Length 30 inches

Fetish Necklace, c. 1970
Hand carved coral, spiny oyster, white clam shell, mother-of-pearl, turquoise, serpentine, jet, alabaster
Length 33 inches

Heishe Necklace, c. 1970
Turquoise with white clam shell corn drops, wrapped backing
Length 26 inches

Courtesy Morning Star Gallery, Santa Fe, New Mexico
Photography by Addison Doty

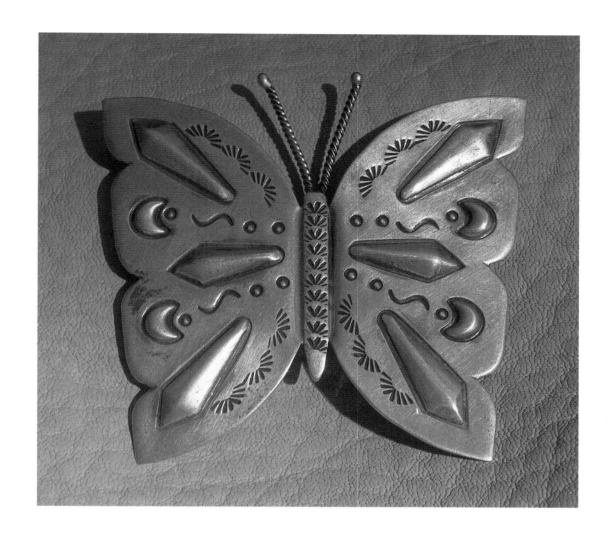

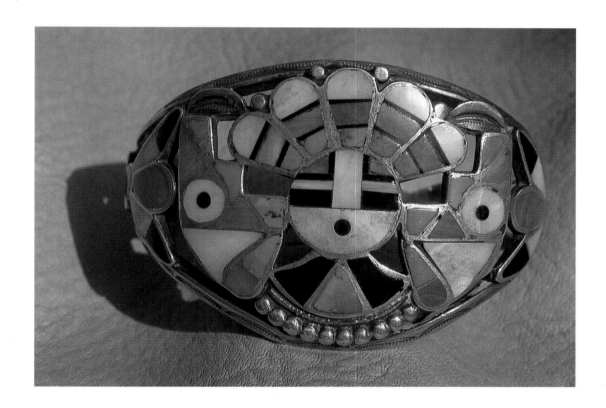

LEFT:
Zuñi Shell Ornament
Shell inlaid with silver, turquoise and abalone
National Museum of the American Indian
Smithsonian Institution

TOP:
Zuñi Butterfly Pin, "Old Pawn," pre-1950
Hand-stamped sterling silver
Collection of Rowena Martinez, El Rincon, Taos, New Mexico
Photography by Gail Russell

ABOVE:
Zuñi Bracelet, "Old Pawn," pre-1950
Silver, turquoise, coral, mother-of-pearl, jet
Collection of Rowena Martinez, El Rincon, Taos, New Mexico
Photography by Gail Russell

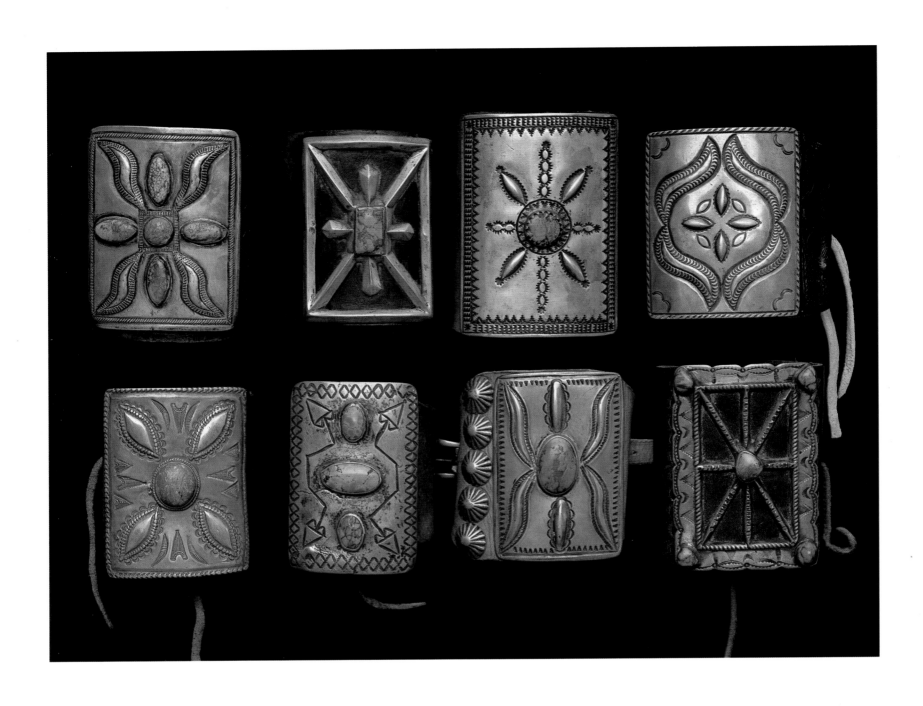

Navajo Ketohs (Bow Guards), 1920-40
Sterling silver, turquoise, leather thongs
Courtesy Morning Star Gallery, Santa Fe,
New Mexico
Photography by Addison Doty

RIGHT:
Group of Bracelets
(From top):

Navajo Bracelet, c. 1940
Sterling silver with turquoise, twisted wire

Navajo Bracelet, c. 1940
Hand-stamped sterling silver with turquoise

Navajo Bracelet, c. 1940
Sterling silver with turquoise, twisted wire,
solder balls

Navajo Bracelet, c. 1930
Hand-stamped sterling silver

Navajo Bracelet, c. 1930
Sterling silver with turquoise, twisted wire,
solder balls

Navajo Bracelet, c. 1930
Sterling silver with turquoise, twisted wire,
solder balls

Navajo Bracelet, c. 1930
Sterling silver with turquoise, twisted wire

Haida Bracelet, c. 1910
Hand-stamped ingot silver

Navajo Bracelet, c. 1940
Sterling silver with turquoise, twisted wire,
stamped solder balls

Navajo Bracelet, c. 1940
Sterling silver with turquoise, twisted wire,
solder balls

Navajo Bracelet, c. 1940
Hand-stamped sterling silver with turquoise,
solder balls

Navajo Bracelet, c. 1940
Hand-stamped sterling silver with turquoise,
twisted wire

Zuñi Bracelet, c. 1940
Sterling silver with petit point turquoise,
solder balls, twisted wire

Navajo Bracelet, c. 1930
Hand-stamped sterling silver with turquoise,
twisted wire

Navajo Bracelet, c. 1940
Hand-stamped sterling silver with turquoise,
twisted wire, solder balls

Courtesy Morning Star Gallery, Santa Fe,
New Mexico
Photography by Addison Doty

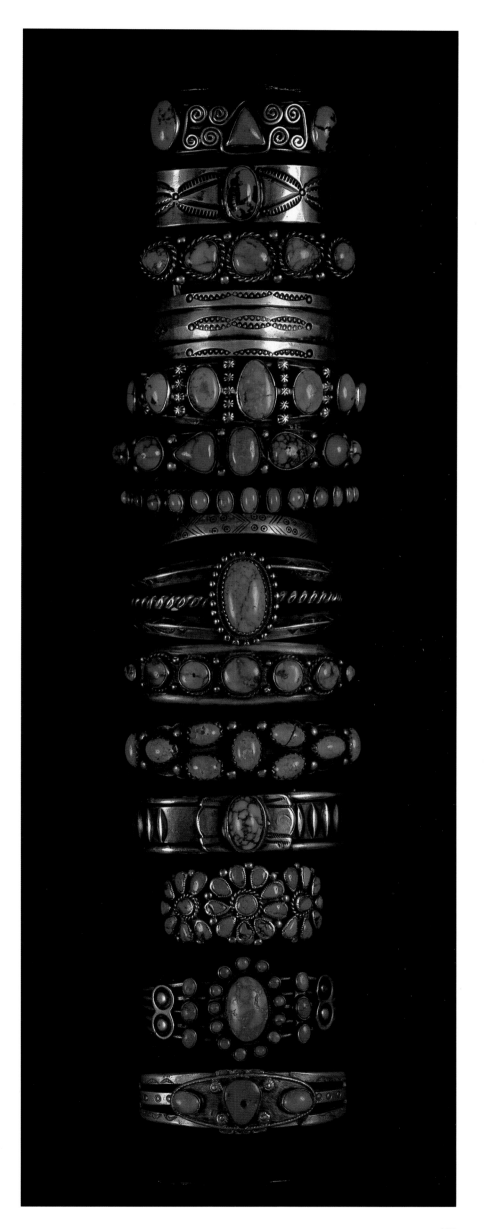

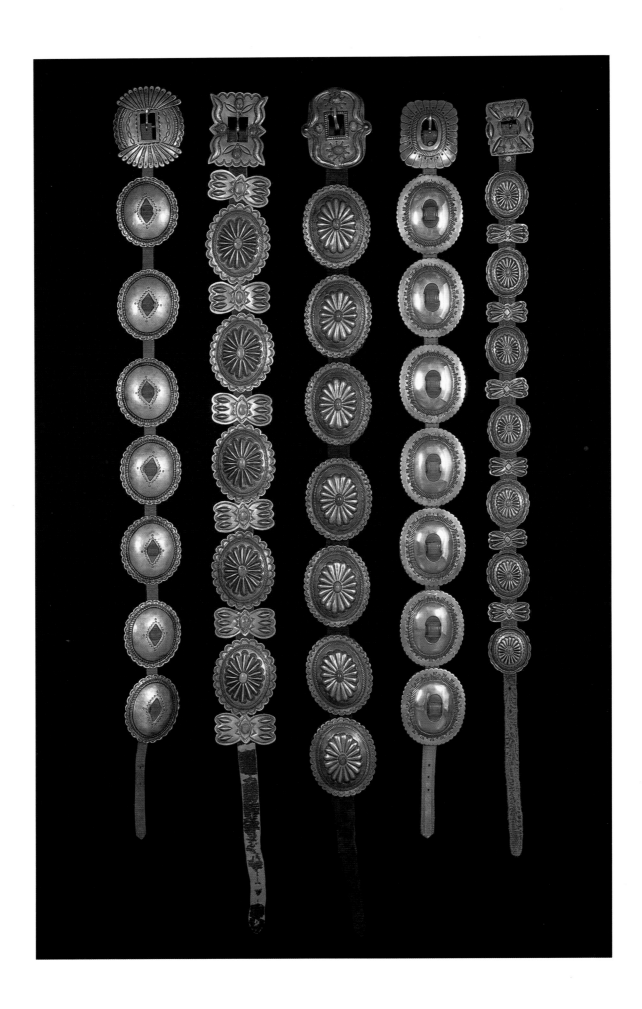

Group of Navajo Concha Belts

(Left to right):

Navajo Revival Concha Belt, c. 1930
Stamped diamond-slot sterling silver, leather strap
Conchas 3½ inches diameter

Navajo Concha Belt, c. 1930
Sterling silver ornamented with hand-stamping, repoussé, turquoise and butterfly-shaped conchas, leather strap
Conchas 4 inches diameter

Navajo Concha Belt, c. 1920
Sterling silver with hand stamping, repoussé, turquoise, leather strap
Conchas 4 inches long

Navajo Concha Belt, c. 1940
Ambrose Roanhorse
Sterling silver, leather strap

Conchas 4 inches diameter

Navajo Concha Belt, c. 1920
Sterling silver ornamented with hand stamping, repoussé, turquoise, leather strap
Conchas 2½ inches diameter

Courtesy Morning Star Gallery, Santa Fe, New Mexico
Photography by Addison Doty

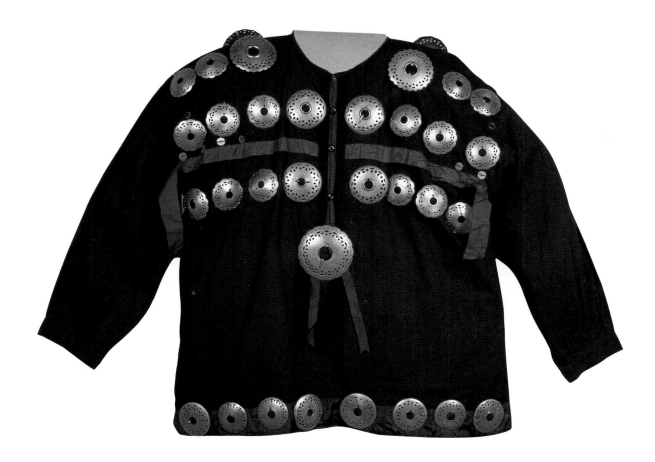

ABOVE:
Fox Woman's Blouse
Blue cloth with metal decoration
National Museum of the American Indian
Smithsonian Institution

BELOW:
Tlingit Button Blanket
Blanket cloth, pearl buttons
6 × 5 feet
Gift of Ralph Goodhue Family
Sheldon Jackson Museum, Sitka, Alaska
Alaska State Museums

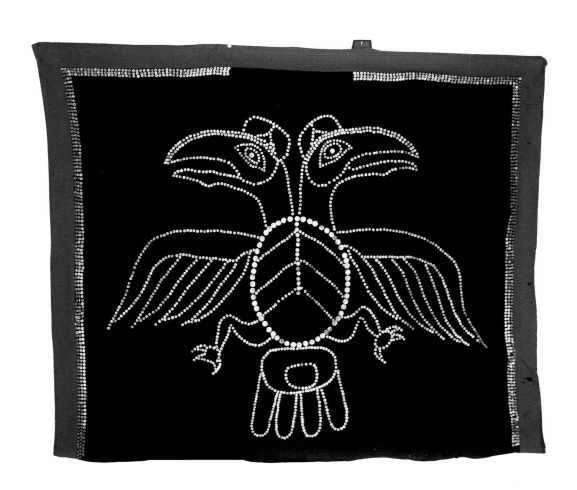

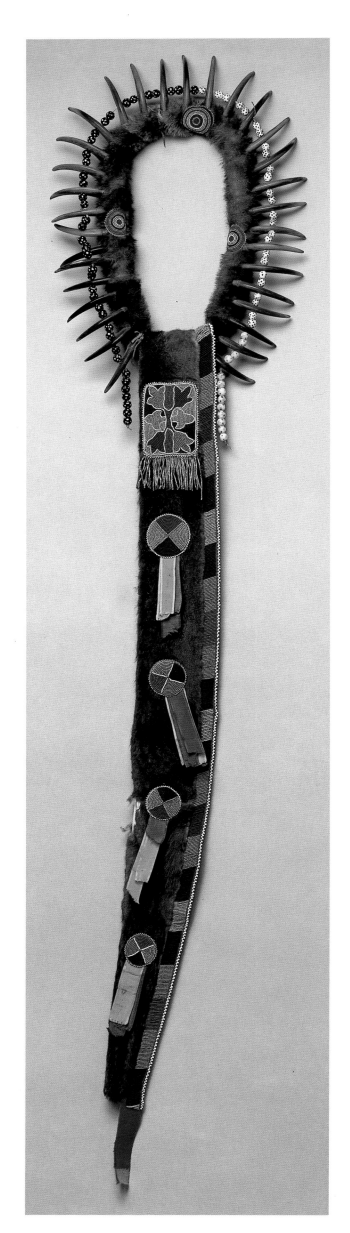

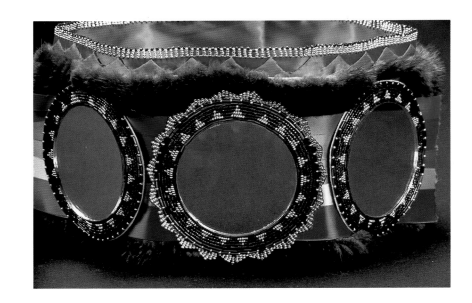

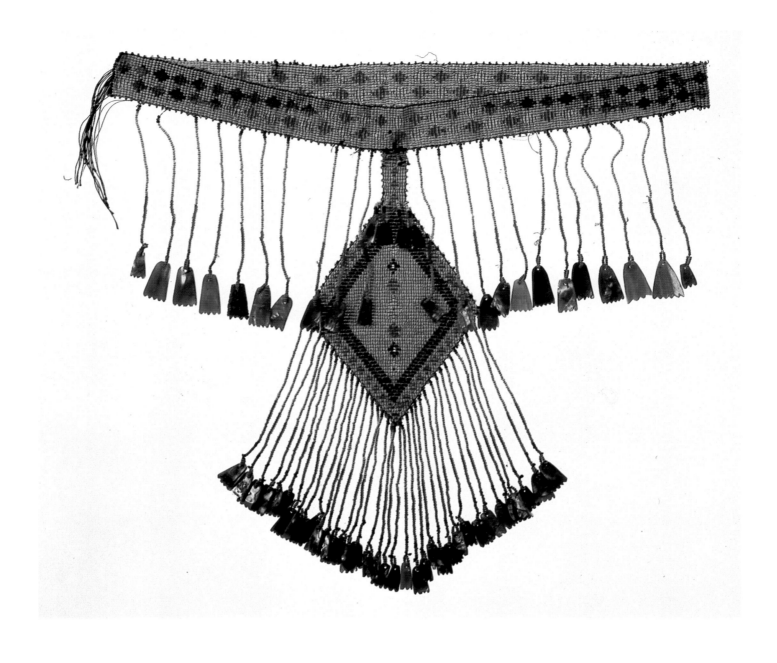

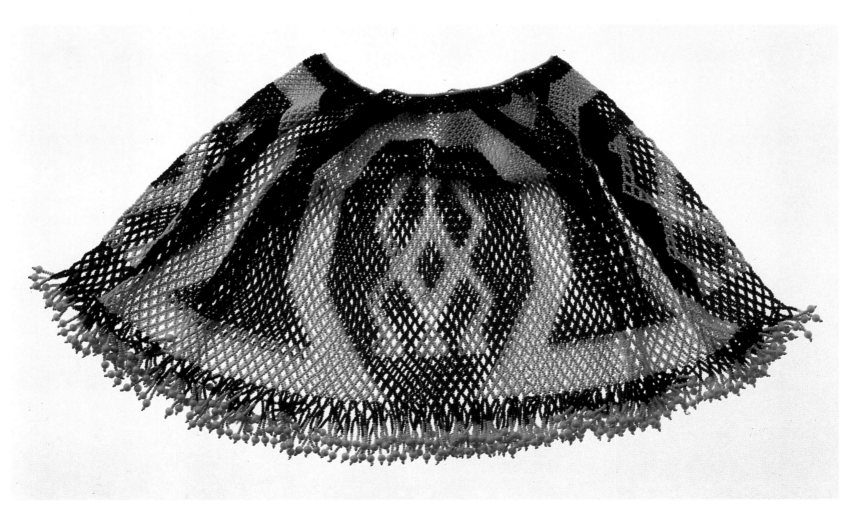

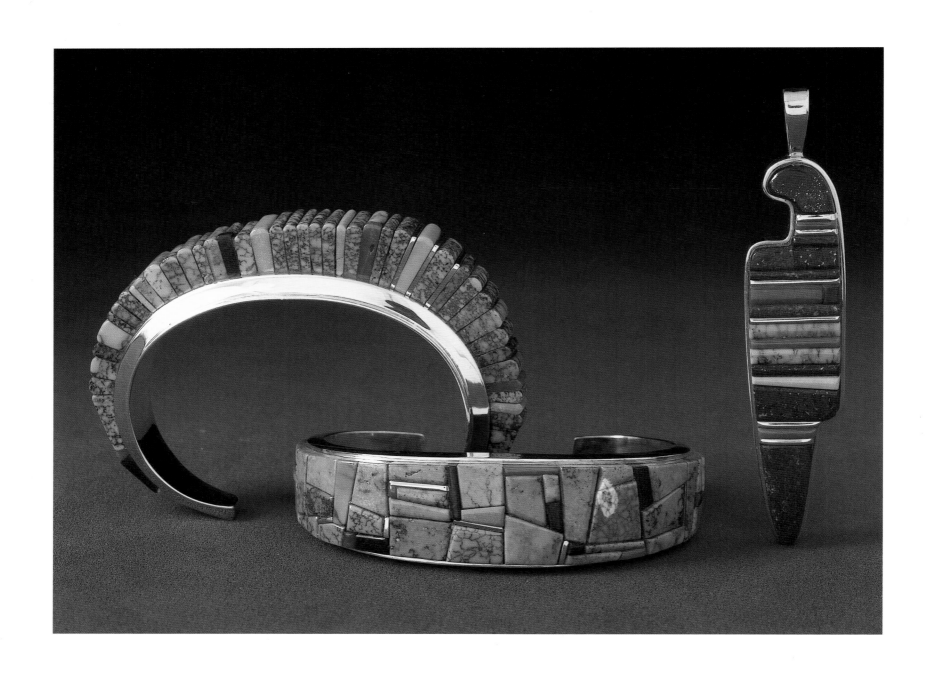

Contemporary Jewelry
Charles Loloma–Hopi
Gold, turquoise, lapis lazuli, coral
Courtesy Lovena Ohl Gallery, Scottsdale,
Arizona
Photography by Jerry Jacka

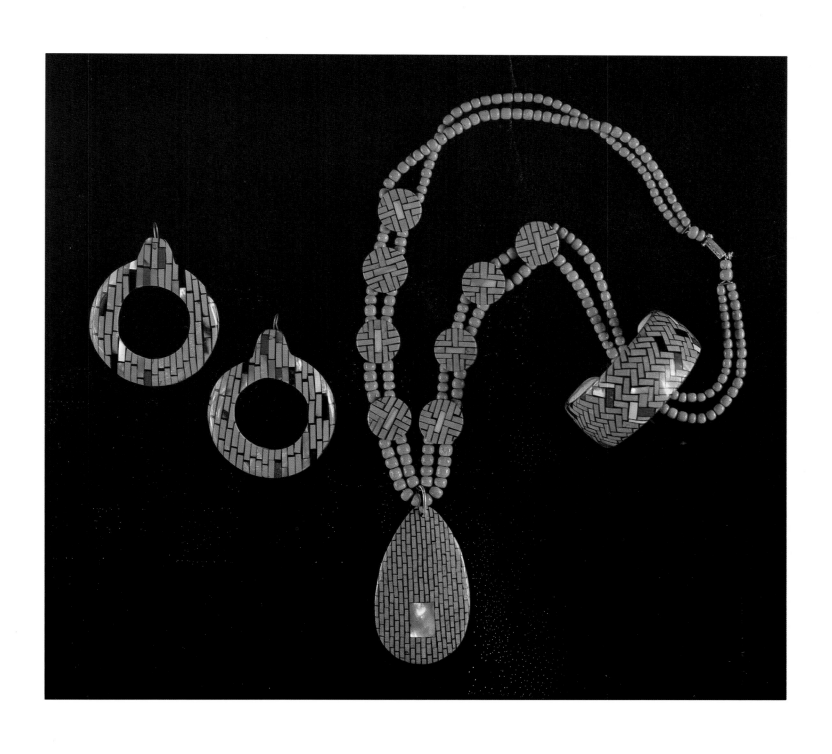

Contemporary Mosaic Jewelry, 1991
Angie Reano Owen – Santo Domingo Pueblo
Shell, turquoise, mother-of-pearl, lapis lazuli,
jet
Courtesy Gallery 10, Scottsdale, Arizona, and
Santa Fe, New Mexico

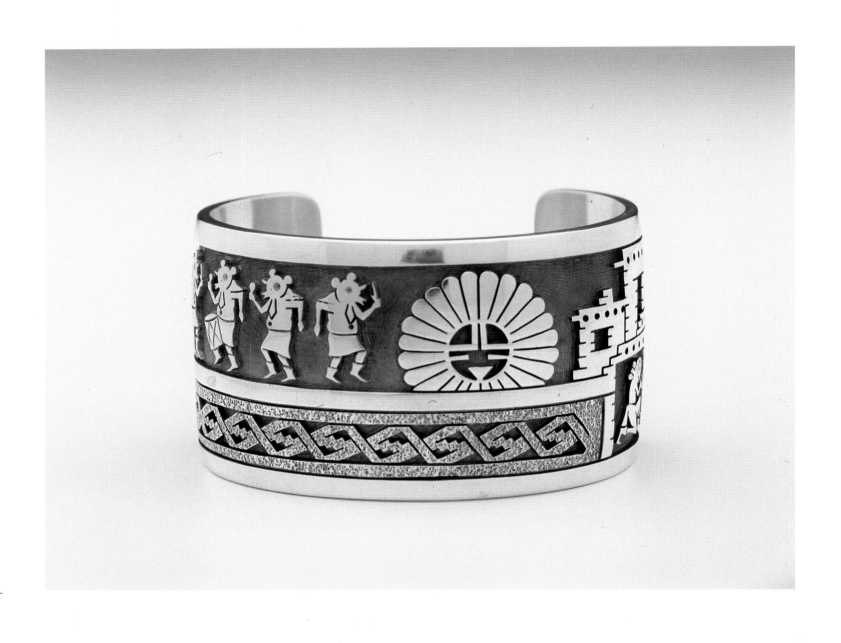

Mudhead Kachina Bracelet, 1991
Gary Yoyokie–Hopi
Sterling silver, gold
University of Kansas Museum of
Anthropology, Lawrence, Kansas
Photography by Jon Blumb

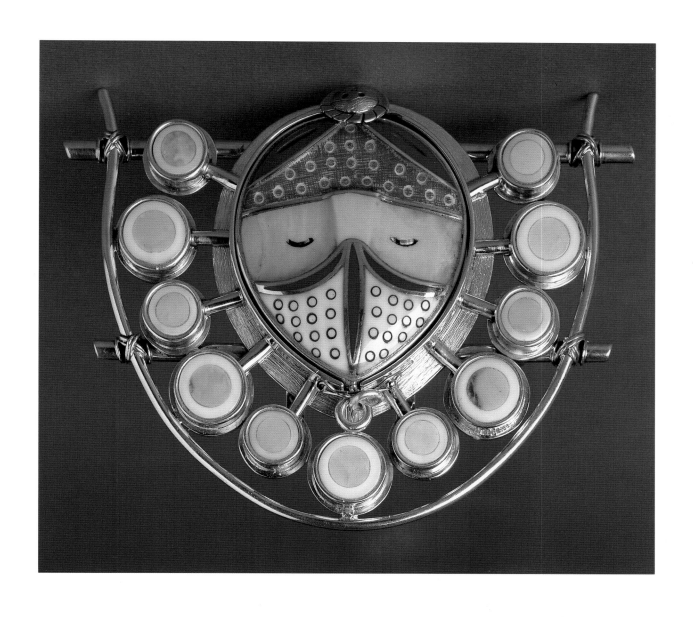

Koniag Bird Mask, 1993
Denise Wallace (Aleut, Prince William Sound)
and Samuel Wallace
Brooch made of sterling silver, 14K gold,
scrimshawed fossil ivory, variscite lapis lazuli
3 × 3¾ inches
Courtesy of the Artists

LEATHERWORK, BEADWORK AND QUILLWORK

✛✛✛✛✛✛✛✛✛✛✛✛✛✛✛✛✛✛✛✛✛✛✛✛✛✛✛✛✛✛✛✛✛✛✛

Because of their nomadic lifestyle, the Plains Indians did little weaving or pottery-making. They are best known for the clothing and household objects they made of raw and tanned buffalo- and deerhide and decorated with quillwork and, later, beadwork. Featherwork was an important Plains art form used primarily for ceremonial regalia and the implements of warfare.

As tribes from the Eastern Woodlands were pushed farther west by European encroachment, they took their traditional arts onto the Plains and modified them to meet the changing environment. The decorative art of porcupine quillwork, in which the quills were colored by vegetal and other natural dyes, gradually gave place to beadwork as glass beads from Europe were introduced by white traders all over the continent. Each tribe had its characteristic style of decorative beadwork and painting, but some symbols, like the box-and-border design, were widely used. A symbol of the buffalo's internal organs – food for the people – this design was painted on hides and worked on their clothing and household effects by women. When they painted and beaded clothing for men of the tribe, women used pictorial designs that showed prowess in battle, personal bravery, and tribal events of significance. Some of these designs were dictated by dreams and visions and could be fully understood only in their context.

A woman's dress was made from two skins of elk, deer, or bighorn sheep, joined at the top with a hole for the head. They were often lavishly fringed, and beaded at the top, where a U-shaped pattern in the center denoted the animal's tail. Where the top was not fully beaded, the tail itself was part of the dress.

The Plains influence extended throughout the Pacific Plateau and the Great Basin and southwest into parts of Arizona, New Mexico, and Texas, where the nomadic Apache made buckskin blouses and beaded necklaces for ceremonial wear. These desert dwellers also wore long, fringed leggings attached to their beaded moccasins.

In general, beadwork was heaviest and most ornate among the Sioux and northern Arapaho tribes, while southern Plains Indians used less beadwork on their footwear and wore less elaborate ceremonial clothing. In both areas, beadwork reached its peak during the Reservation period, when cradle boards, moccasins, belts and bags were often solidly beaded in a multitude of colors. Saddlebags were always made in pairs for moving camp and painted much like the *parfleches*, or rawhide containers used to store and carry food, usually in geometric designs. The solid triangle symbolized both the tepee and the mountain, while triangular or U-shaped outlines stood for animal tracks. Traditional floral designs remained popular with the Nez Percé and many other tribes, including the Slave of Canada's Mackenzie River and the Athapaskan-speaking peoples of the sub-Arctic, who adopted them from French trade goods.

The accoutrements of hunting and warfare were highly decorated, including quivers and spear cases, painted hide shields, knives and their sheaths, breastplates, and battle flags. The Crow, Sioux, Mandan-Hidatsa, Ute, and Comanche tribes were especially well known for work of this kind, in quills, feathers, beads, bells, and other materials.

In the Eastern Woodlands and Great Lakes regions, porcupine quillwork and moose hair was often used to decorate storage chests and boxes made of locally available birch bark and willow.

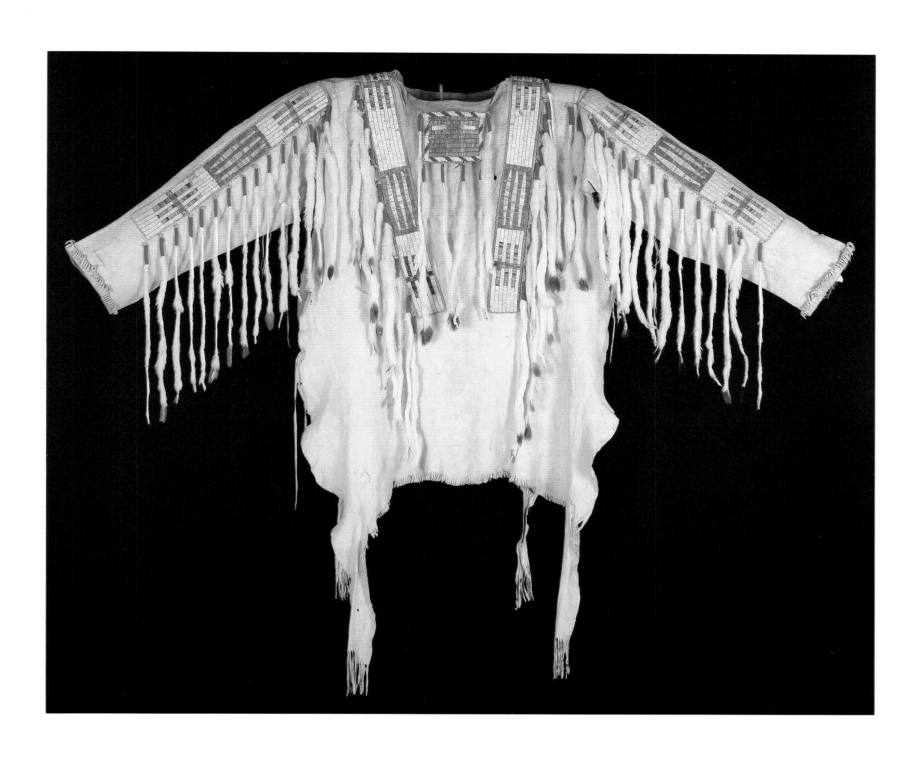

Sioux Quilled War Shirt, c. 1890
Tanned deer hide with fitted sleeves, quilled
plaited shoulder and sleeve strips with white
ermine drops, and bib with quilled stylized
American flags. Bottom of shirt is left uncut
with deerskin legs trailing on each side
Courtesy Morning Star Gallery, Santa Fe,
New Mexico
Photography by Addison Doty

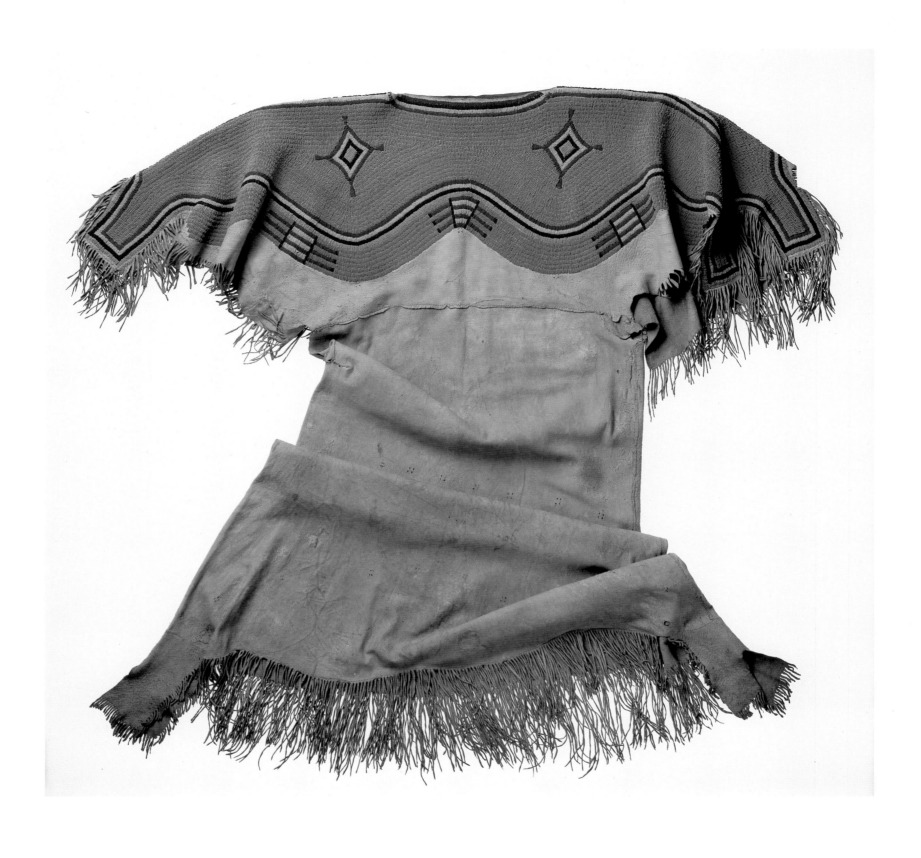

Sioux Buckskin Woman's Dress,
North Dakota, c. 1855
Tanned hide, beads
David T. Vernon Collection
Colter Bay Indian Arts Museum, Grand Teton
National Park, Wyoming
Photography by John Oldencamp and Cynthia
Sabransky

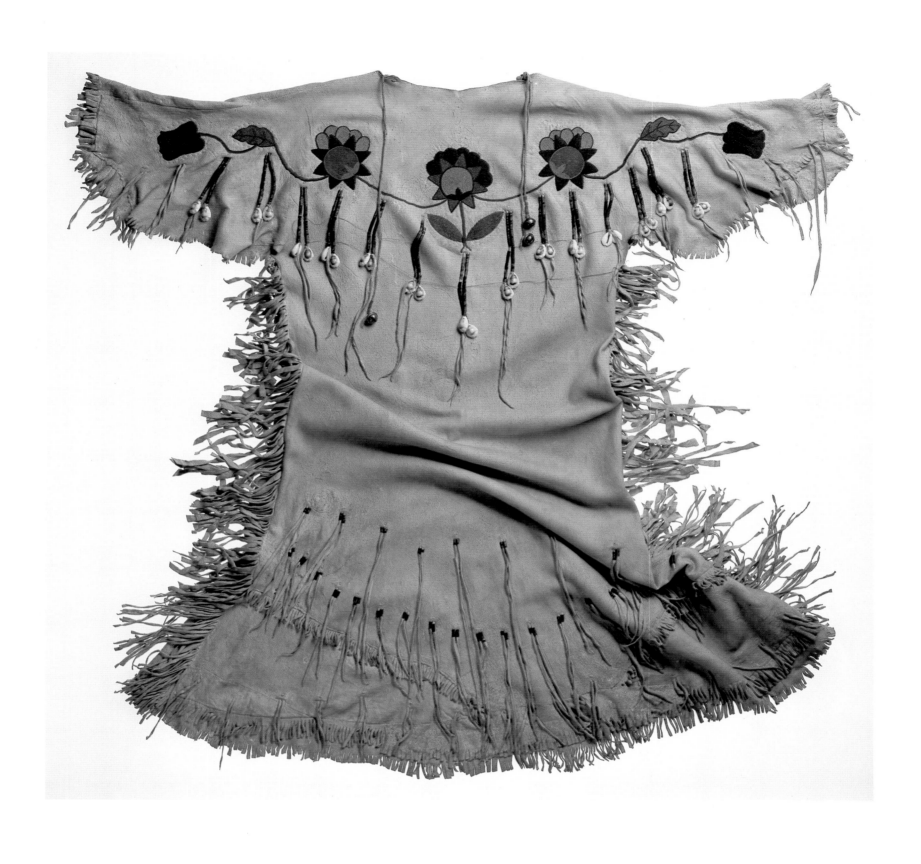

Nez Percé Woman's Dress, 1910
Tanned hide, beads, bells, cowrie shells
David T. Vernon Collection
Colter Bay Indian Arts Museum, Grand Teton
National Park, Wyoming
Photography by John Oldencamp and Cynthia
Sabransky

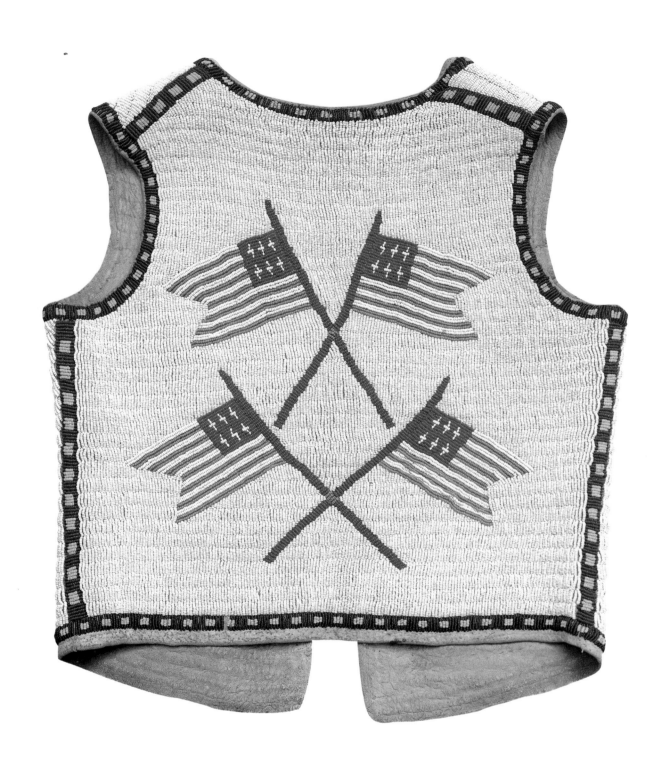

Cheyenne or Arapaho Child's
Beaded Vest, 1880-1900
Tanned hide, beads
16¹⁵⁄₁₆ × 15 inches
Saint Louis Art Museum, Missouri
Photography by Bob Kolbrener

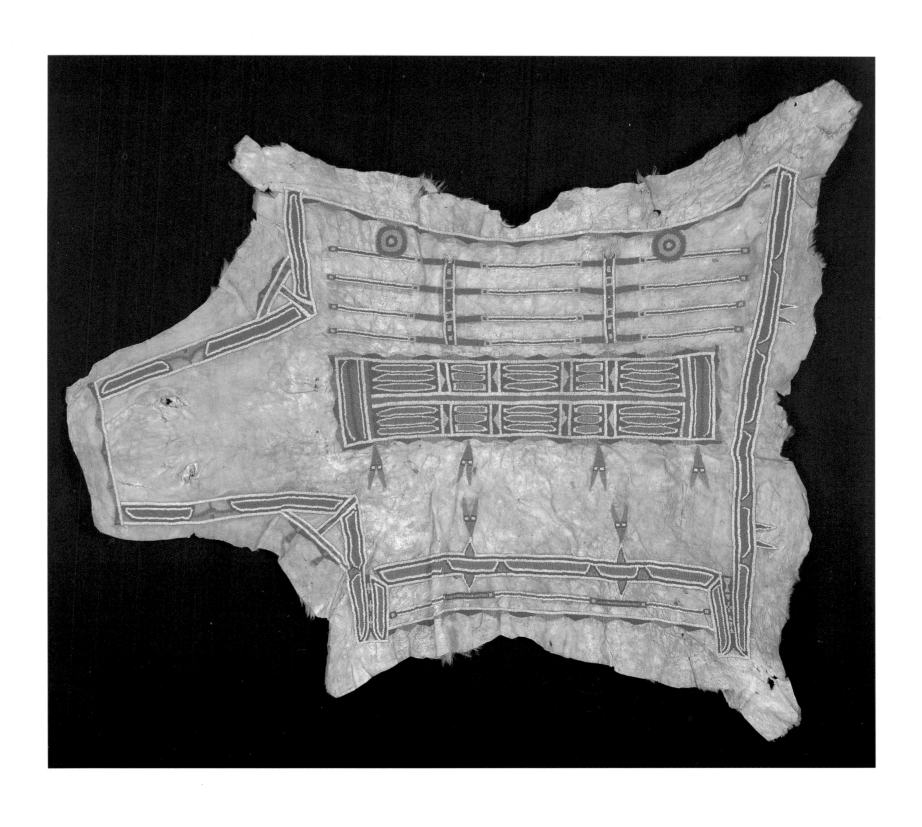

**Sioux Girl's Beaded Box-and-
Border Robe,** c. 1880
Whole calf hide, seed beads
47½ × 53 inches
Courtesy Morning Star Gallery, Santa Fe,
New Mexico
Photography by Addison Doty

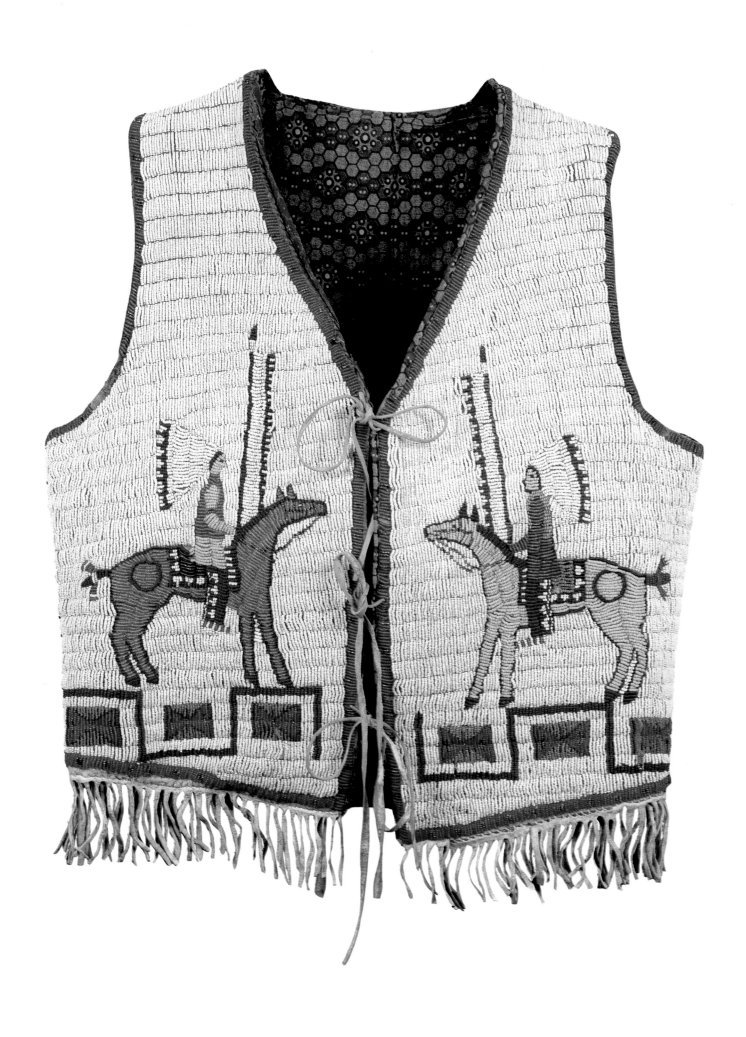

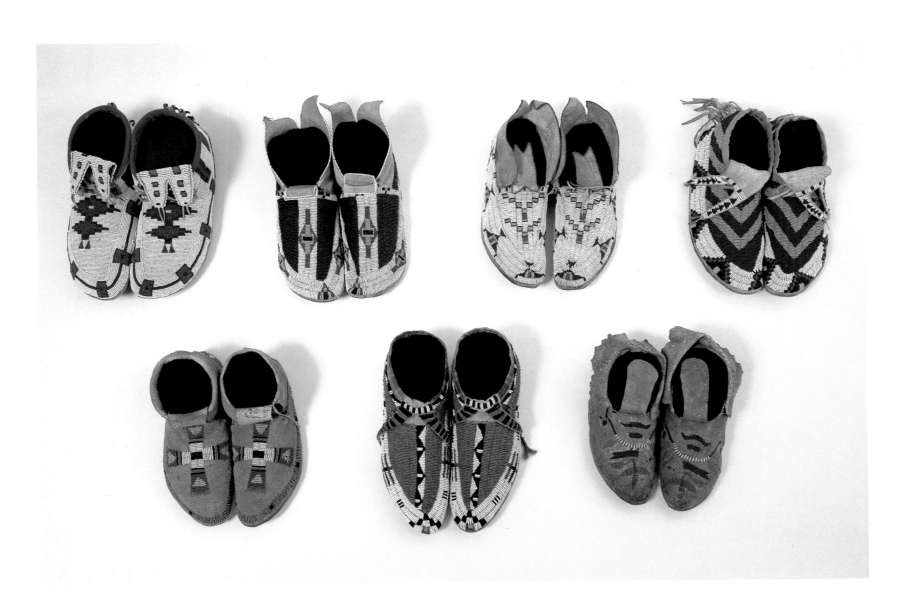

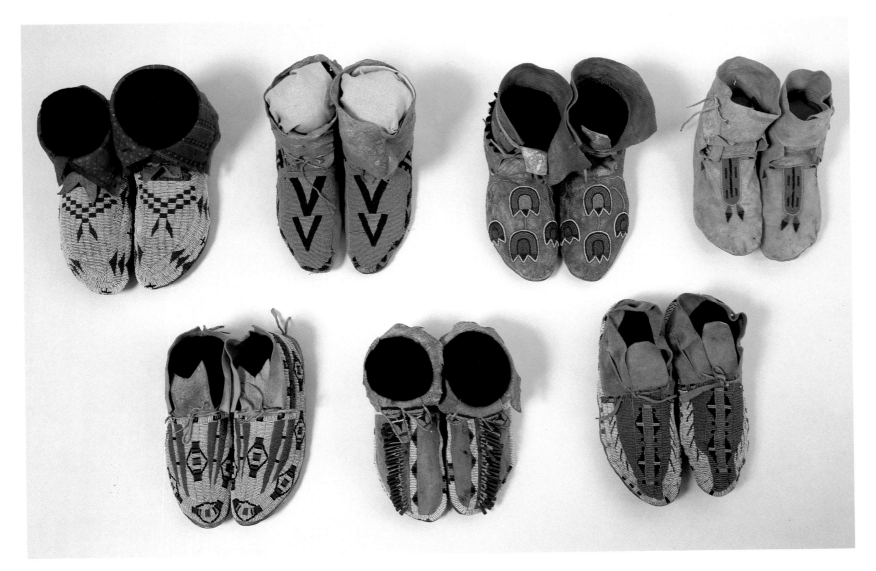

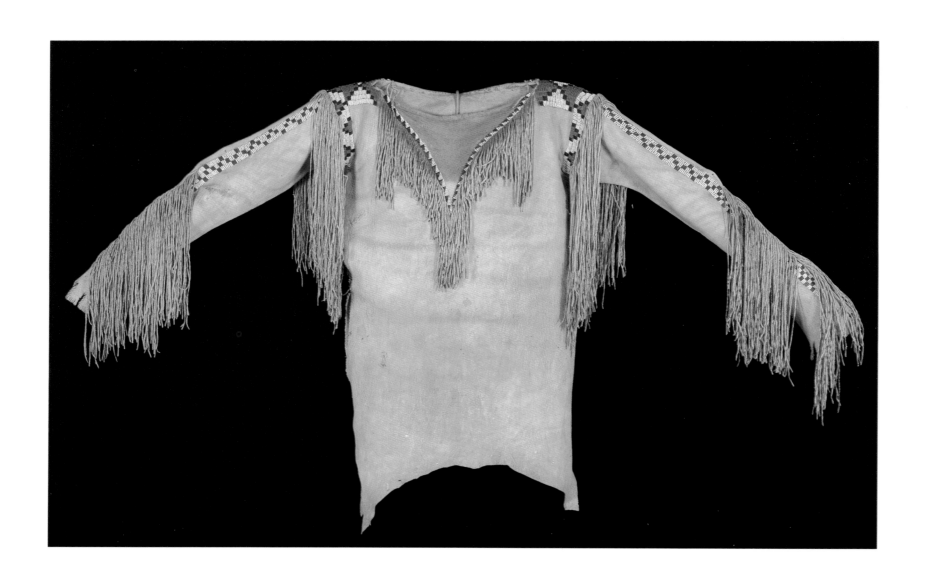

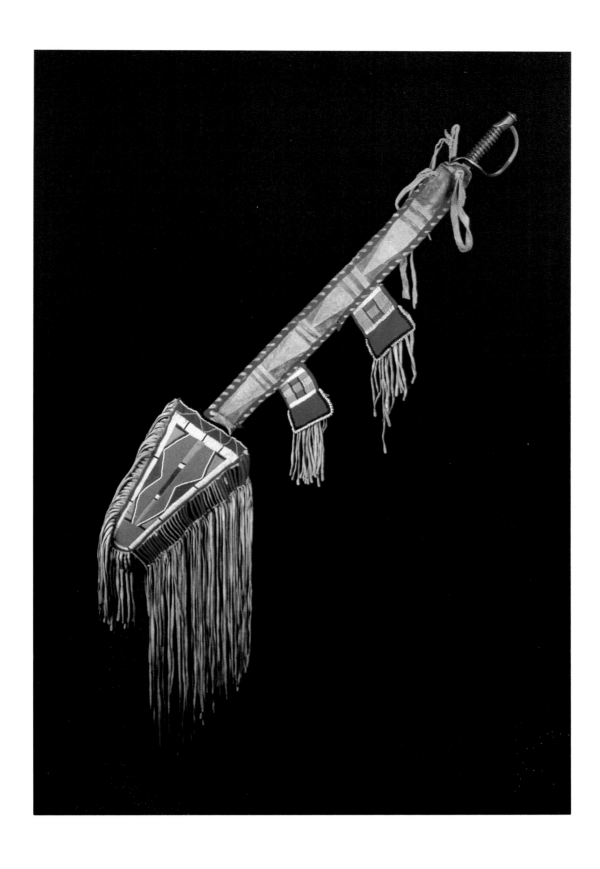

LEFT:
Apache Playing Cards
Painted rawhide
National Museum of the American Indian
Smithsonian Institution

TOP LEFT:
Ute/Apache Shirt, c. 1880
Tanned deer hide, beads, natural pigment
Courtesy Morning Star Gallery, Santa Fe,
New Mexico
Photography by Addison Doty

ABOVE:
Crow Beaded Sword Scabbard
Hide, beads, cloth
National Museum of the American Indian
Smithsonian Institution

93

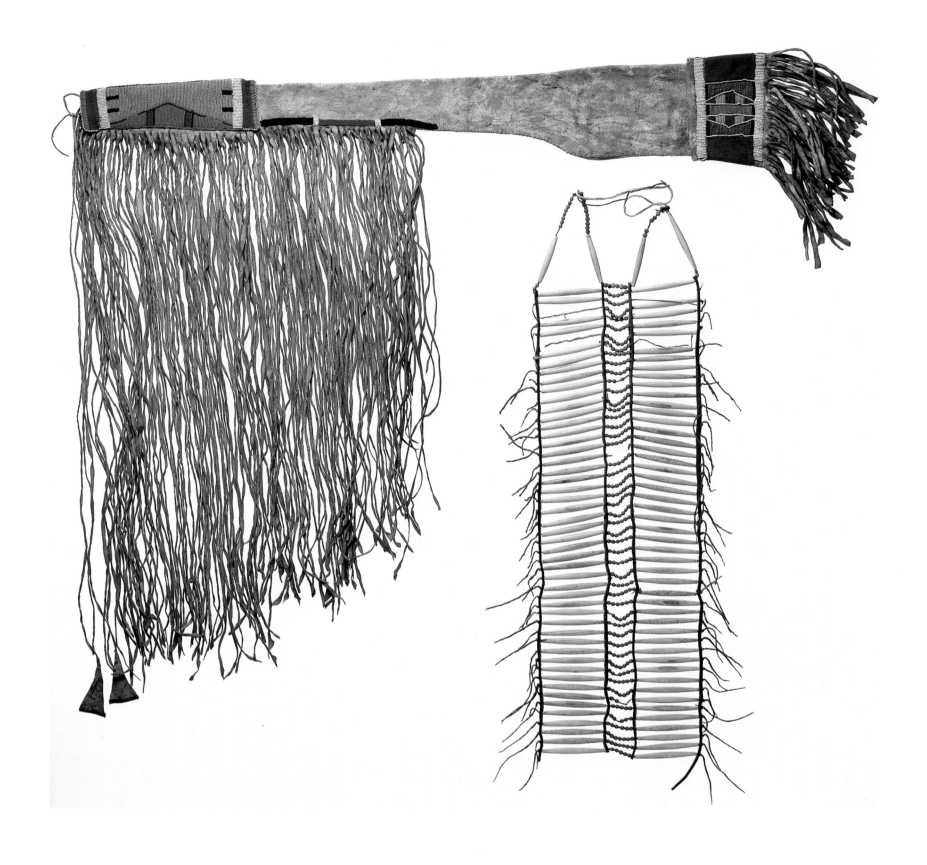

Crow Rifle Case, Eastern Montana,
c. 1880
**Brule Sioux Breastplate of
Hairpipes,** South Dakota, c. 1900
David T. Vernon Collection
Colter Bay Indian Arts Museum,
Grand Teton National Park, Wyoming
Photography by John Oldencamp and Cynthia
Sabransky

Great Lakes Knife and Sheath, early
18th century
Tanned deer hide sheath decorated with bird
quills; wood handle of knife decorated with
bird quills and tin cones
Length 9⅛ inches
Courtesy Morning Star Gallery, Santa Fe,
New Mexico
Photography by Addison Doty

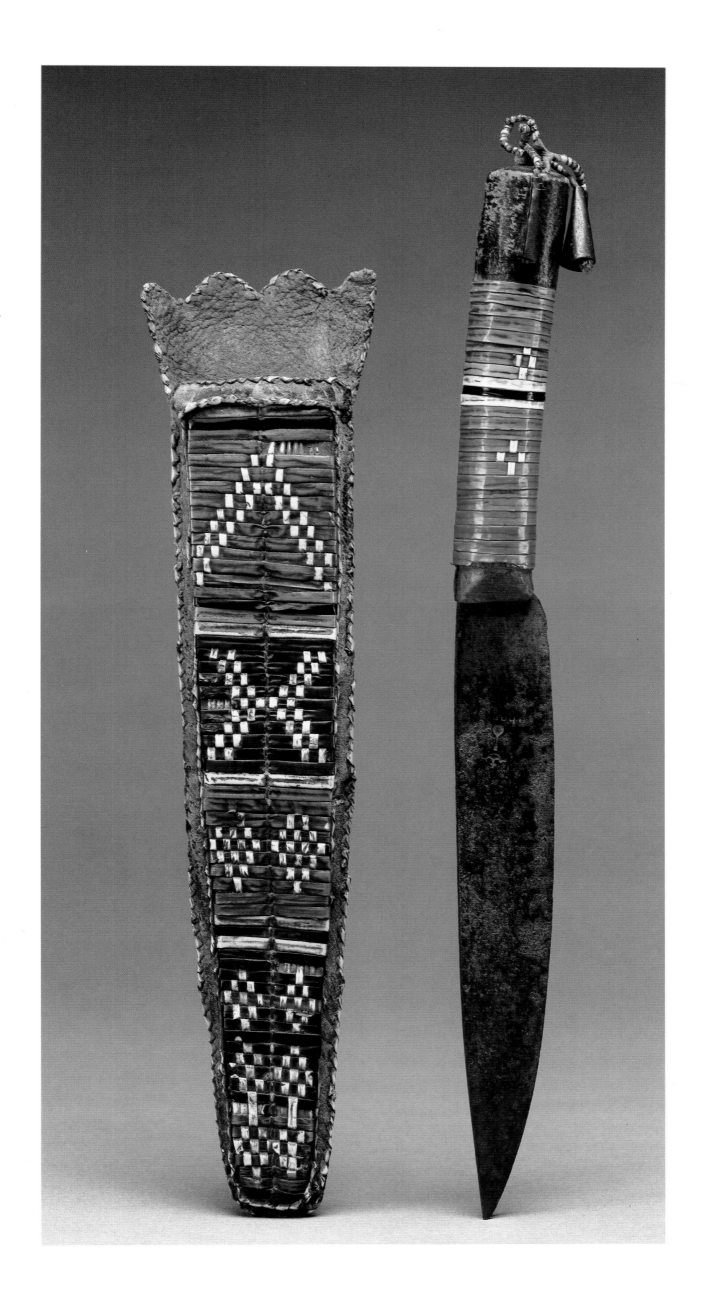

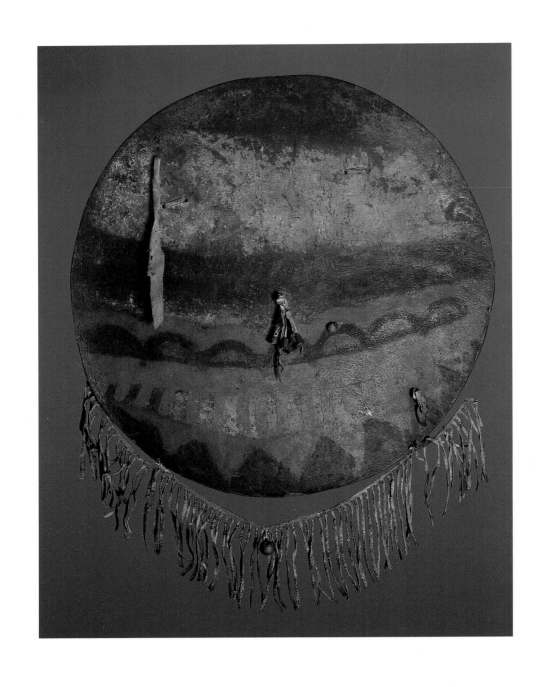

Comanche Buffalo Hide Shield,
c. 1850
Painted buffalo hide, quills, brass bells,
thimbles
Courtesy Morning Star Gallery, Santa Fe,
New Mexico
Photography by Addison Doty

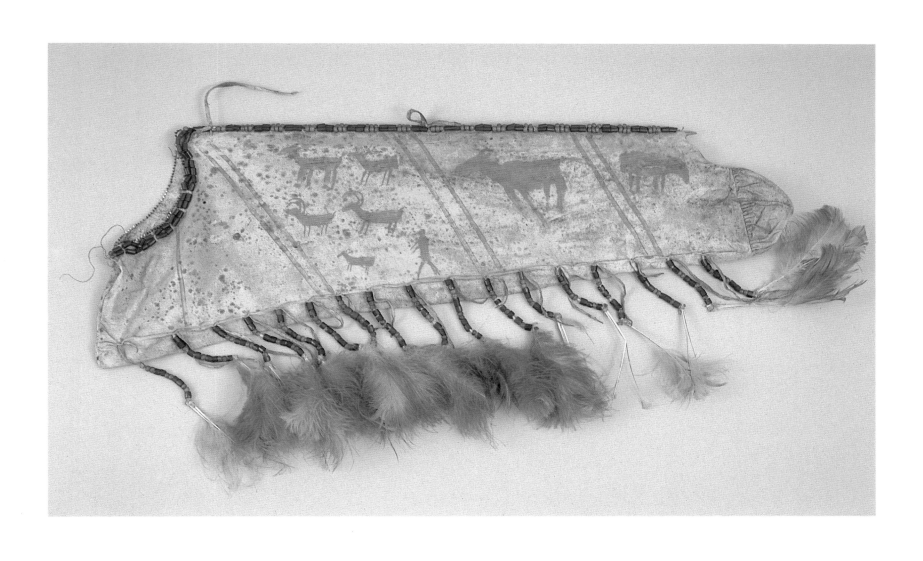

Athapaskan Quiver, 19th century
Dyed leather, beads, paint, feathers
Phoebe Hearst Museum of Anthropology
University of California, Berkeley

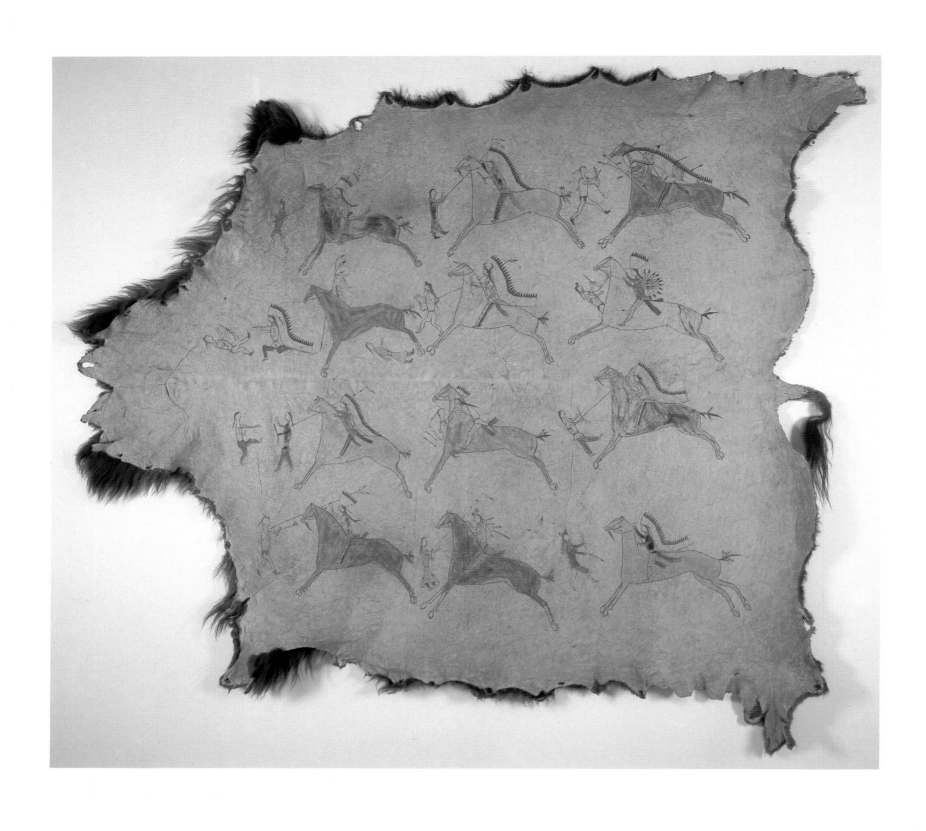

Sioux Painted Buffalo Hide, c. 1880
Buffalo hide, pen/pencil, paint/dyes
100 × 90 inches
Courtesy Morning Star Gallery, Santa Fe,
New Mexico
Photography by Addison Doty

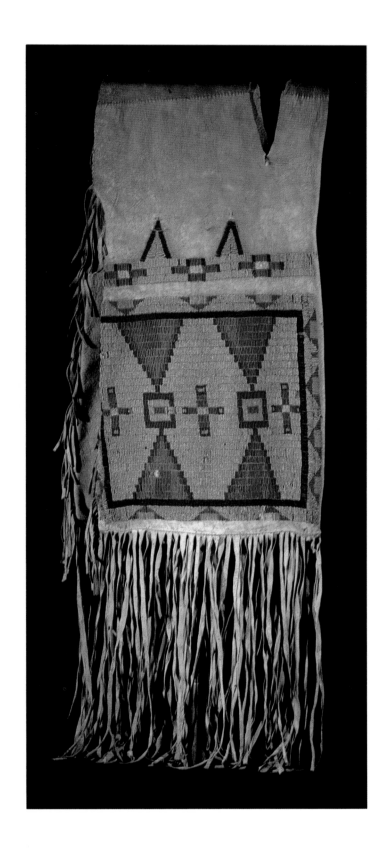

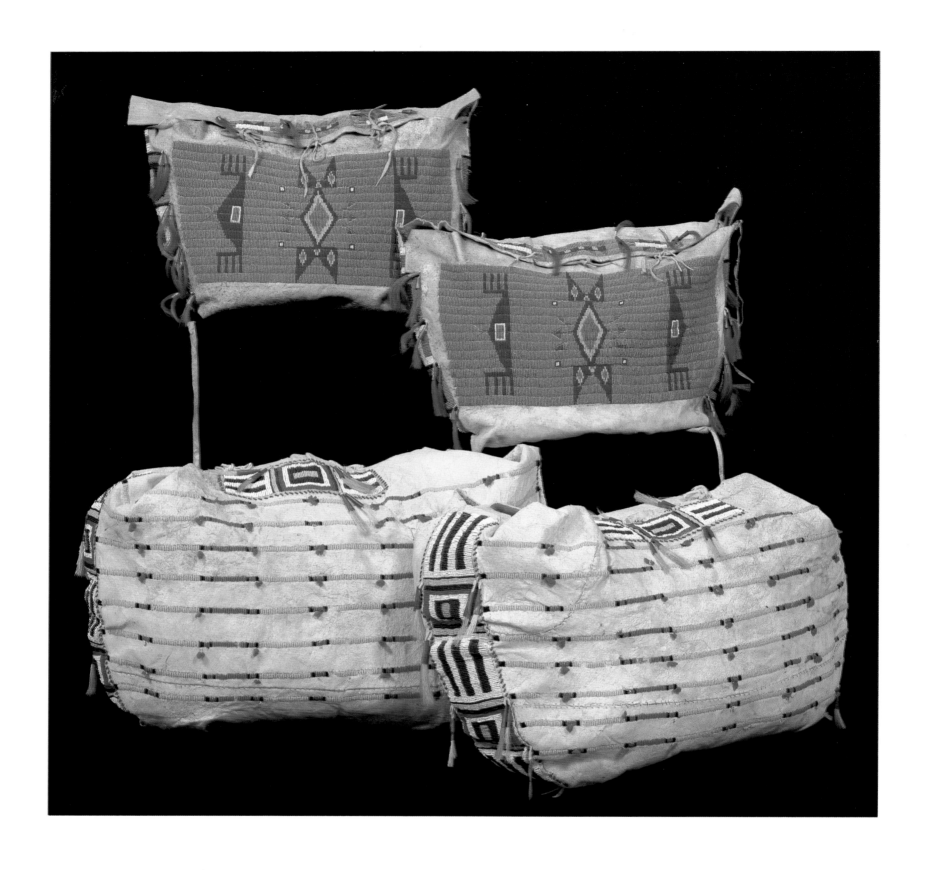

Possible Bags

(Top two):
Pair of Plains Possible Bags, c. 1880
Tanned hide, beads, dyed horsehair, tin cones
Length 18 inches

(Bottom two):
Pair of Cheyenne Possible Bags, c. 1890
Tanned hide, beads, horsehair, tin cones, trade cloth
Length 22 inches

Courtesy Morning Star Gallery, Santa Fe, New Mexico
Photography by Addison Doty

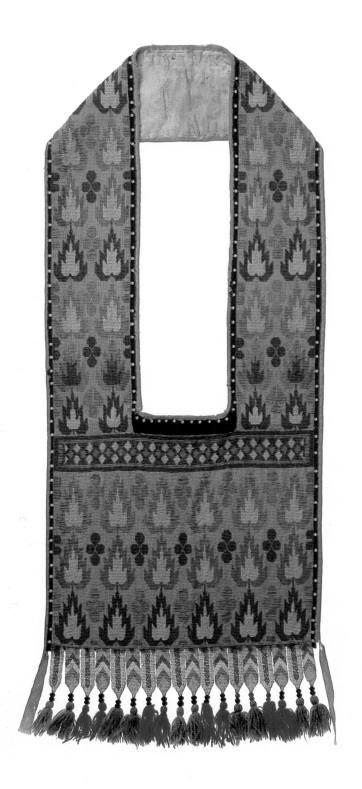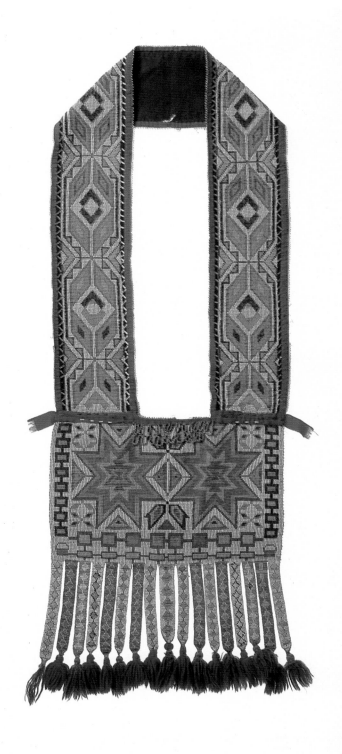

Bandolier Shoulder Bags, c. 1890
(Left to right):
Woodlands Tribes Bandolier Shoulder Bag
Potawatomi Bandolier Shoulder Bag
David T. Vernon Collection
Colter Bay Indian Arts Museum, Grand Teton
National Park, Wyoming
Photography by John Oldencamp and Cynthia
Sabransky

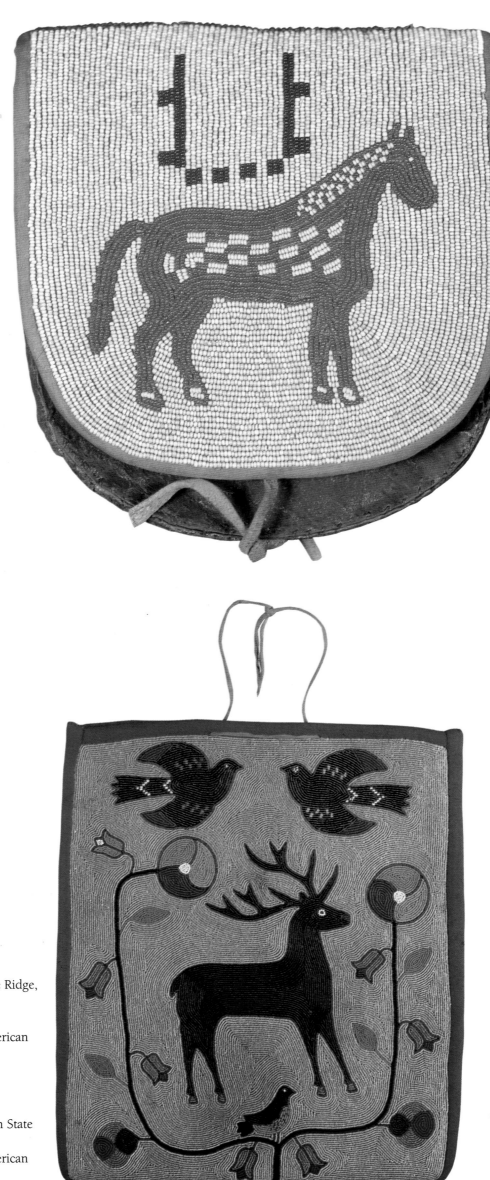

TOP:
Oglala Sioux Bag, Pine Ridge,
South Dakota
Leather, beads
National Museum of the American
Indian
Smithsonian Institution

RIGHT:
Klikitat Bag, Washington State
Leather, beads
National Museum of the American
Indian
Smithsonian Institution

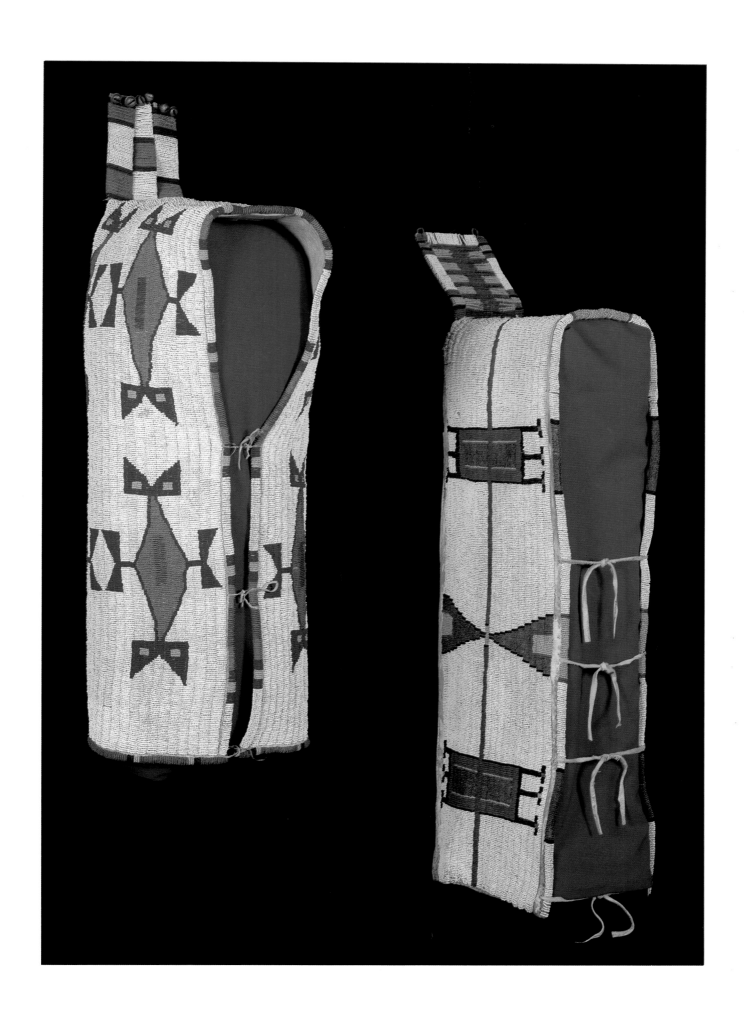

Sioux Cradle Boards, c. 1880
Hide, beads, bells
Length 25-26 inches
Courtesy Morning Star Gallery, Santa Fe,
New Mexico
Photography by Addison Doty

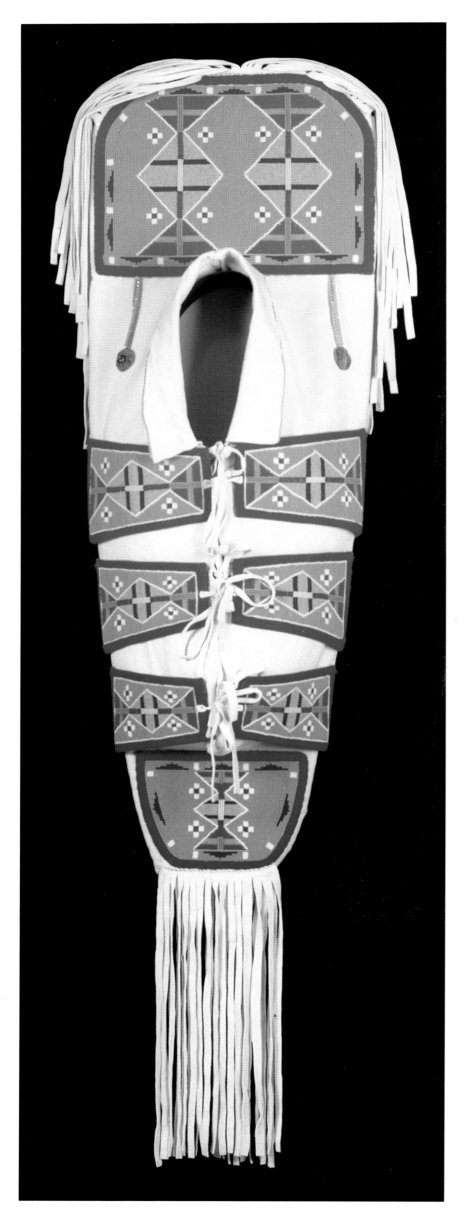

LEFT:
Crow Cradle Board, 1991
Rose Rock Above
Wood, glass beads, buckskin, brass hawk bells
Length 36 inches
Courtesy Putt and Jill Thompson
Custer Battlefield Trading Post, Crow Agency,
Montana

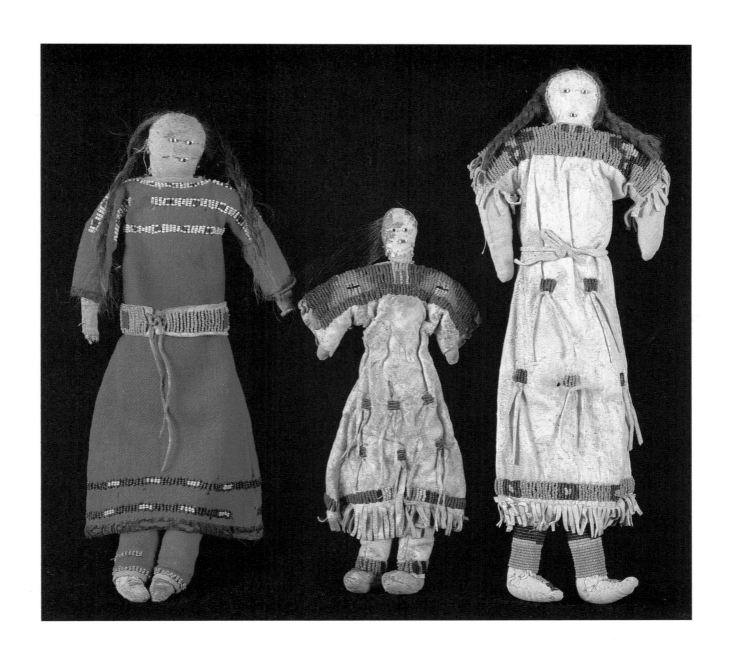

Sioux Dolls, c. 1880
Tanned hide, trade cloth, beads, buffalo hair
and human hair; heads made of tanned hide
Height 10-13½ inches
Courtesy Morning Star Gallery, Santa Fe,
New Mexico
Photography by Addison Doty

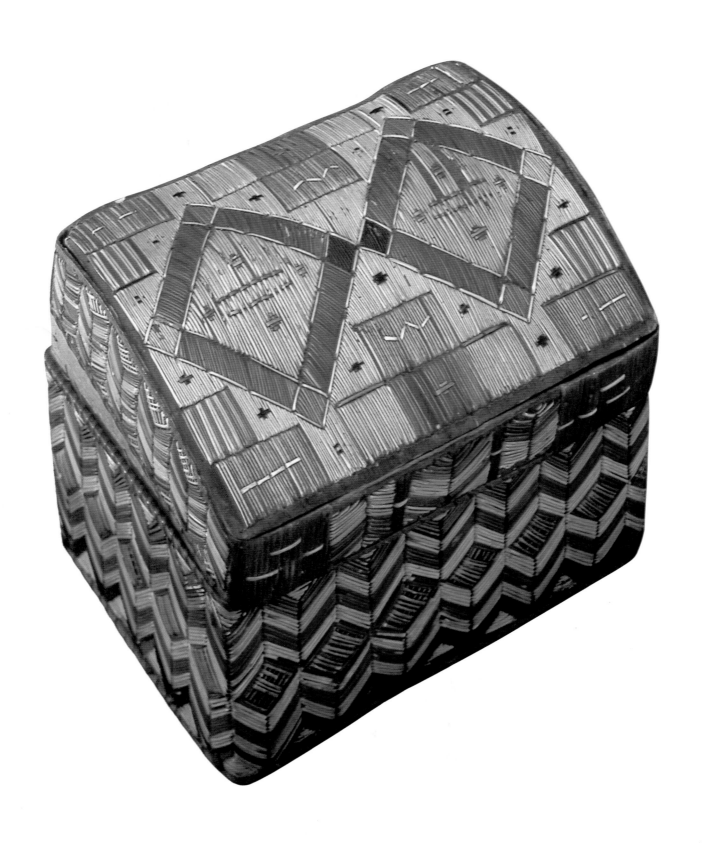

Micmac Birch Bark Chest,
Nova Scotia, Canada, c. 1850
Birch bark, porcupine quills
David T. Vernon Collection
Colter Bay Indian Arts Museum, Grand Teton
National Park, Wyoming
Photography by Jerry Jacka

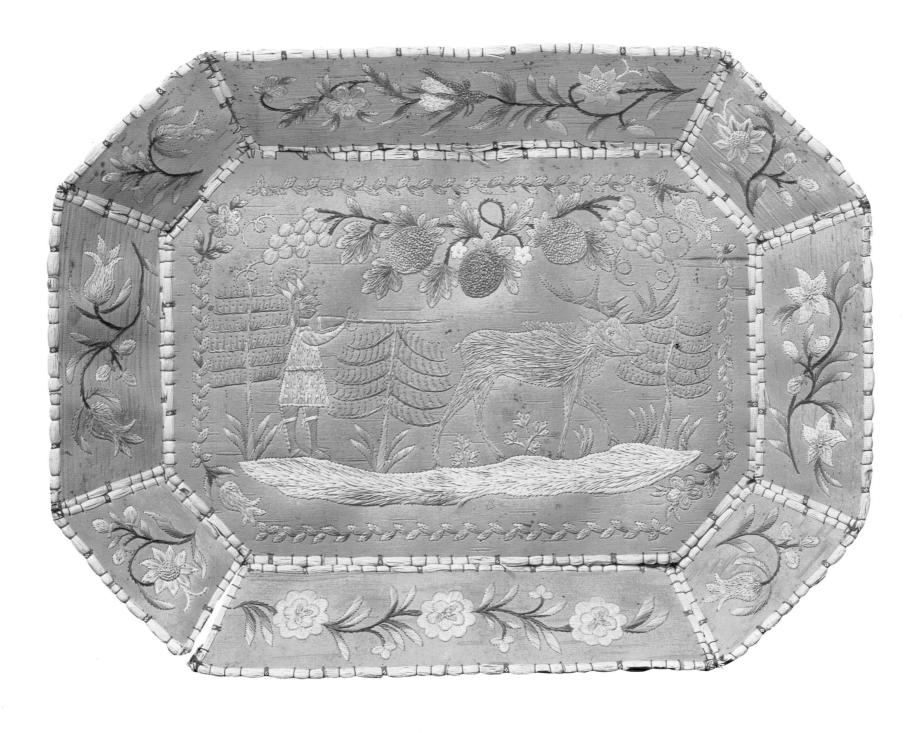

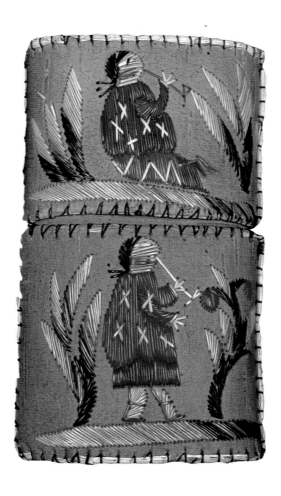

ABOVE:
Huron Birch Bark Tray
Birch bark, moose hair
9½ × 12 inches
National Museum of the American Indian
Smithsonian Institution

RIGHT:
Huron Tobacco Case and Cover
Birch bark, dyed porcupine quills
National Museum of the American Indian
Smithsonian Institution

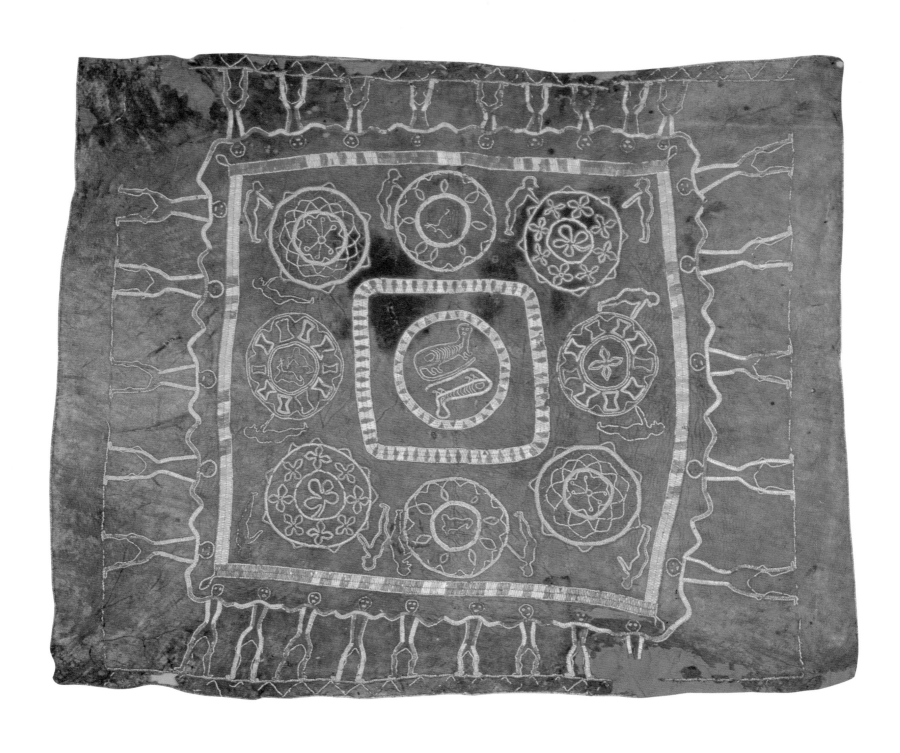

Iroquois Quilled Skin
National Museum of the American Indian
Smithsonian Institution

BELOW:
Ojibwa Bandolier Bag, 1880s
Cloth, beads
Frank H. McClung Museum
The University of Tennessee, Knoxville
Photography by W. Miles Wright

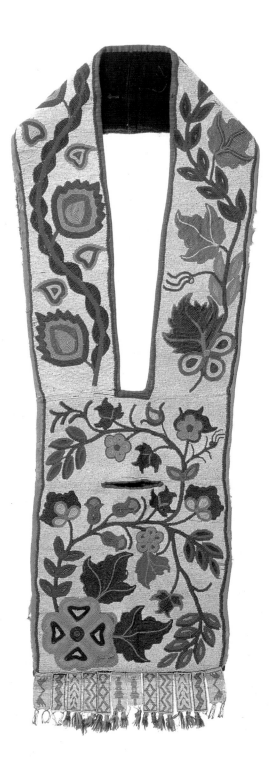

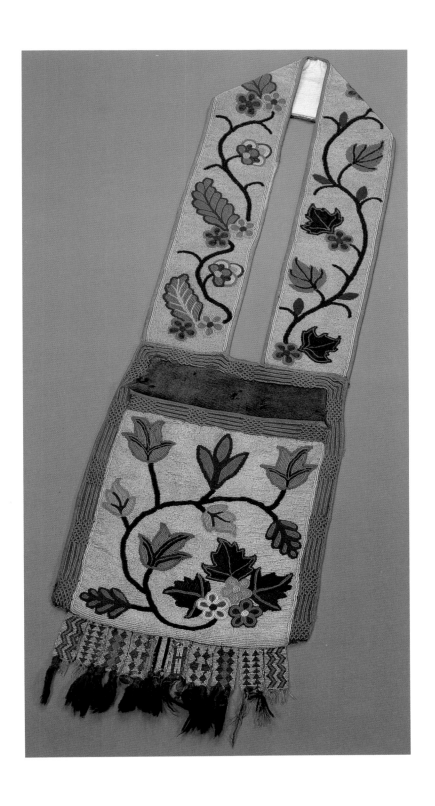

ABOVE:
Ojibwa Bandolier Bag, Minnesota,
c. 1890
David T. Vernon Collection
Colter Bay Indian Arts Museum, Grand Teton
National Park, Wyoming
Photography by John Oldencamp and Cynthia
Sabransky

109

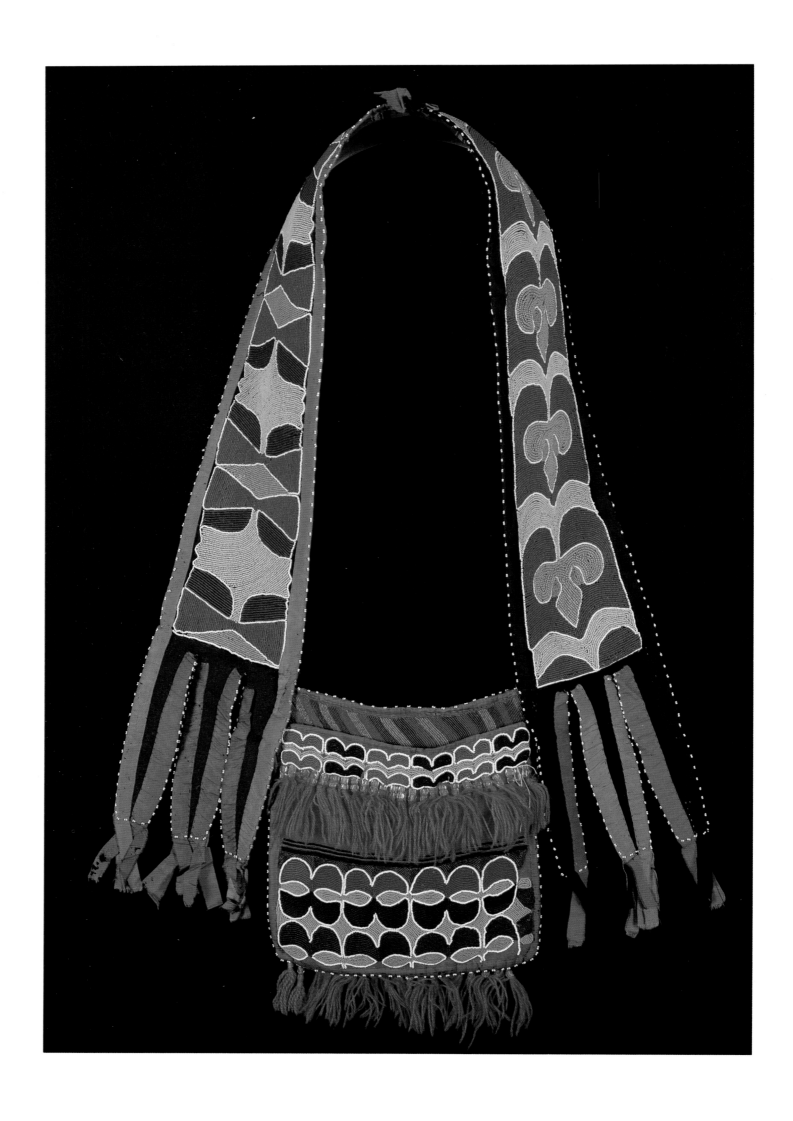

Delaware Bandolier Bag, c. 1840
Cloth, ribbon, yarn, and beads
Length 30 inches
Courtesy Morning Star Gallery, Santa Fe,
New Mexico
Photography by Addison Doty

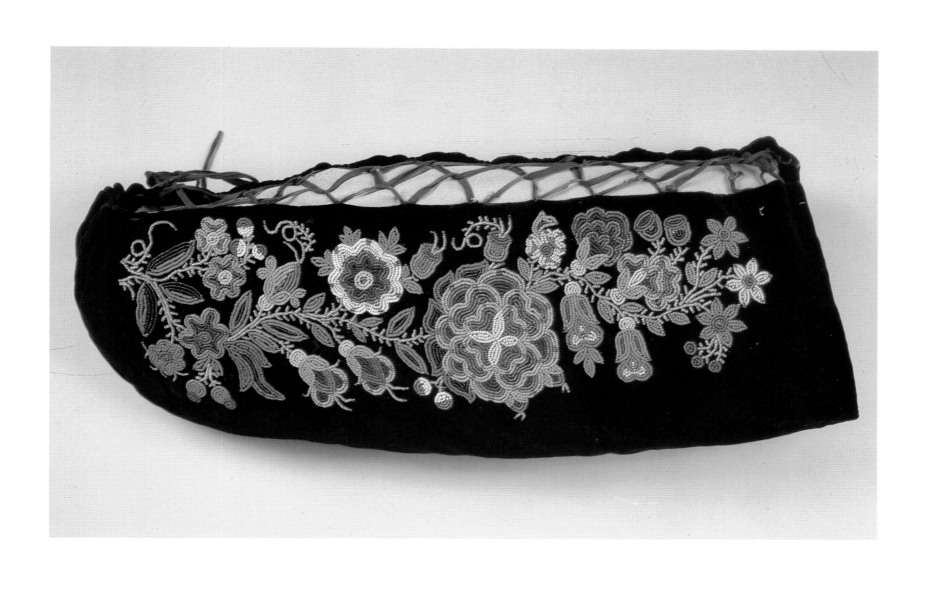

Slave Moss Bag for Baby Carrier,
Mackenzie River, Canada
Velvet with beaded decoration, leather thongs
National Museum of the American Indian
Smithsonian Institution

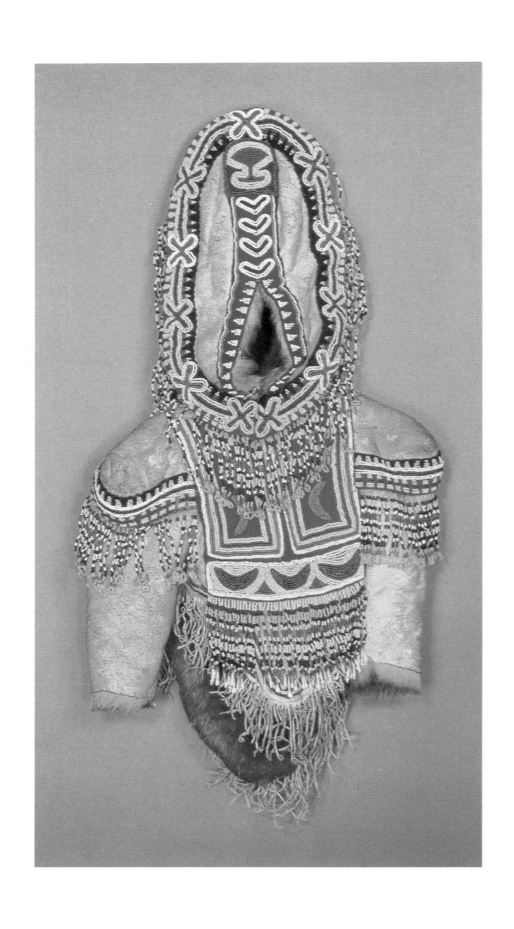

Inuit Girl's Coat
Caribou skin, fur, beads
National Museum of the American Indian
Smithsonian Institution

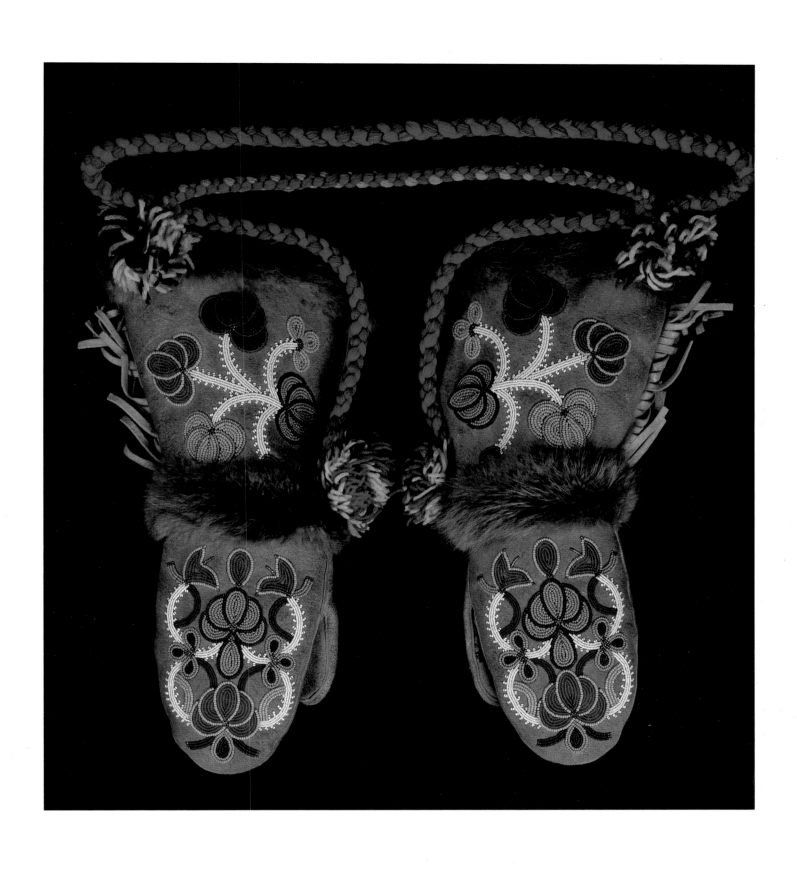

Athapaskan Mittens, 1920-30
Moose hide, wool, beaver fur, glass beads
17 × 10 inches
Alaska State Museum
II-C-203 a,b

REGALIA AND THE SPIRIT WORLD

✦✦✦✦✦✦✦✦✦✦✦✦✦✦✦✦✦✦✦✦✦✦✦✦✦✦✦✦✦✦✦✦

All tribal societies shared a similar view of the universe in which the unseen supernatural and the physical components of being were totally interrelated, to the degree that Native languages have no words for either art or religion. Ceremonials devoted to healing, invocation, protection, and rites of passage permeated the fabric of daily life. Shamans and medicine men – or women – were deeply revered and entrusted with spiritual responsibility for the tribal unit. Certain ritual objects, including masks and medicine bags, were considered sacred and could not be seen except by initiates. Among the Iroquois, the basswood masks of the False Face Society, which warded off evil spirits, were treated as members of the family; ritual offerings of food and tobacco were placed before them.

Some ceremonial objects also symbolized rank, as in the case of the bear-claw necklace. Among the Plain Indians, horned headdresses and eagle-feather fans and war bonnets implied both social and spiritual power: they were used only by warriors, medicine people, and chiefs. Rituals of face-painting and battle dress were dictated by generations of tradition. Originally, tribesmen went into battle naked and unadorned in the belief that wounds sustained by the naked body would heal more quickly. Over time, elaborate taboos, ceremonial dances, and resplendent battle array became the rule.

All tribes practiced healing rites and evolved their own cere-monies employing a host of sacred objects – dolls, fetishes, fans, gourd and tortoise-shell rattles, masks, and headpieces.

Masks represent the spiritual beings they depict and take on their power. This is why no one speaks through them during ceremonial activities: the power emitted can affect the mind or the senses. Carved and painted wooden masks representing sacred animals and supernatural beings are among the most dramatic artworks of the Northwest Coast, while Hopi masks, *kachina* dolls, and tablitas played a similar role in Southwestern religion. During the late 1800s, Ghost Dance dresses and shirts were believed to make their wearers invulnerable to white bullets. When an Apache medicine man donned his ritual shirt, he became the power he called upon.

Ritual use of pipes and tobacco was widespread; some of the oldest Native American artifacts are clay and stone effigy pipes. These evolved into a variety of shapes and sizes, with bowls carved from wood or heat-resistant stone such as steatite, catlinite, shale, and limestone. Detachable wooden stems were elaborately decorated with quillwork, feathers, beads, fur, and other natural materials. The bowl is usually separated from the stem for storing, since the pipe symbolizes the unity of all that is. Among the Lakota Sioux, for example, the pipe bowl is said to signify all people and the stem to represent all living things: together, they symbolize the universe.

114

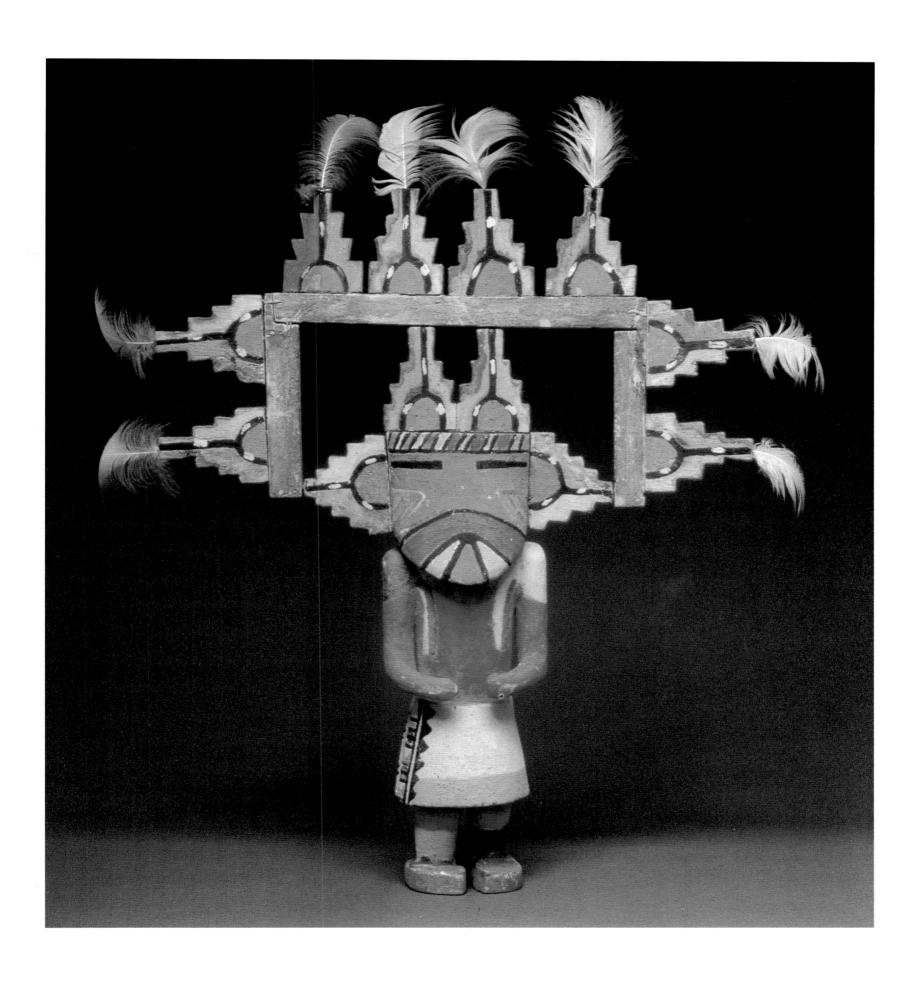

Hopi Kachina Doll (Shalako)
National Museum of the American Indian
Smithsonian Institution

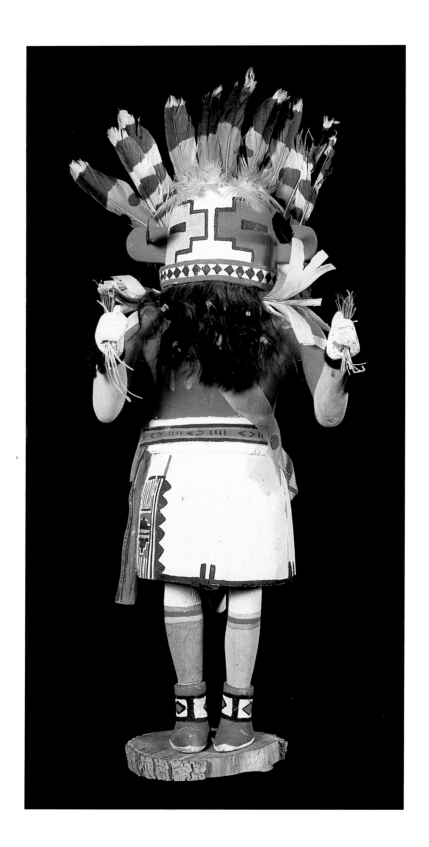

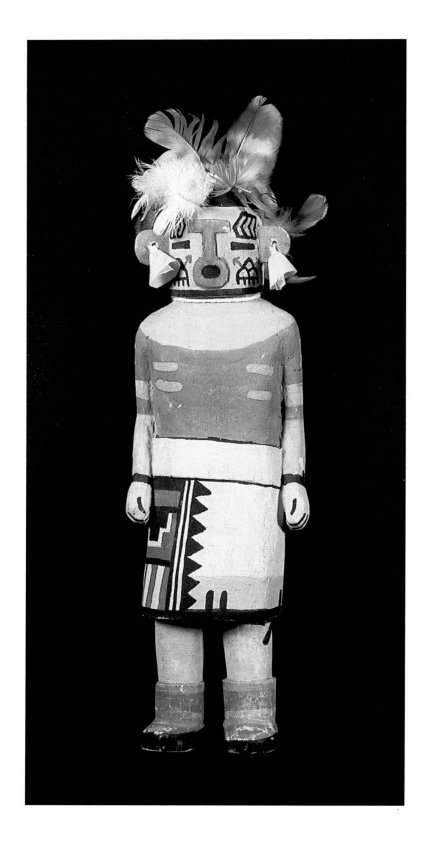

***Hopi Kachina Doll (Hehea's
Uncle),*** Third Mesa, Arizona, 1971
James Kootshongsie
Carved wood, feathers, natural earth pigments
Height 13 inches
San Diego Museum of Man, California
Photography by Ken Hedges

Hopi Kachina Doll (Hilili), c. 1940
Carved wood, feathers, natural earth pigment
Height 17 inches
San Diego Museum of Man, California
Photography by Ken Hedges

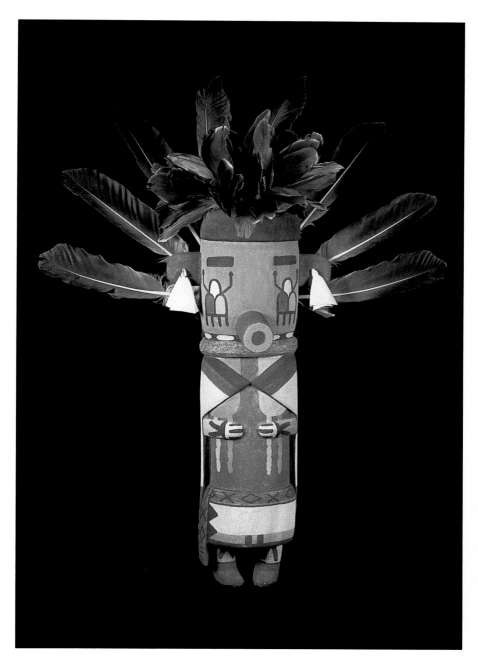

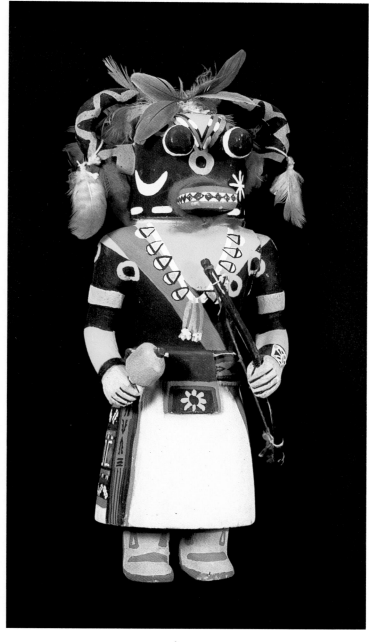

***Hopi Kachina Doll (Da-la-vai, or
Dawn),*** 1992
Manfred Susunkewa
Carved wood, goose feathers, natural earth
pigments
Height 24 inches
Gift of the Artist
San Diego Museum of Man, California
Photography by Ken Hedges

Hopi Kachina Doll (Ho-o-te), c. 1950
Jimmy Kewanwytema
Carved wood, feathers, natural earth pigments
Height 13 inches
San Diego Museum of Man, California
Photography by Ken Hedges

117

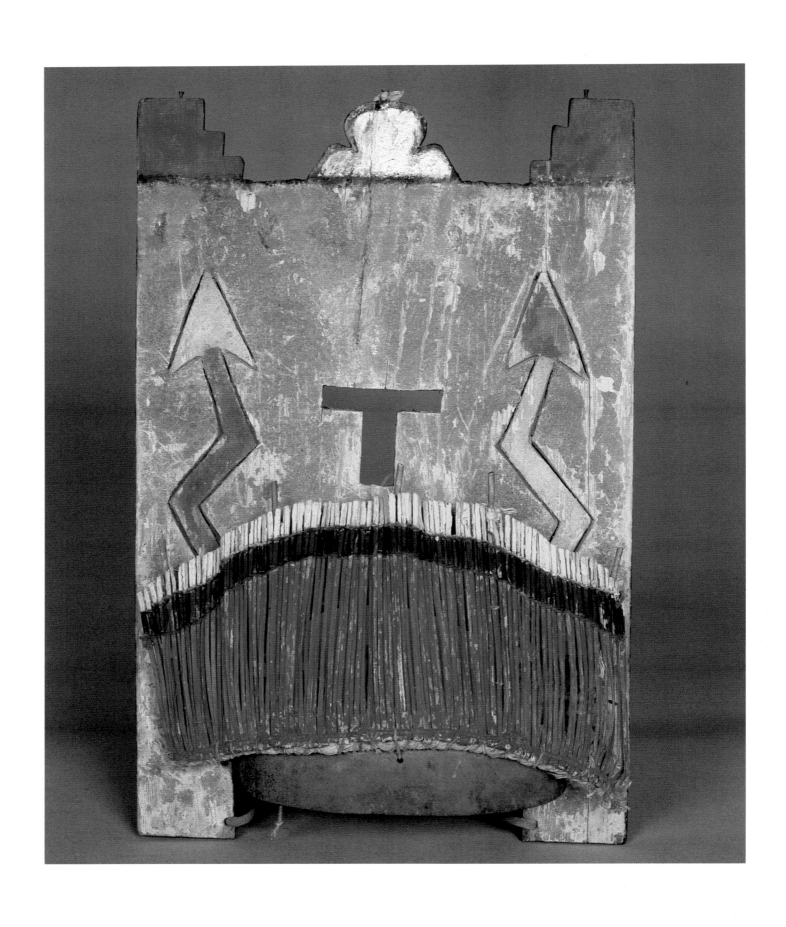

Jemez Tablita, c. 1900
Milled lumber, paint
18 × 11¾ inches
Courtesy Morning Star Gallery, Santa Fe,
New Mexico
Photography by Addison Doty

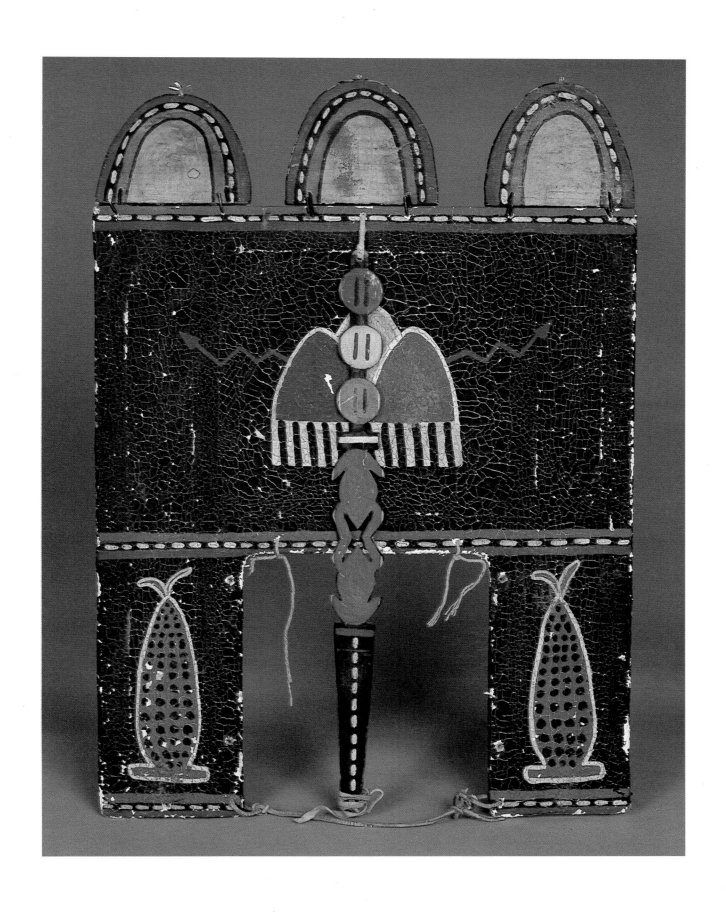

Jemez Tablita, c. 1860
Cottonwood, cotton trade cloth, mineral
pigment, cotton thread
16 × 15 inches
Courtesy Morning Star Gallery, Santa Fe,
New Mexico
Photography by Addison Doty

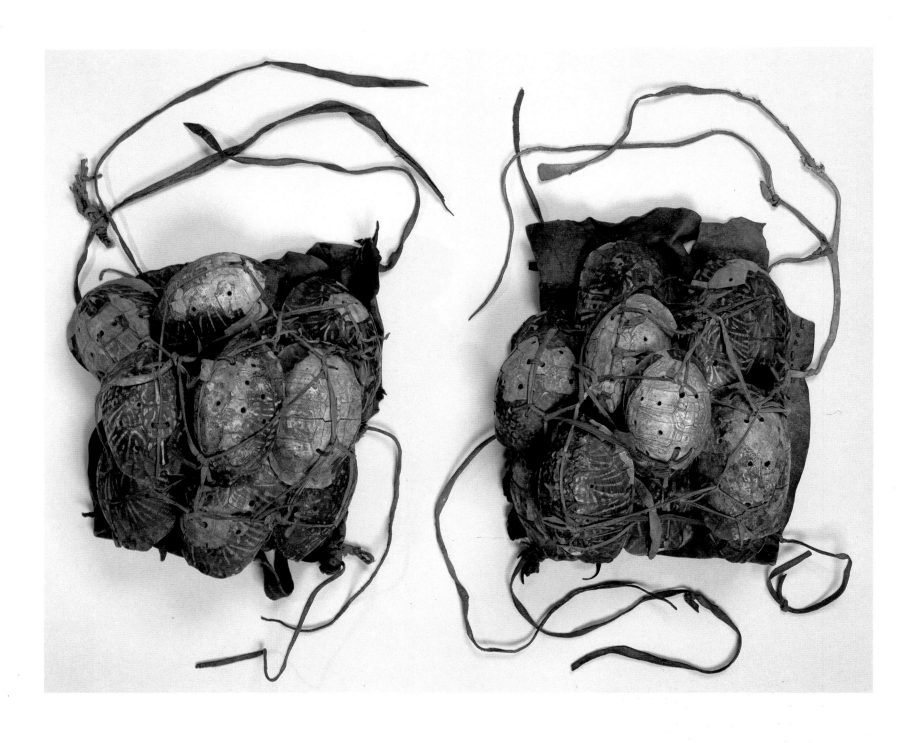

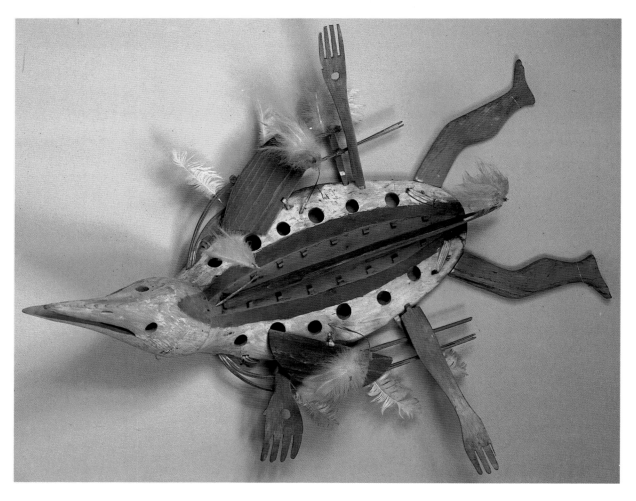

120

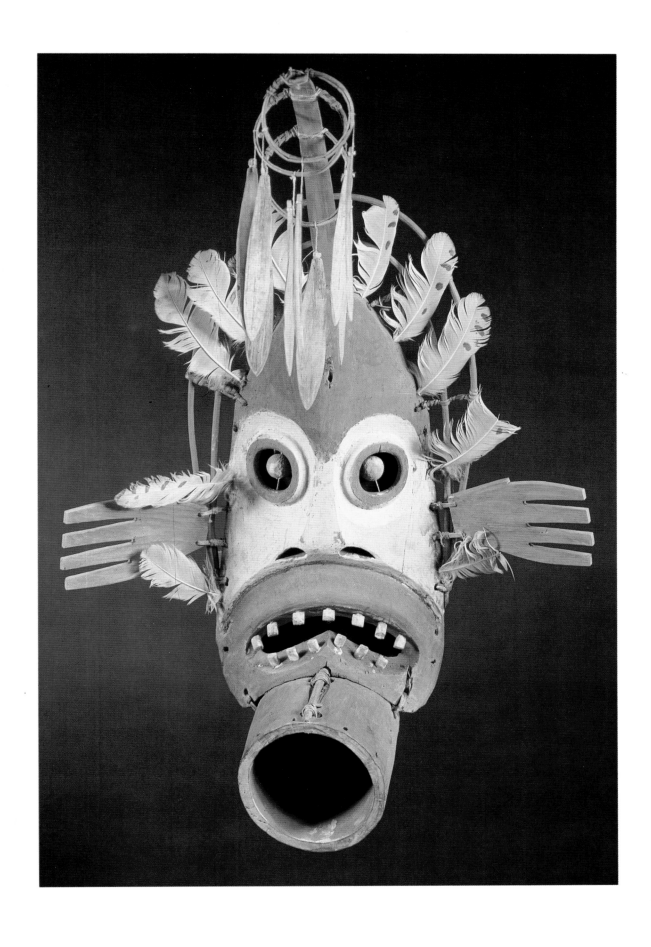

121

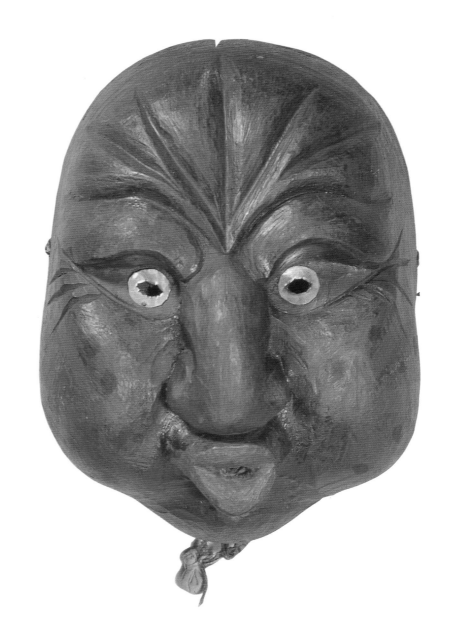

RIGHT:
Iroquois (Onondaga) Wind Mask
Carved hardwood with metal fittings
National Museum of the American Indian
Smithsonian Institution

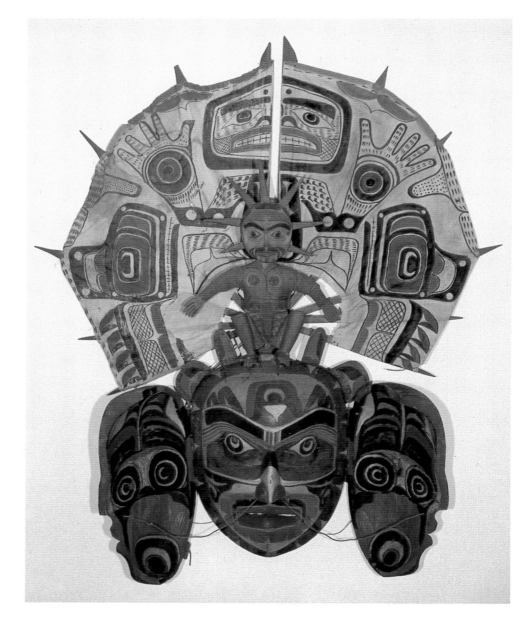

RIGHT:
Kwakiutl Mechanical Mask, Alert
Bay, Vancouver Island, British Columbia
Mask representing human (sun) face opens to
reveal another human face
Painted carved wood, painted cloth
National Museum of the American Indian
Smithsonian Institution

122

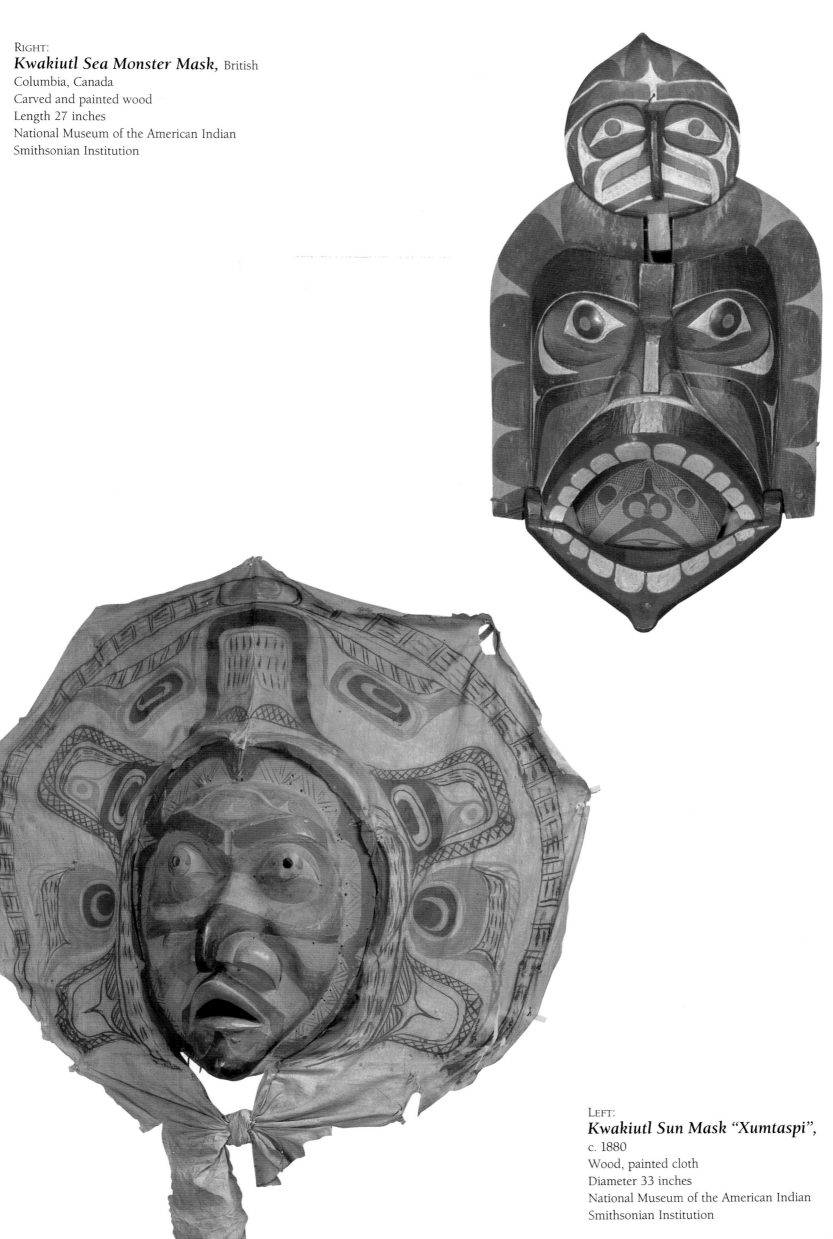

123

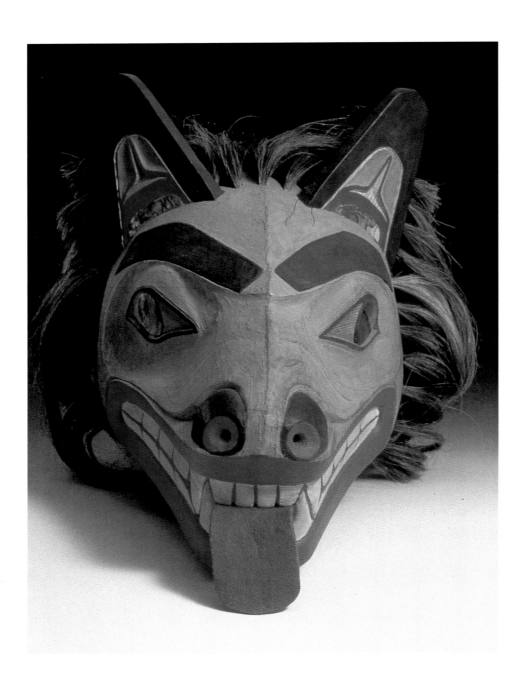

LEFT:
Wolf Mask, c. 1989
Nathan P. Jackson – Chilkoot/Tlingit
Carved and painted wood, human hair
Courtesy of the Artist

BELOW:
Kwakiutl Raven Rattle, Vancouver
Island, British Columbia
Carved wood, natural pigments
Length 13 inches
National Museum of the American Indian
Smithsonian Institution

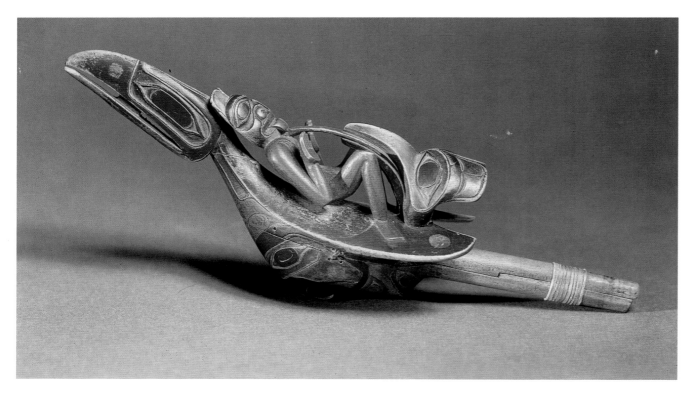

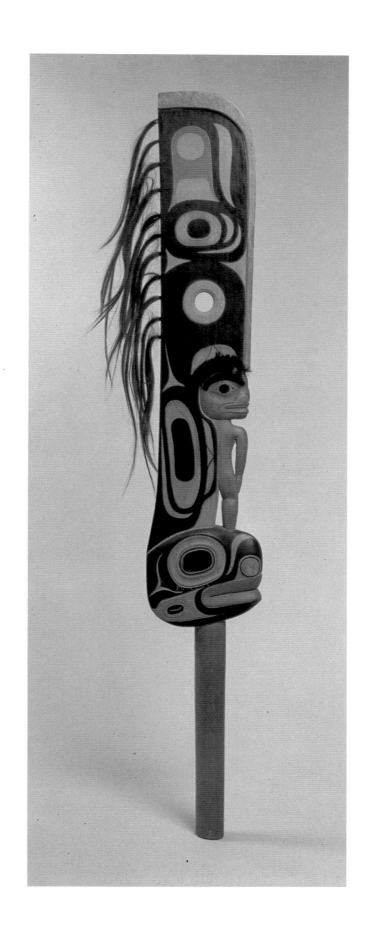

Tlingit Dance Wand, Sitka, Alaska
Carved and painted wood representing the
killer whale crest
National Museum of the American Indian
Smithsonian Institution

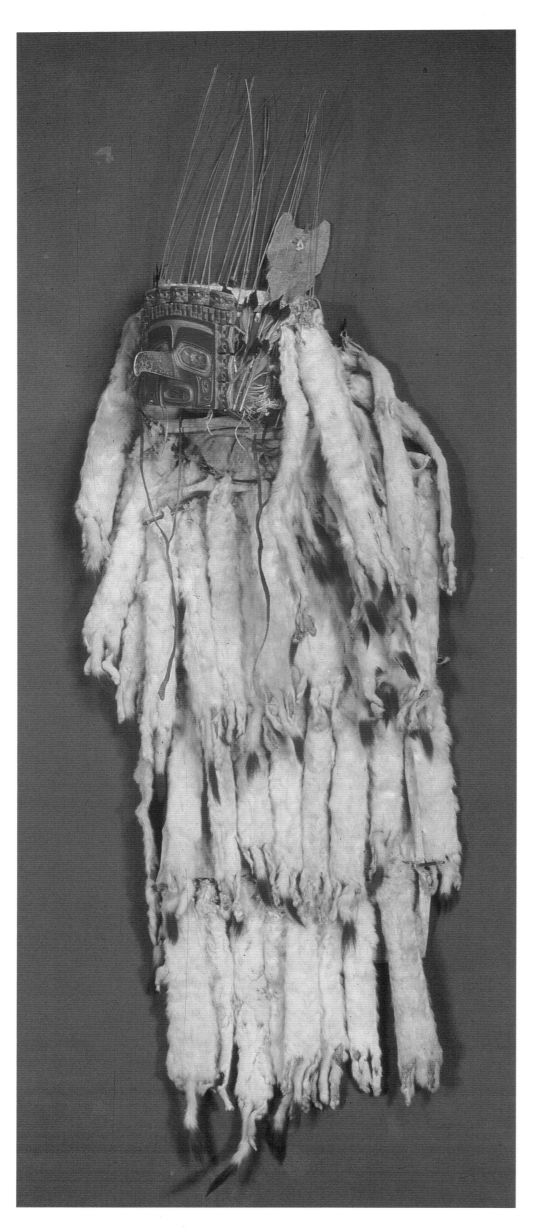

Niska Ceremonial Chief's Headdress, Nass River, British Columbia
Carved wood, ermine skins, feathers, reeds
National Museum of the American Indian
Smithsonian Institution

Kitikshan Beaver Mask, British
Columbia
Carved and painted cedar, abalone, swan skin,
swan feathers, reeds
National Museum of the American Indian
Smithsonian Institution

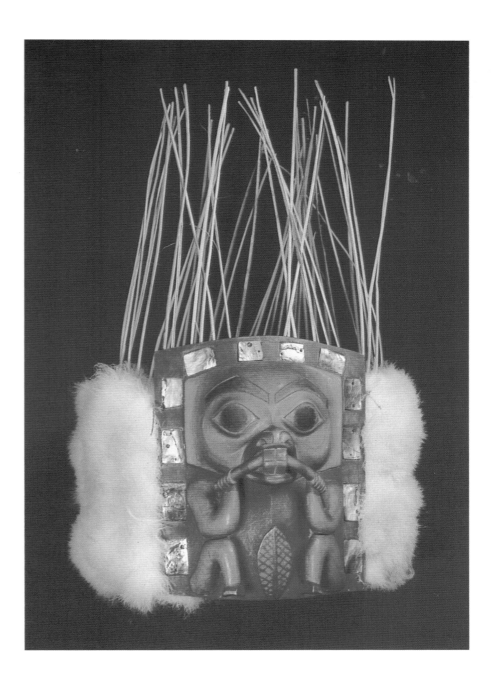

Niska Headdress
Carved and painted cedar, abalone
National Museum of the American Indian
Smithsonian Institution

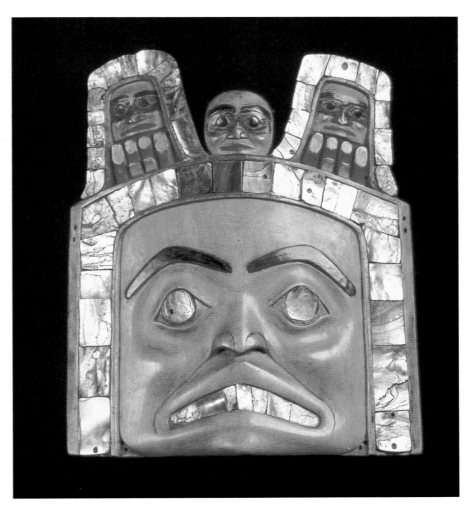

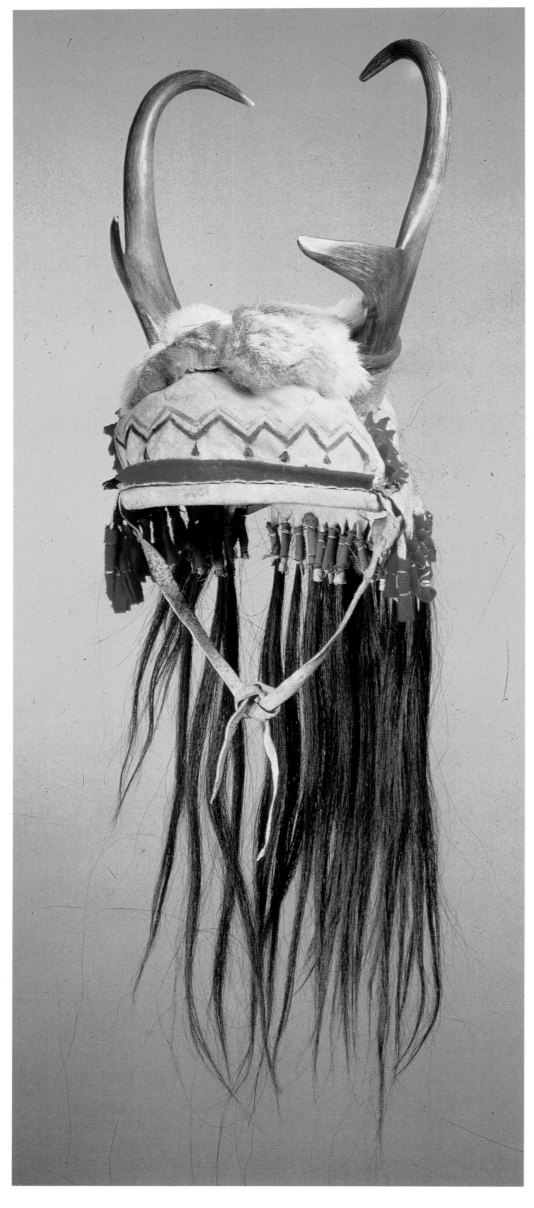

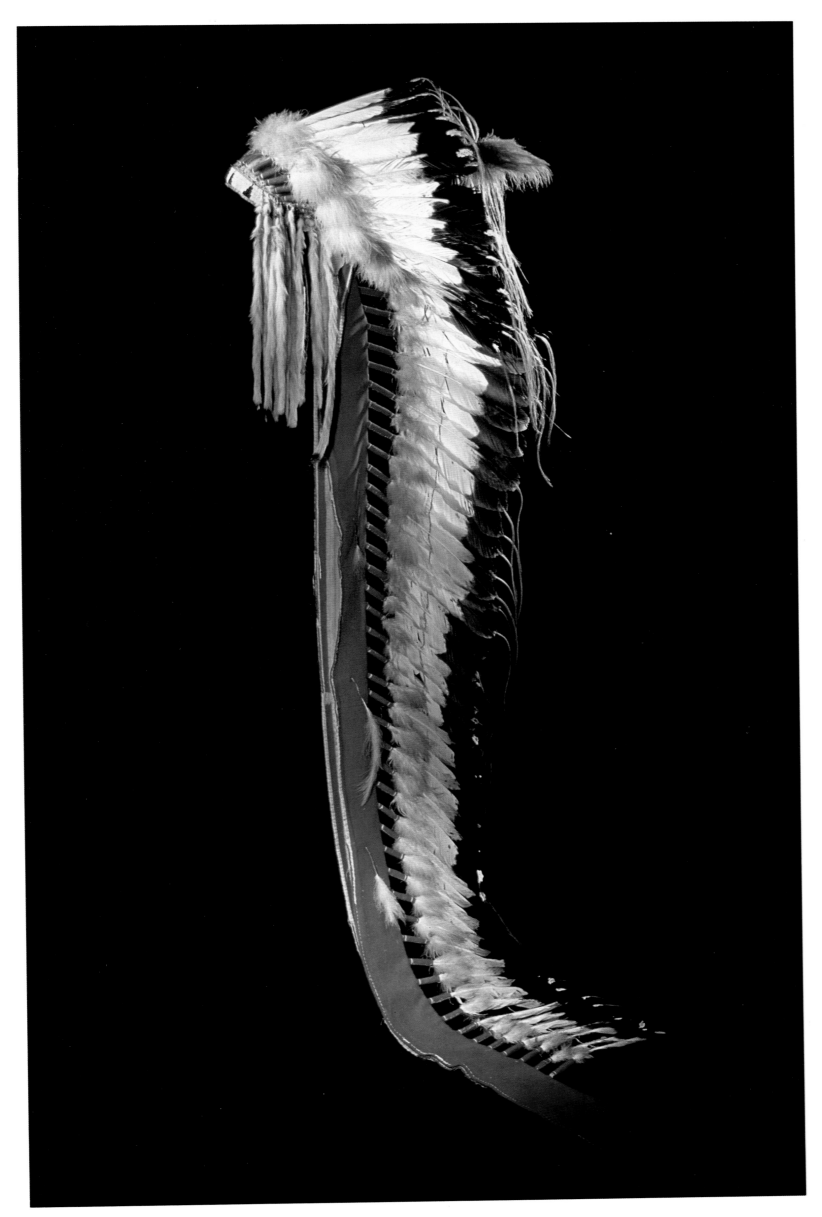

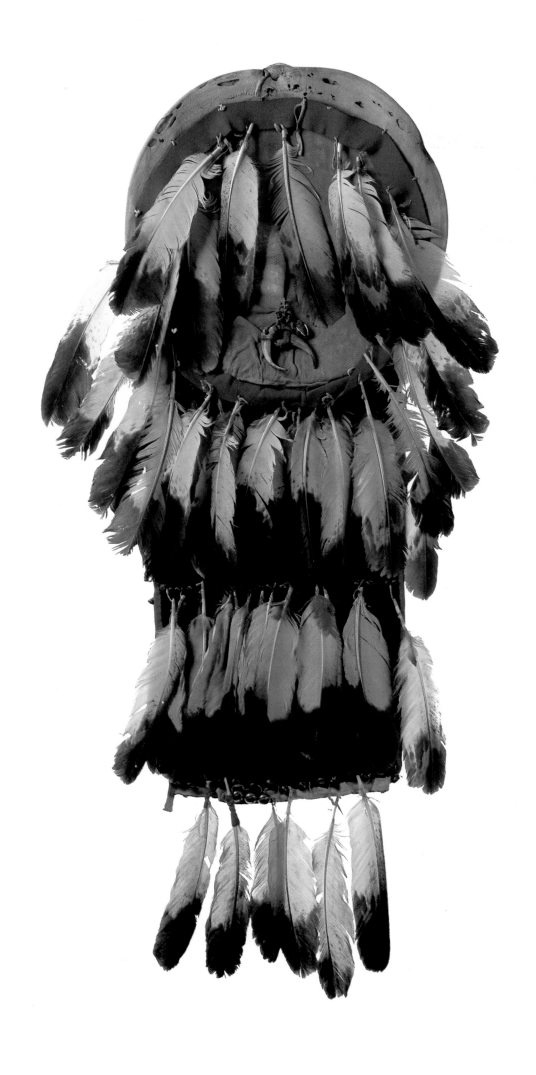

Crow Shield and Shield Cover,
Eastern Montana, c. 1880
Hide, cloth, paint, golden eagle feathers, bear
claws, brass bells
David T. Vernon Collection
Colter Bay Indian Arts Museum, Grand Teton
National Park, Wyoming
Photography by John Oldencamp and Cynthia
Sabransky

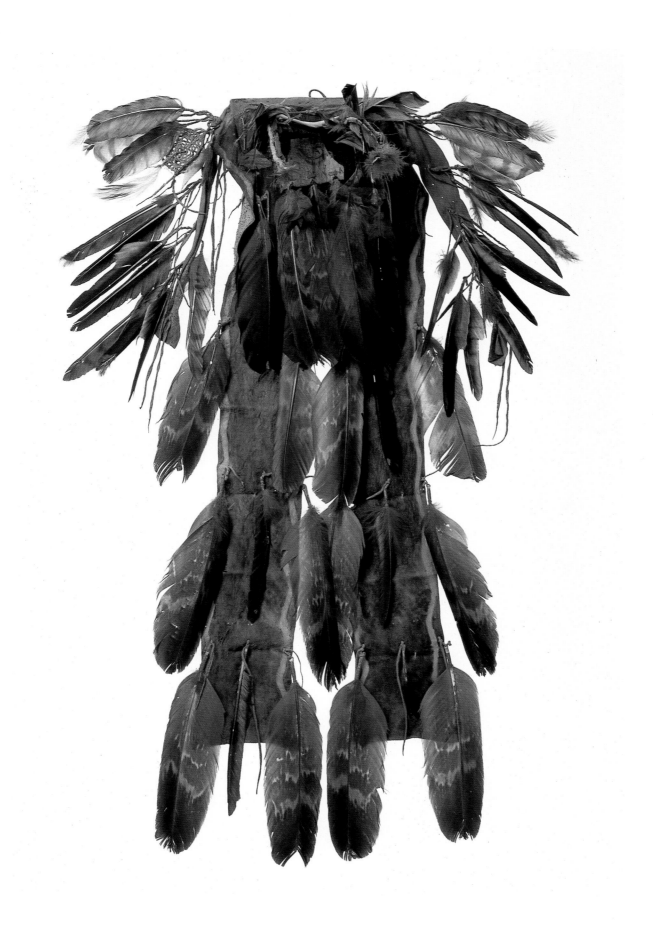

Arapaho Grass Dance Bustle,
Wyoming, c. 1875
Feathers (including golden eagle), rawhide,
paint
David T. Vernon Collection
Colter Bay Indian Arts Museum, Grand Teton
National Park, Wyoming
Photography by John Oldencamp and Cynthia
Sabransky

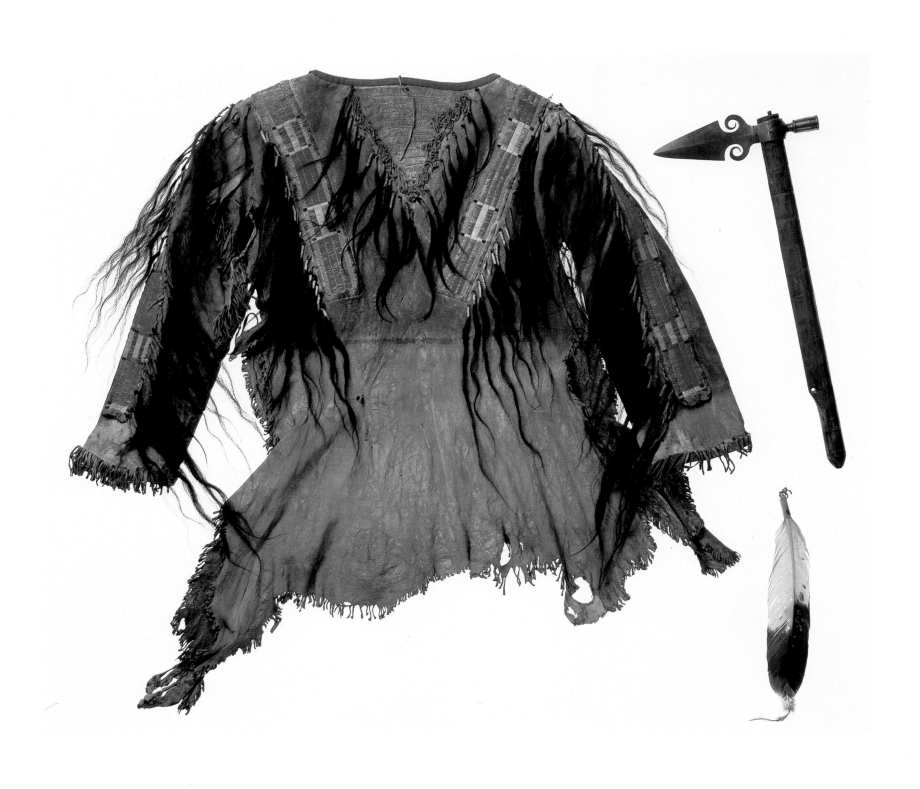

Sioux War Shirt, South Dakota, c. 1890
Ponca Tomahawk Pipe, Oklahoma,
1875-1900
Potawatomi Roach Feather, Kansas,
1875-1900
David T. Vernon Collection
Colter Bay Indian Arts Museum, Grand Teton
National Park, Wyoming
Photography by John Oldencamp and Cynthia
Sabransky

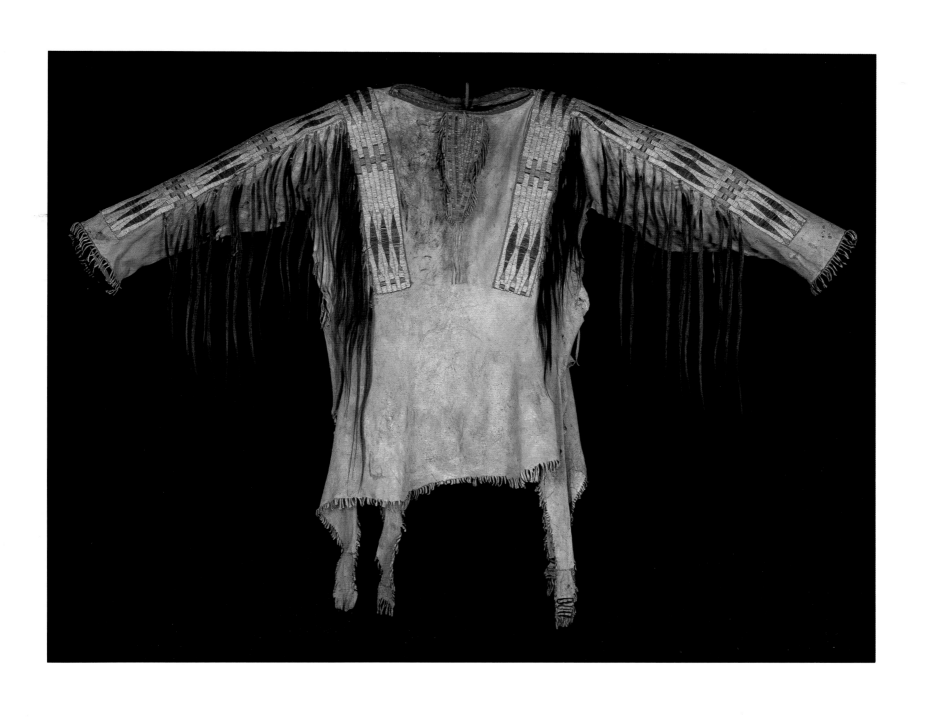

Sioux Quilled War Shirt, c. 1880
Tanned deer hide painted with yellow ochre
and blue and green pigments, cloth-bound
neck and sleeve edges, quilled shoulder and
sleeve strips and bib, quill-wrapped human
hair suspensions
Courtesy Morning Star Gallery, Santa Fe,
New Mexico
Photography by Addison Doty

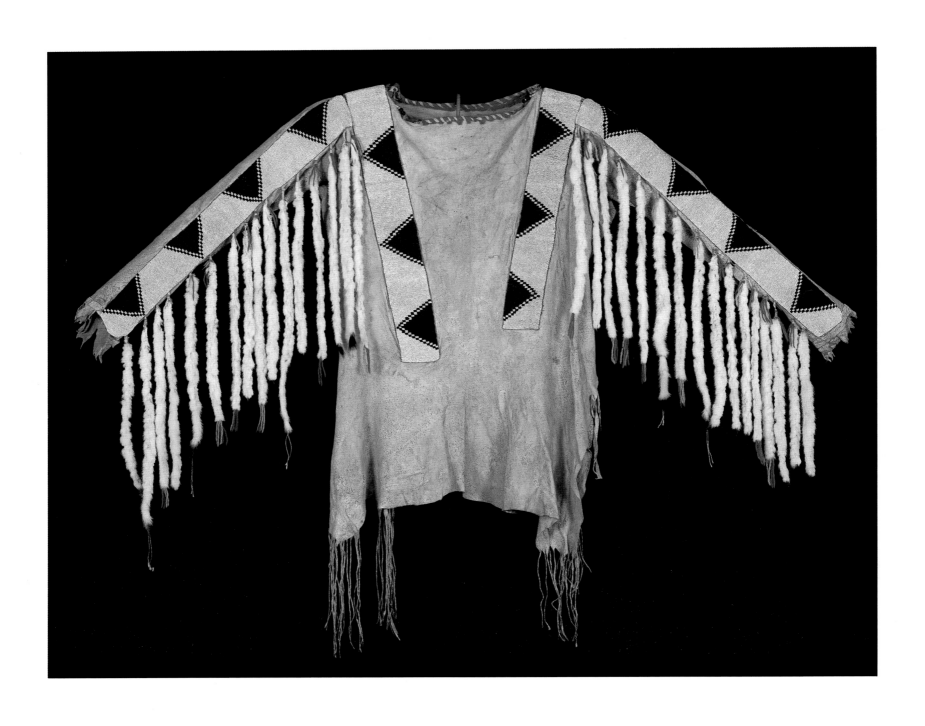

Blackfeet War Shirt, c. 1880
Tanned deer hide, yellow ochre paint, beads,
red trade cloth at neck, winter weasel fringe,
red and white string
Courtesy Morning Star Gallery, Santa Fe,
New Mexico
Photography by Addison Doty

RIGHT:
**Arapaho Woman's Ghost Dance
Dress,** c. 1890
Hide with yellow ochre overall and green
ochre fringe, green, red and blue pigments,
metal bells
Courtesy W. E. Channing and Co., Santa Fe,
New Mexico
Photography by Addison Doty

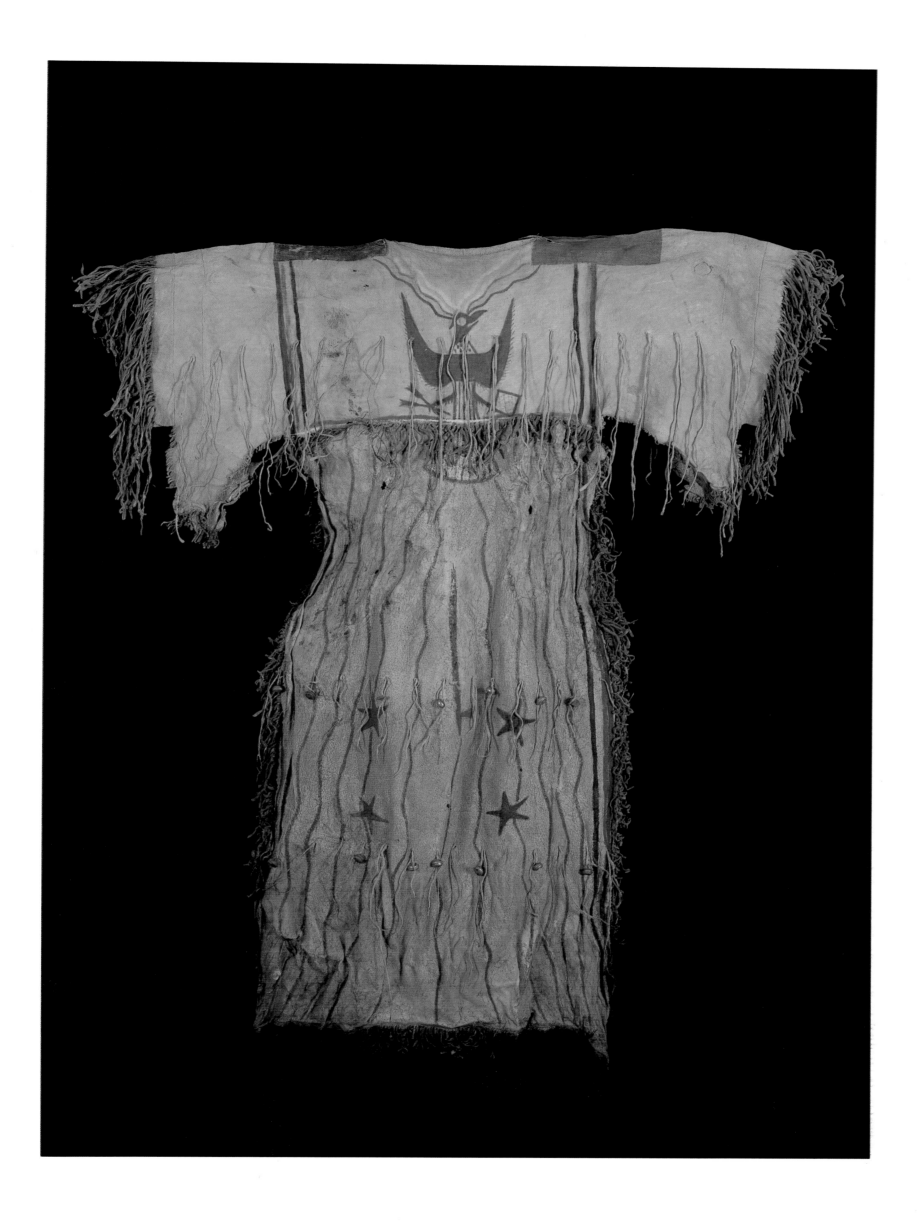

Group of Pipes with Pipe Bag
(From top):
Cheyenne Wooden Pipe Stem, South Dakota, pre-1850
(Bowl not part of the Vernon Collection)

Potawatomi Catlinite Pipe and Stem, Kansas, 1875-1900

(left) *Northern Cheyenne Bone Pipe,* Montana, c. 1900

(right) *Mound Culture Elbow Pipe,* Ohio, A.D. 1000-1500

Yankton Sioux Multistem Pipe, South Dakota, c.1865

Ponca Tomahawk Pipe, Oklahoma, 1875-1900

Sioux Catlinite Pipe, fish design, South Dakota, c. 1900

(left) *Sauk and Fox Pipe,* Iowa, 1875-1900

(right) *Potawatomi French Tomahawk Pipe,* Kansas, 1875-1900

(left) *Kickapoo Catlinite Pipe with Wooden Stem,* Oklahoma, 1875-1900

(right) *Sauk and Fox English Tomahawk Pipe,* Iowa, 1875-1900

Sioux Tomahawk Pipe, South Dakota, 1875-1900

(Right):
Sioux Catlinite Pipe with Wooden Stem, South Dakota, 1900-20

Sioux Beaded Pipe Bag, South Dakota, c. 1890

David T. Vernon Collection
Colter Bay Indian Arts Museum, Grand Teton National Park, Wyoming
Photography by John Oldencamp and Cynthia Sabransky

137

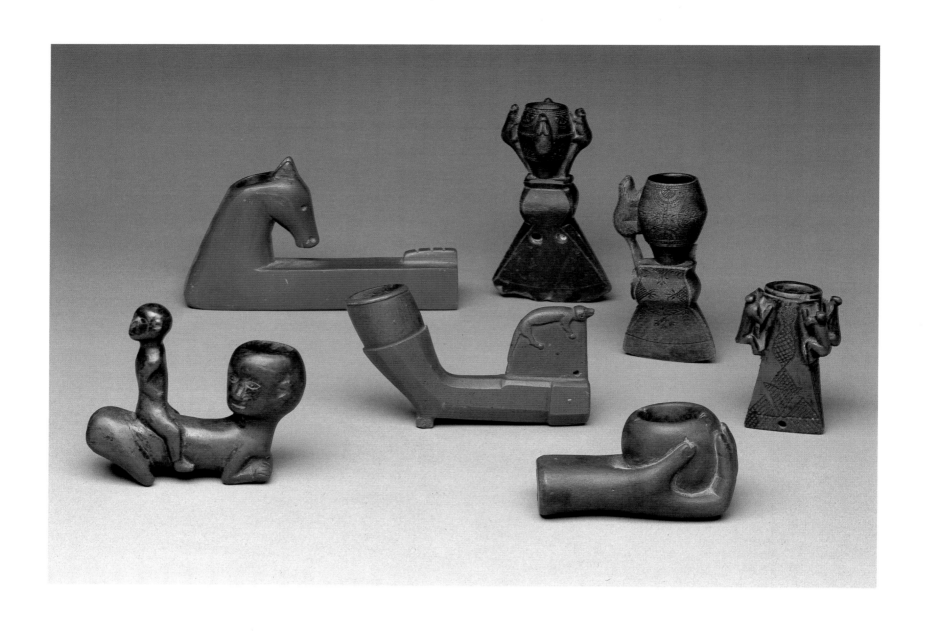

Group of Pipe Bowls
(Clockwise from upper left):
Sioux Pipe Bowl
Catlinite horse effigy bowl

Micmac Pipe Bowl
Steatite bowl surrounded by four animal
figures

Micmac Pipe Bowl
Steatite beaver effigy bowl

Micmac Pipe Bowl
Steatite bowl surrounded by four crouched
human figures

Huron Pipe Bowl
Black pipestone of hand holding bowl

Great Lakes Pipe Bowl
Catlinite otter effigy bowl

Great Lakes Pipe Bowl
Steatite "Trickster" pipe bowl

Courtesy Morning Star Gallery, Santa Fe,
New Mexico
Photography by Addison Doty

138

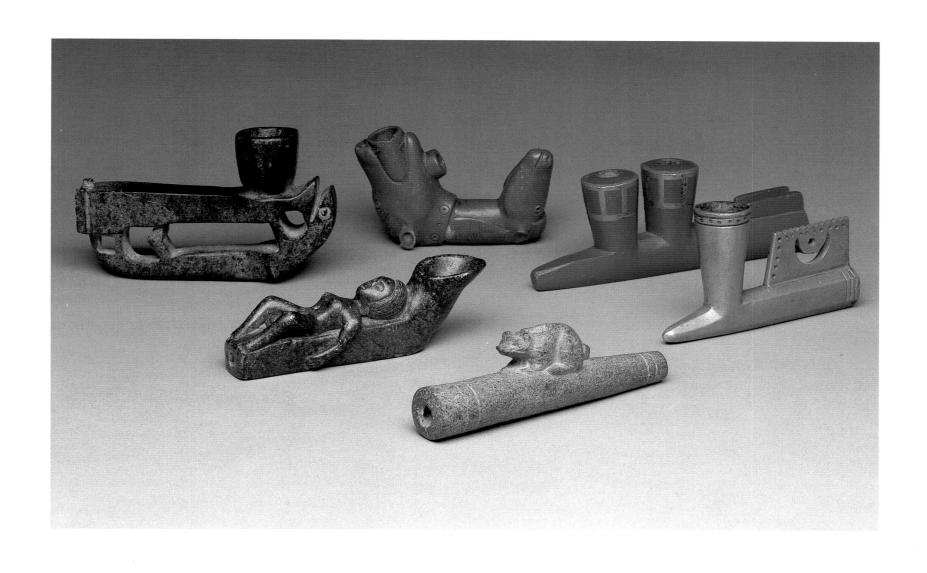

Group of Pipe Bowls
(Clockwise from upper left):
Iroquois Pipe Bowl
Steatite lizard effigy bowl

Eastern Sioux Pipe Bowl
Catlinite double dog head bowl

Plains Pipe Bowl
Catlinite dual head bowl with lead inlay

Plains Pipe Bowl
Pewter with cut-out crescent moon

Huron Pipe Bowl
Greystone beaver effigy bowl

Cherokee Pipe Bowl
Steatite bowl depicting a woman giving birth

Courtesy Morning Star Gallery, Santa Fe,
New Mexico
Photography by Addison Doty

CARVING AND SCULPTURE

The arts of carving and sculpture in such materials as wood, stone, and horn have been practiced in North America for thousands of years. Ancient burial mounds have yielded stone fetishes and figures made from shell and bone. The Inuit of Alaska and the sub-Arctic have a long tradition of carving marine ivory and stone into animal and human images of great stylistic refinement. Engraving is another prehistoric technique that has been revived in modern times by such artists as Lawrence Ullaaq Ahvakana, who also works in stone, wood, glass, and silver. Aleut artist Bill Prokopiof has done award-winning sculptures on traditional Inuit themes in welded steel, marble, and candy alabaster.

Wood carving in the Pacific Northwest is identified with the region's monumental totem poles, which document the lineage and social position of the patron who commissioned them. Carved primarily of cedar, they shared artistic honors with brightly painted house posts, canoe ornaments, feasting dishes, and dance masks. The Haida, Tsimshian, and Tlingit tribes in the northern part of the region are all well known for this work, while the Bella Coola of British Columbia and the Kwakiutl and Nootka of Vancouver Island evolved their own colorful and distinctive styles. In totemic art from the Northwest, the semi-abstract designs, usually of conventionalized animal forms, tend to occupy every available space.

Another art form indigenous to this region is that of steaming and bending wood into various shapes, from Aleut chief's hats to Tlingit lidded storage boxes. Such objects were often painted and decorated with shells and other native materials and sewn together with spruce root.

The number of contemporary Native American sculptors continues to grow. Doug Coffin, of Potawatomi and Creek heritage, is known for both modern and traditional totems and is a gifted painter as well. Bruce LaFountain, a Turtle Mountain Chippewa, makes powerful, fluid carvings in stone. Cree Gerald McMaster's sculpture shown on page 158 is both amusing and poignant. The arresting piece entitled *Winter Shaman* (page 159) was done by Reuben Kent in raku and mixed media – a testimony to the exciting work being done by Native Americans whose vision appropriates Euro-American modernism to its own purposes in the service of fine art.

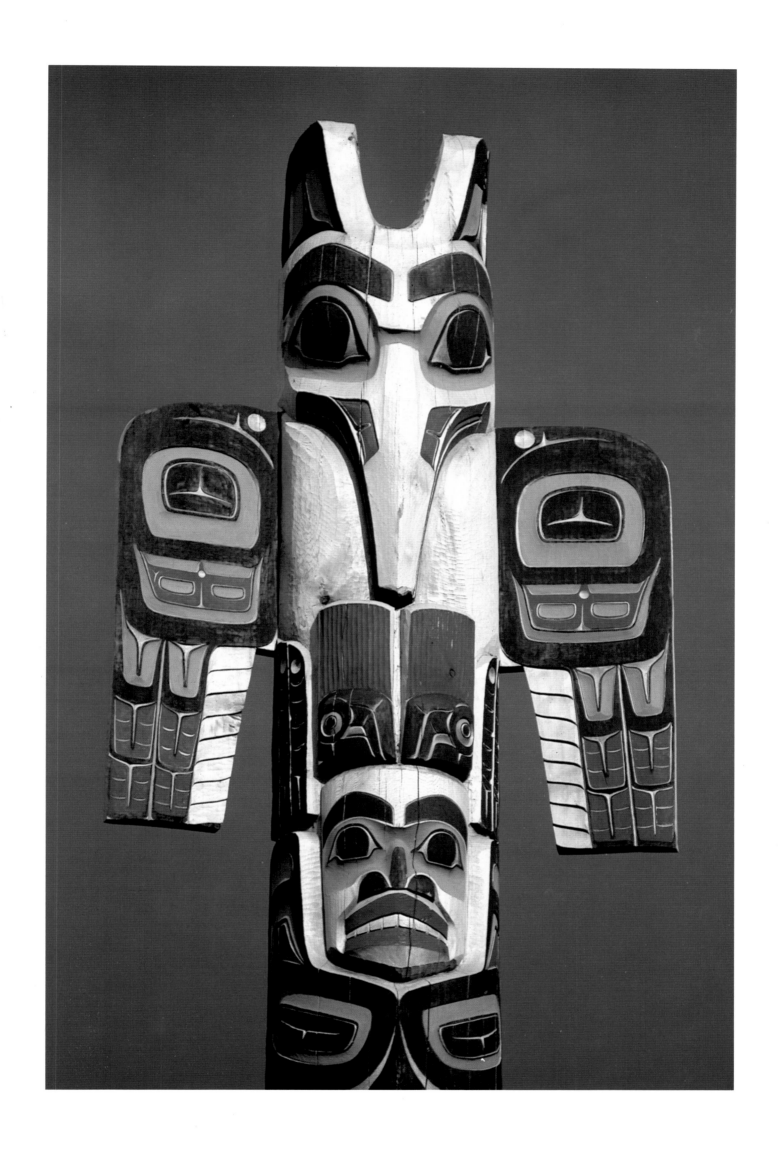

Tlingit Totem Pole, Haines, Alaska
Carved and painted wood
Photo Network: Mark Newman

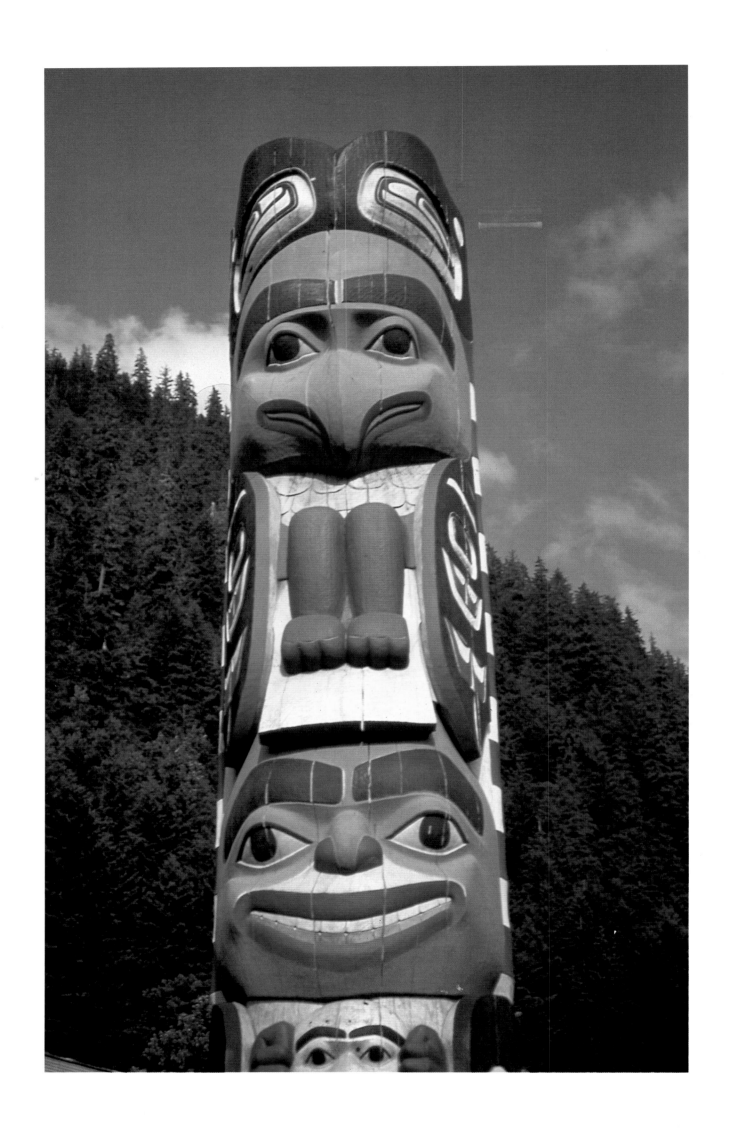

Tlingit Totem Pole (detail), Juneau,
Alaska
Carved and painted cedar log
Photography by Bill Yenne

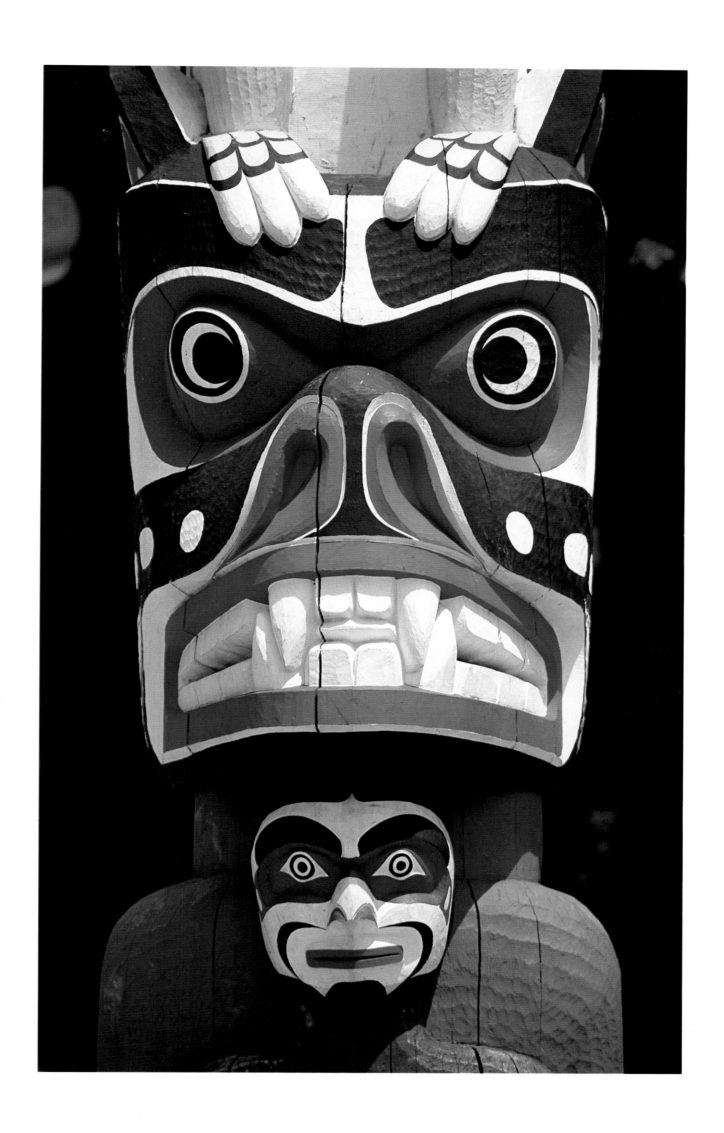

Kwakiutl Thunderbird House Post
in Stanley Park, Vancouver, British Columbia
Replica, by Tony Hunt, 1987
Photo Network: Phyllis Picardi

Tsimshian Totem Pole of Laxsel Clan, Detail of Owl, Kitwancool, British Columbia, c. 1870
Weathered carved and painted cedar
Photography by Bill Yenne

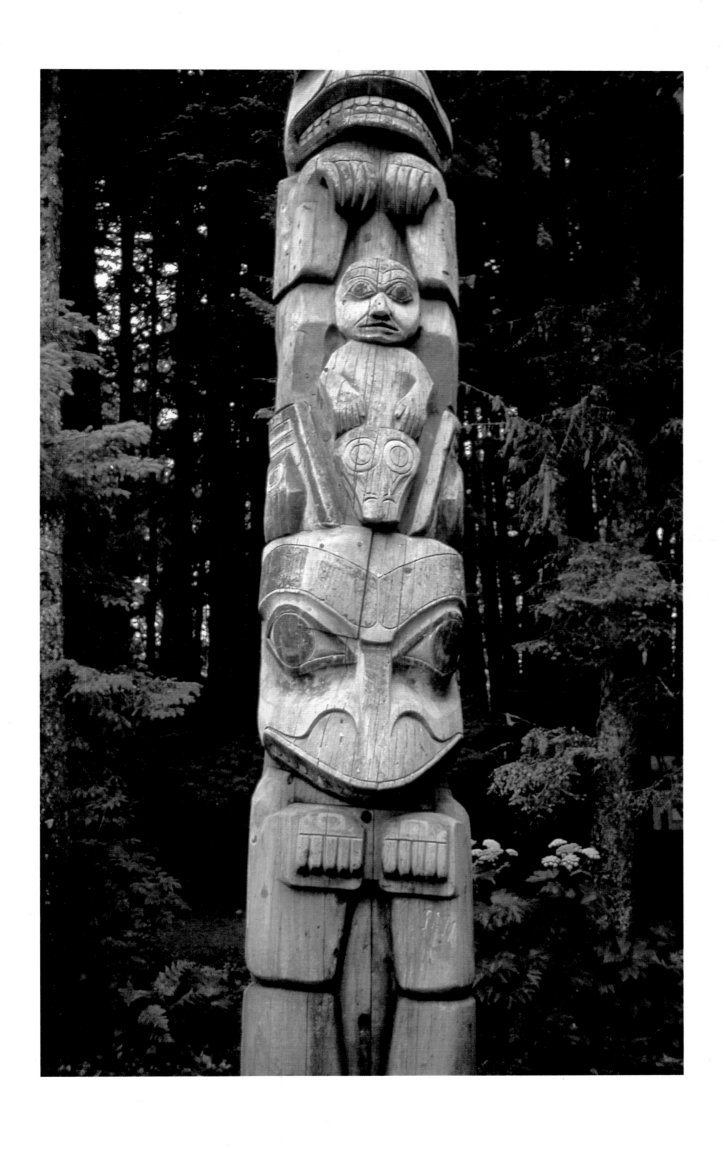

Haida Totem Pole, Sitka, Alaska, 1875-1900
Carved and painted cedar
Photography by Bill Yenne

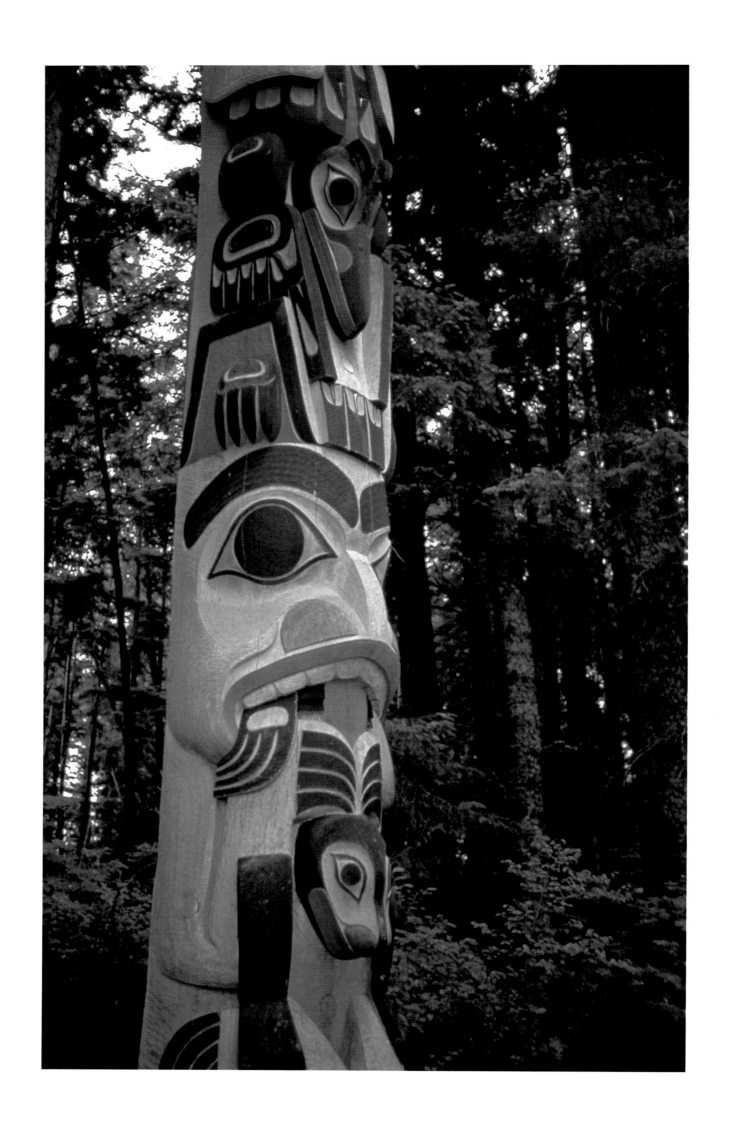

Haida Totem Pole of Yaadaas Clan, Sitka, Alaska, c. 1890
Carved and painted cedar
Photography by Bill Yenne

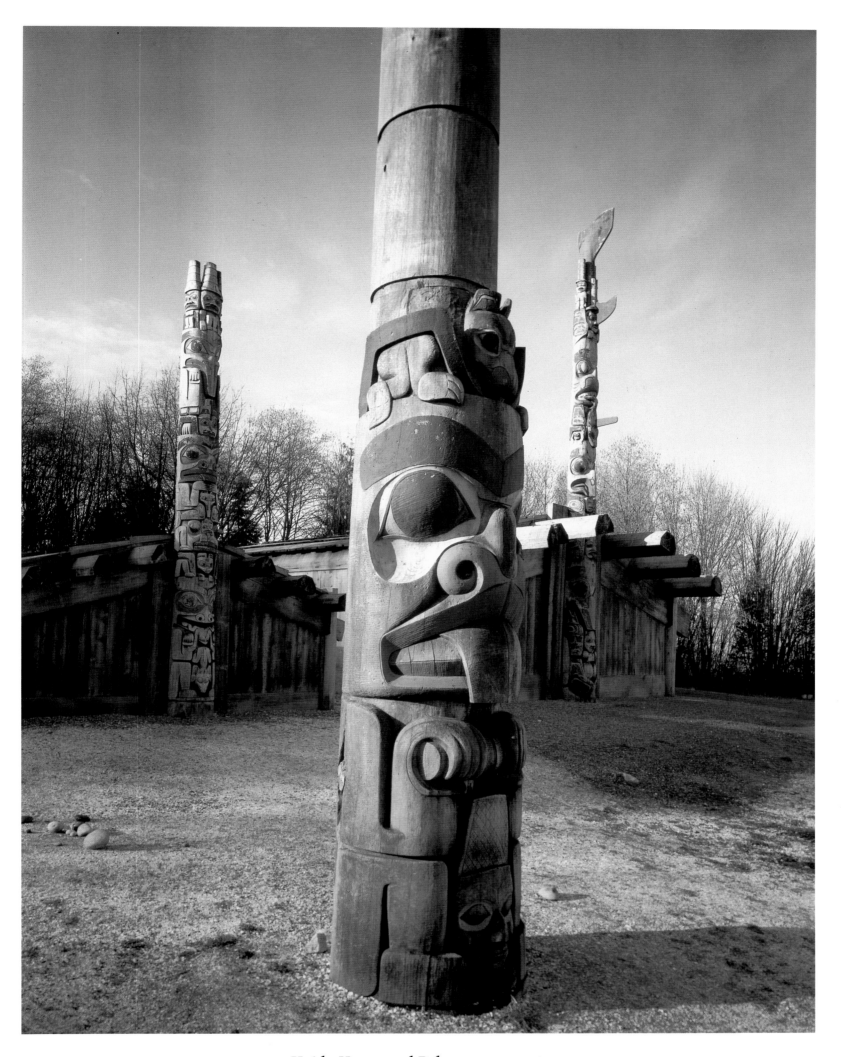

Haida House and Poles at University of
British Columbia Museum of Anthropology,
Vancouver, 1959-62
Bill Reid – Haida and Doug Cranmer –
Kwakwaka'wakw
Courtesy of the University of British Columbia
Museum of Anthropology, Vancouver, British
Columbia
Photography by Bill McLellan

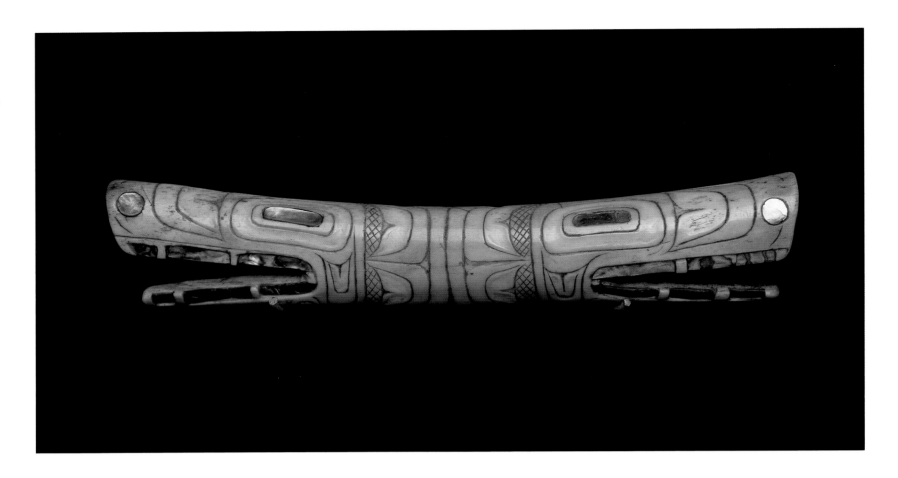

ABOVE:
Tlingit Soul Catcher, c. 1850
Carved femur bone of a bear, inlaid with
abalone shell
Length 8½ inches
Originally from the Oldman Collection,
England
Courtesy Morning Star Gallery, Santa Fe,
New Mexico
Photography by Addison Doty

BELOW:
Tlingit or Haida Grease Bowl,
c. 1840
Carved mountain sheep horn representing
totemic wolf
Courtesy Morning Star Gallery, Santa Fe,
New Mexico
Photography by Addison Doty

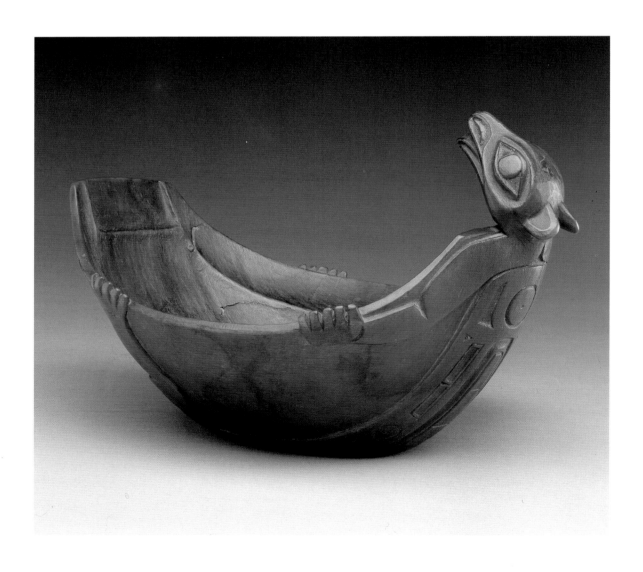

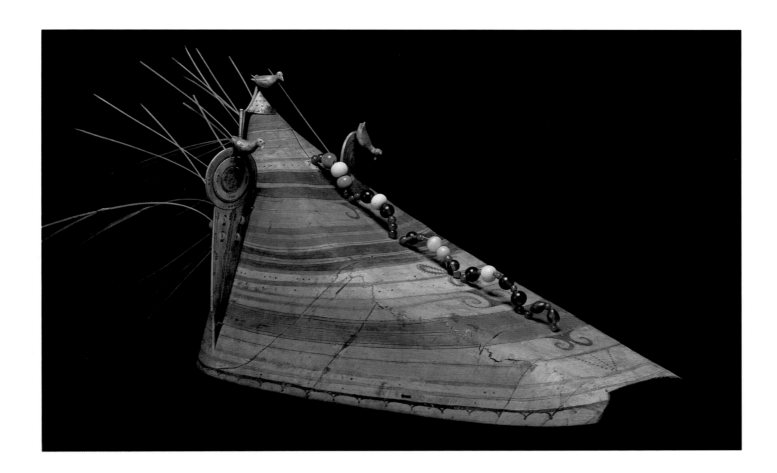

ABOVE:
Aleut Chief's Hat, Unalaska, Alaska
Carved from one piece of wood, decorated
with paint, metal, beads, ivory, sea lion
whiskers
10 × 18 inches
Peabody Museum of Salem, Massachusetts
Photography by Mark Sexton

BELOW:
Haida Thlinqwan Helmet, Southern
Coast of Prince of Wales Island, Alaska
Carved and painted wood representing eagle
National Museum of the American Indian
Smithsonian Institution

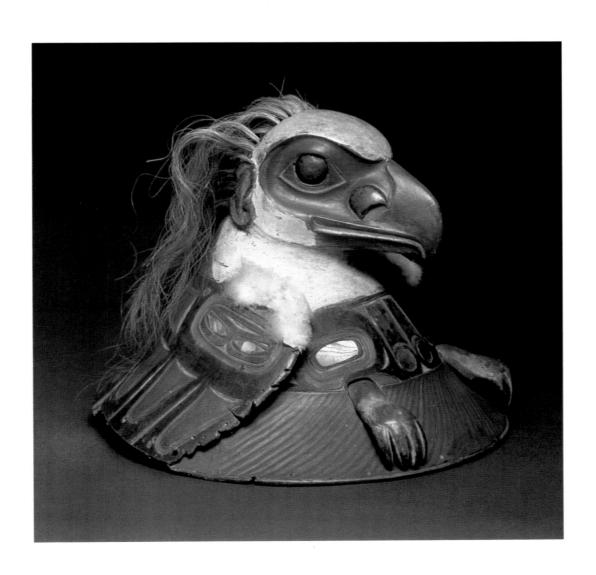

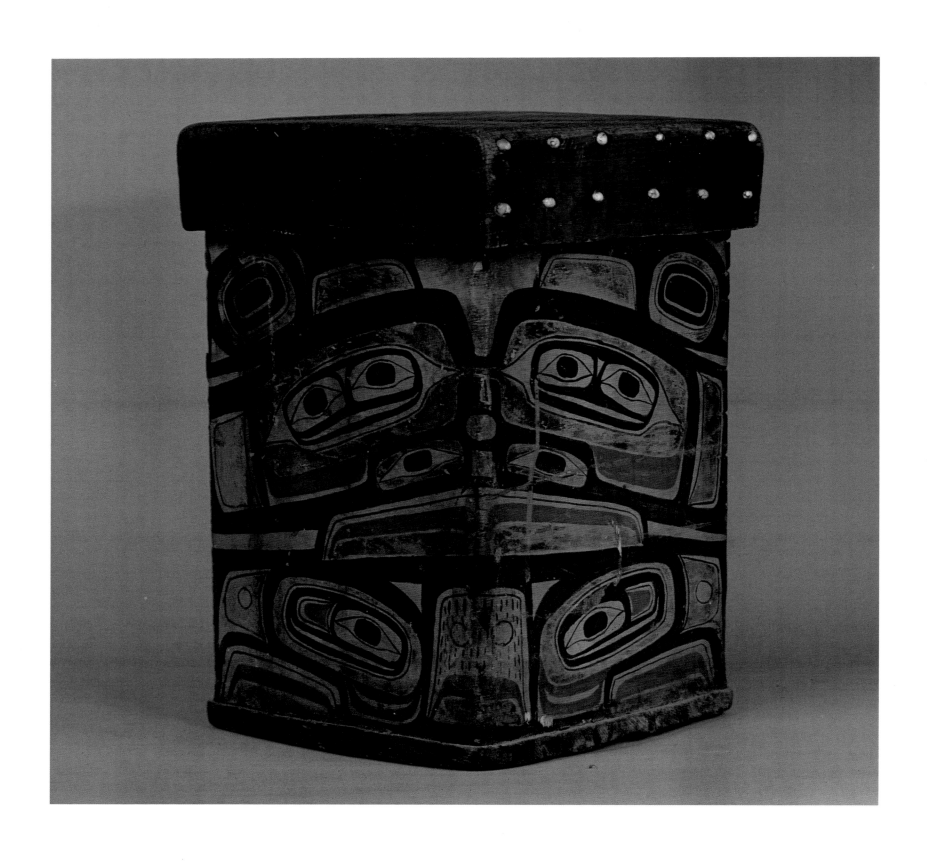

***Tlingit or Chilkat Storage Box with
Cover***
Painted single plank red cedar steamed and
bent, sewn with spruce root, sides of cover
decorated with opercula of sea snail
Height 11¾ inches with cover; cover 9 × 9
inches (does not belong to original box)
Sheldon Jackson Museum, Sitka, Alaska
Alaska State Museums

ABOVE:
Aleut Model of a Three-hatch Skin Boat with Three Human Figures,
c. 1890
Carved and painted wood, leather
Phoebe Hearst Museum of Anthropology
University of California, Berkeley

BELOW:
Inuit Cribbage Board, Nome, Alaska
Ivory carved in the shape of a caribou
National Museum of the American Indian
Smithsonian Institution

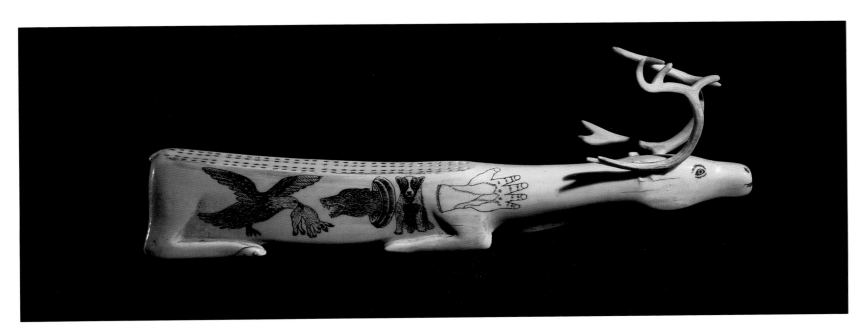

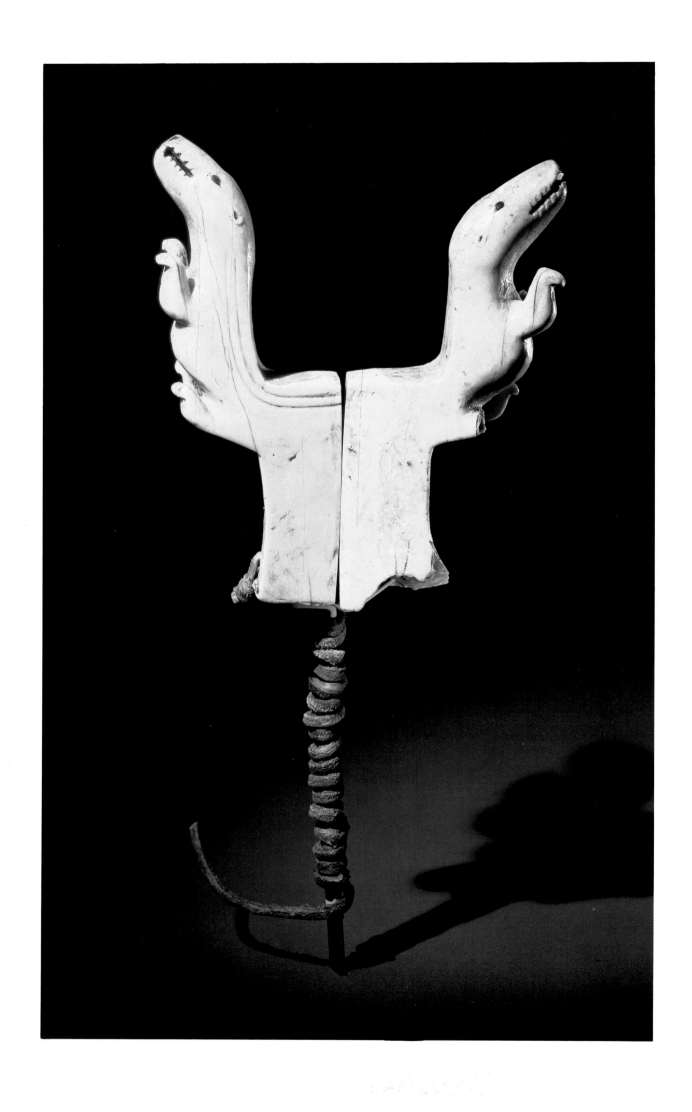

Inuit Harpoon Rest, Little Diamond
Island, Alaska
Carved ivory representing two bears
National Museum of the American Indian
Smithsonian Institution

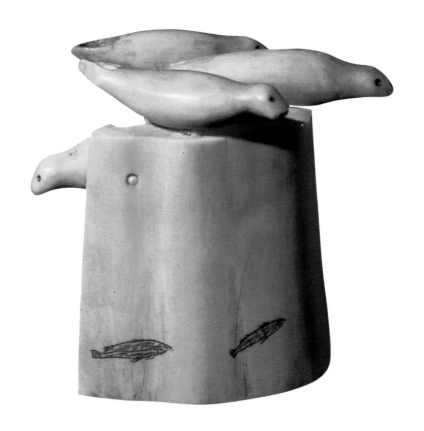

ABOVE:
Inuit Ivory Carving with Seals
National Museum of the American Indian
Smithsonian Institution

BELOW:
Inuit Carving, 1910-30
Carved walrus tusk representing walruses on
ice flow
Phoebe Hearst Museum of Anthropology
University of California, Berkeley

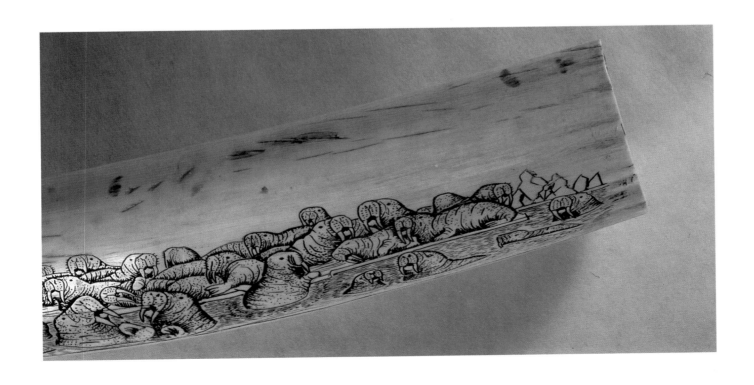

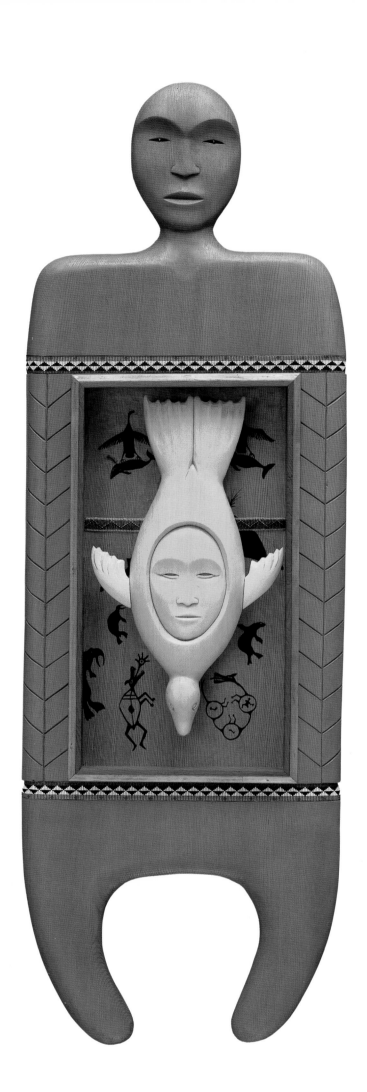

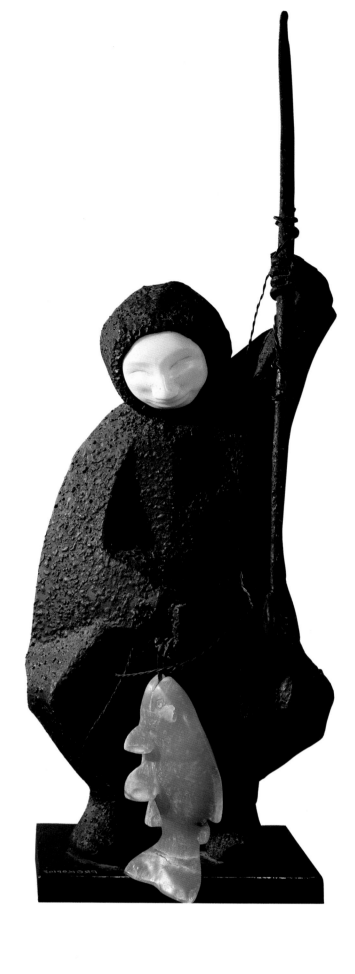

The Guardian of the Mask, 1992
Larry Ahvakana – Inuit (Inupiag)
Carved red cedar exterior, Alaskan yellow
cedar mask, loom-beaded work, acrylic paint
5 feet × 2½ feet × 5 inches
Courtesy of the Artist

For Those Who Sit and Wait, 1991
Bill Prokopiof – Aleut
Handmade steel, marble, candy alabaster
Height 36 inches
Courtesy of the Artist

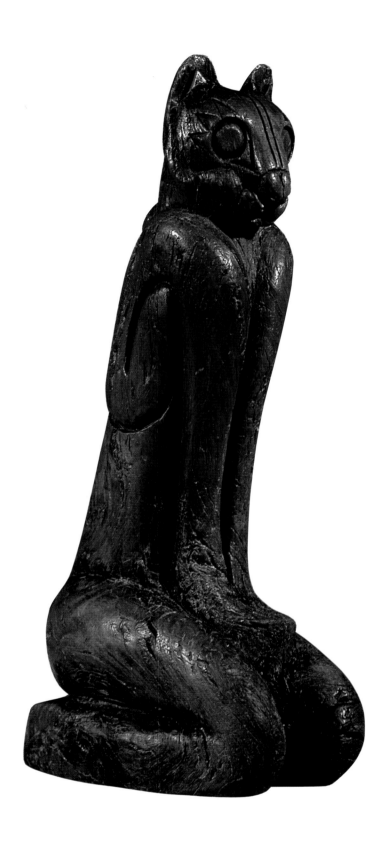

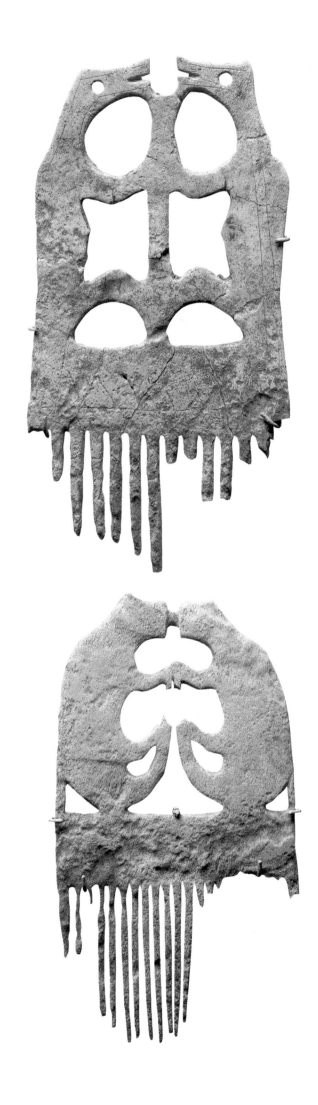

ABOVE:
Muskogean Kneeling Cougar
Figure, Key Marco, Florida, 16th century
Carved wood
Height 6 inches
National Museum of Natural History
Smithsonian Institution, Washington, D.C.

ABOVE RIGHT:
Iroquois Combs, 18th century
Carved antler
Courtesy Morning Star Gallery, Santa Fe,
New Mexico
Photography by Addison Doty

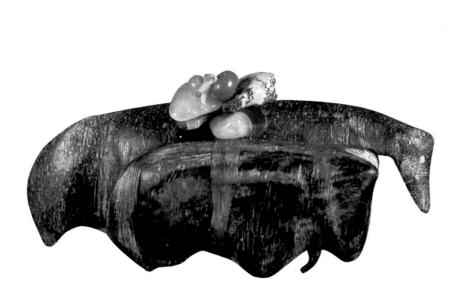

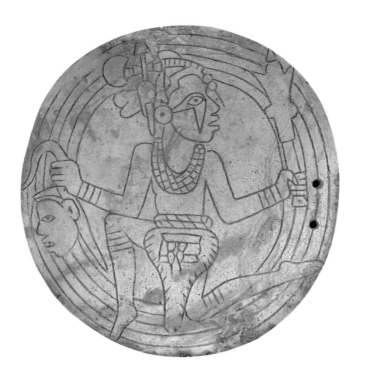

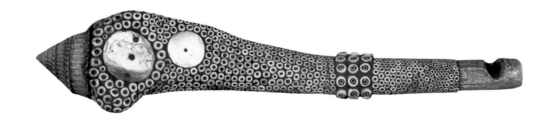

ABOVE:
Bone Whistle, San Nicolas Island,
California
Bone with shell inlay
Length 11 inches
National Museum of the American Indian
Smithsonian Institution

TOP LEFT:
Contemporary Fetish, New Mexico,
1993
Salvador Romero–Cochiti Pueblo
Carved local stone, gemstones, turquoise, glass
beads, attached with sinew
2⅛ × 1 inches
San Diego Museum of Man, California
Photography by Ken Hedges

TOP RIGHT:
Pre-Columbian Shell Gorget,
Castilian Springs, Sumner County, Tennessee
Incised shell, figure of man kneeling, holding
head in one hand and club in the other
National Museum of the American Indian
Smithsonian Institution

RIGHT:
**Echoes Through the Canyon,
Black Mesa,** 1992
Bruce LaFountain–Turtle Mountain Chippewa
Hand sculpted Belgian marble, Australian opal,
gold leaf, marble base
Height 6 feet
Photography by Jerry Jacka

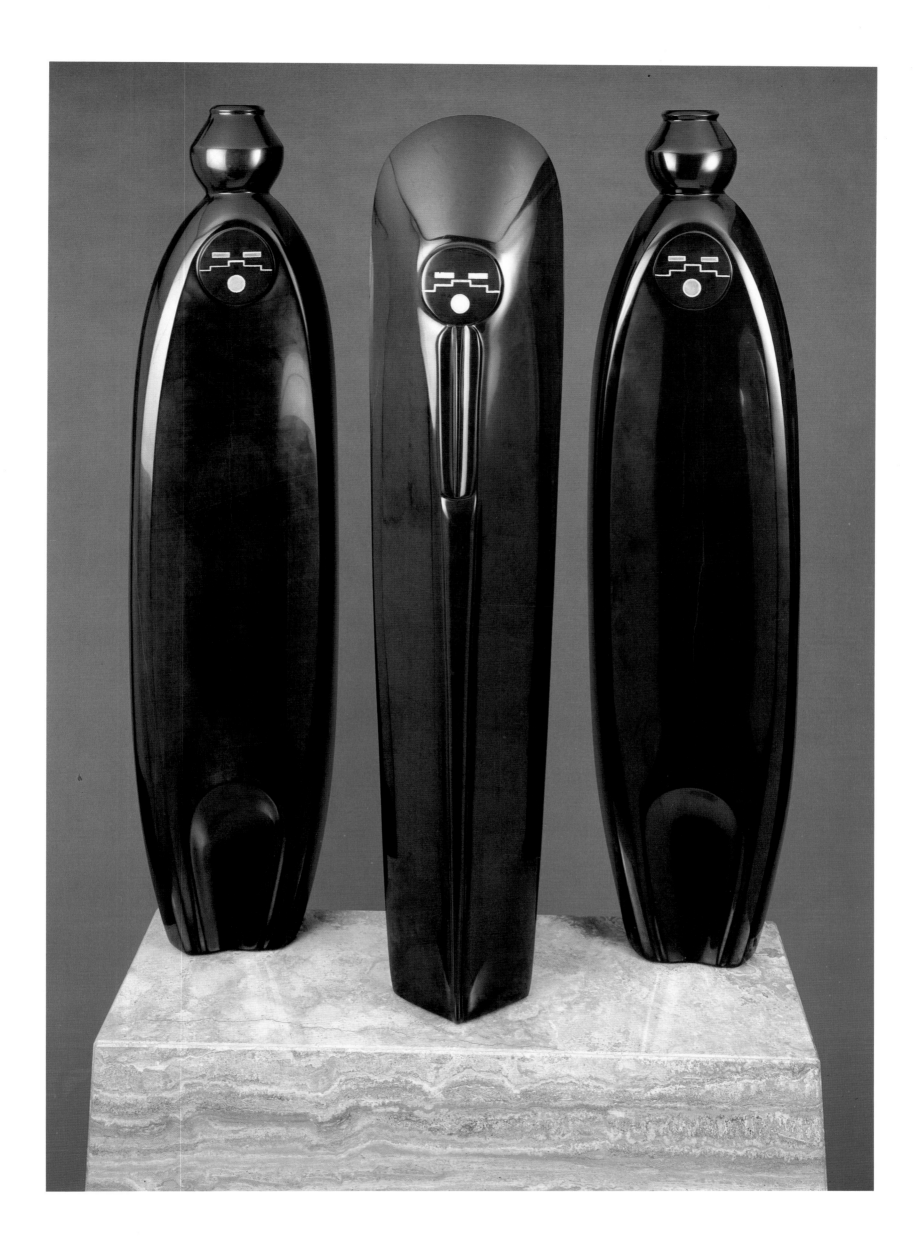

**Bases Stolen From the Cleveland
Indians and a Captured Yankee,**
1989
Gerald McMaster – Cree
Mixed media
Purchase 1989
McMichael Canadian Art Collection, Kleinberg,
Ontario, Canada

RIGHT:
Winter Shaman, 1990
Reuben Kent – Kickapoo/Iowa/Oto
Raku and mixed media
17½ × 11 inches
University of Kansas Museum of
Anthropology, Lawrence, Kansas
Photography by Jon Blumb

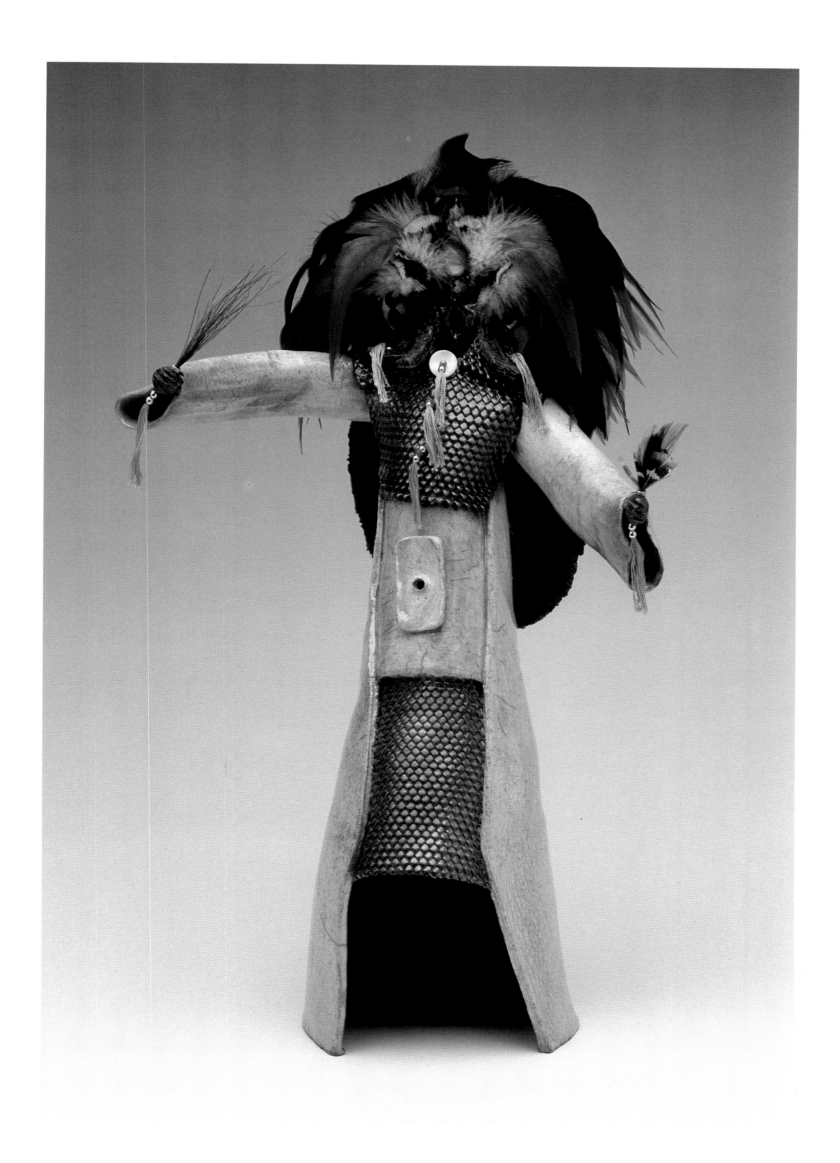

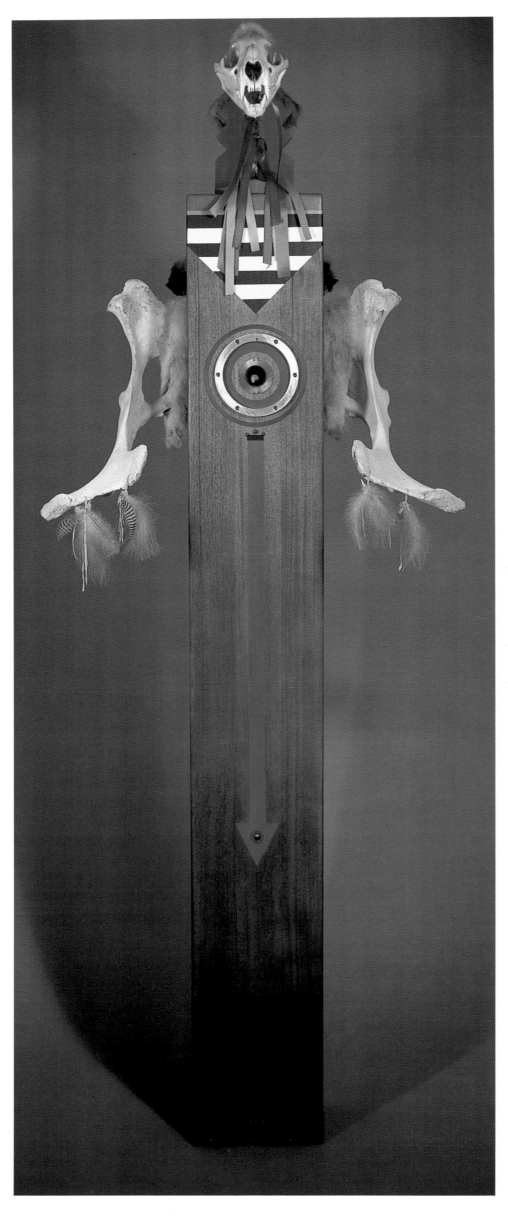

LEFT:
Mountain Lion Spirit Totem,
c. 1991
Doug Coffin – Potawatomi/Creek
Wood, paint, bones, glass, bronze
Height 7 feet
Courtesy of the Artist

RIGHT:
Earth Messenger Totem, c. 1991
Doug Coffin – Potawatomi/Creek
Painted steel
Height 28 feet
Collection of Wheelwright Museum, Santa Fe,
New Mexico
Courtesy of the Artist

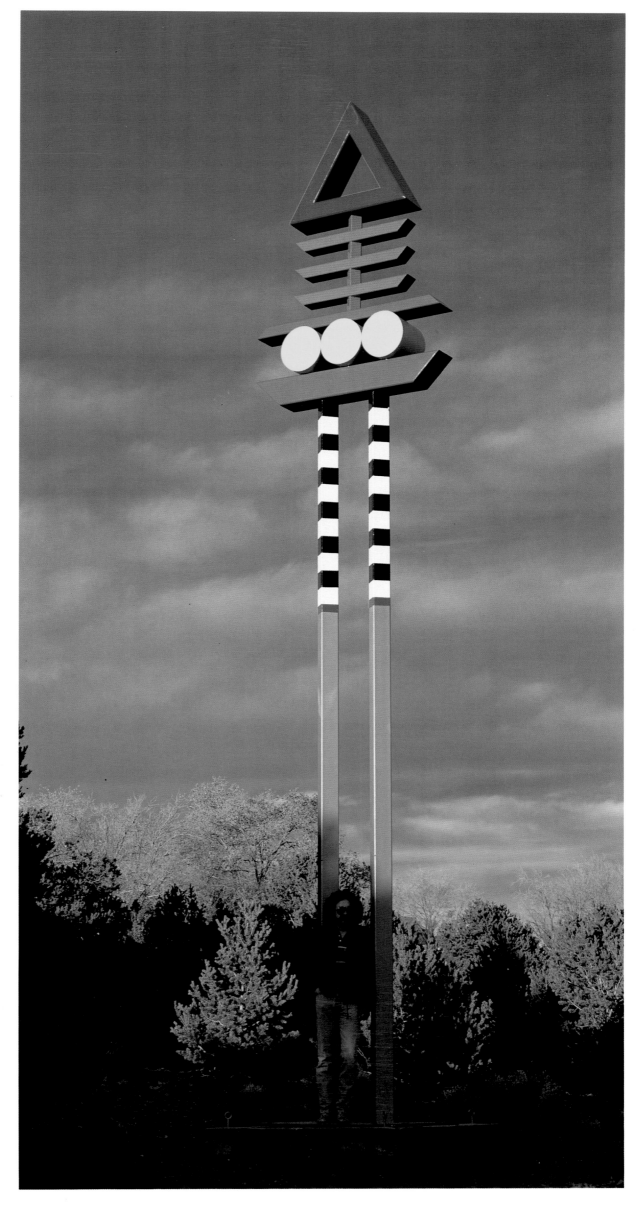

PAINTING

Native American painting has undergone profound changes in style and media throughout the twentieth century, but few contemporary artists have rejected their roots. Some pay homage to the past by using certain conventions of an earlier day, like the simple lines and flat colors of traditional hide painting, or the angular, one-dimensional figures of rock art. Others have adopted styles associated with Euro-American art, while their subject matter remains traditional, drawing upon the legends of the past to tell their stories to a new audience in a new way.

The Kiowa artist N. Scott Momaday is also a Pulitzer–prize–winning writer, who once described himself as "a man made of words." Now he is a man made of words and images – drawings, paintings, and prints that have been described as visual poetry.

Fritz Scholder, a Luiseño from Minnesota, became an instructor at the newly established Institute of American Indian Art (IAIA) in 1962. While there he completed his best-known series, the *Indian Series*, which combined Abstract Expressionism and Pop Art to ironic effect. One of his students there was T. C. Cannon, of Caddo and Kiowa heritage, who exhibited with Scholder. Their work is often compared. Sadly, Cannon died at the age of only thirty-one.

Bill Soza, a Cahuilla/Apache, is also a graduate of the IAIA whose work has been exhibited across the United States as well as in Europe. Politically radical, he participated in much of the Indian activism of the 1970s, and the boldness of his artwork echoes his political sentiments. Merlin Little Thunder, a Southern Cheyenne, paints scenes and themes from his native hills of Oklahoma. His work displays a timeless vision and reflects a sense of continuum in Native American thought and feeling.

Navajo artist R. C. Gorman has achieved success with his paintings of Navajo women, rendered with an economy of line that other artists attribute to his studies in Mexico. The women in Gorman's work are down-to-earth, proud, and reserved, often viewed in profile from behind, lending an air of distance and mystery. An example of his earlier work is shown on page 165. Another Navajo artist of renown is Emmi Whitehorse, who uses both familiar and abstract imagery in her striking compositions. The artist says, "As I move along in my career, it's like opening a door and stepping into another room."

Kevin Red Star, a member of the Crow tribe, is widely known for his powerful paintings, which include *Blackbird Headdress, Tipi Series Number 9*, and *Crow Indian Woman*. His work has been acquired by major museums and by collectors on the world market. Another notable Crow artist is Earl Biss, whose works have been acquired by the Institute of American Indian Arts Museum in Santa Fe.

Some artists have moved from a sardonic representation of life caught between two cultures to a spirit of reconciliation and wholeness. Such is the case with Harry Fonseca, a painter and sculptor who achieved great commercial success with his Coyote paintings prior to 1990. The character of Coyote appears in the stories of many tribes as a trickster and mischief-maker. Utilizing the techniques of modern art, Fonseca portrayed Coyote in many identities: actor, rock star, tourist – even himself, in the early work entitled *When Coyote Leaves the Reservation (a portrait of the artist as a young Coyote)*, complete with zippered leather jacket and platform work boots. In the last several years, he has reached more deeply into his background, using the petroglyphs of the Mojave Desert as a springboard from the past into a new kind of present exemplified in his series *Stone Poems*.

Jaune Quick-to-See Smith is a gifted artist of Cree/Flathead/Shoshone heritage who has been an outspoken advocate for Native issues. "By itself," she says, "this work isn't going to make change, but I hope it can move people – some people – to think about these issues."

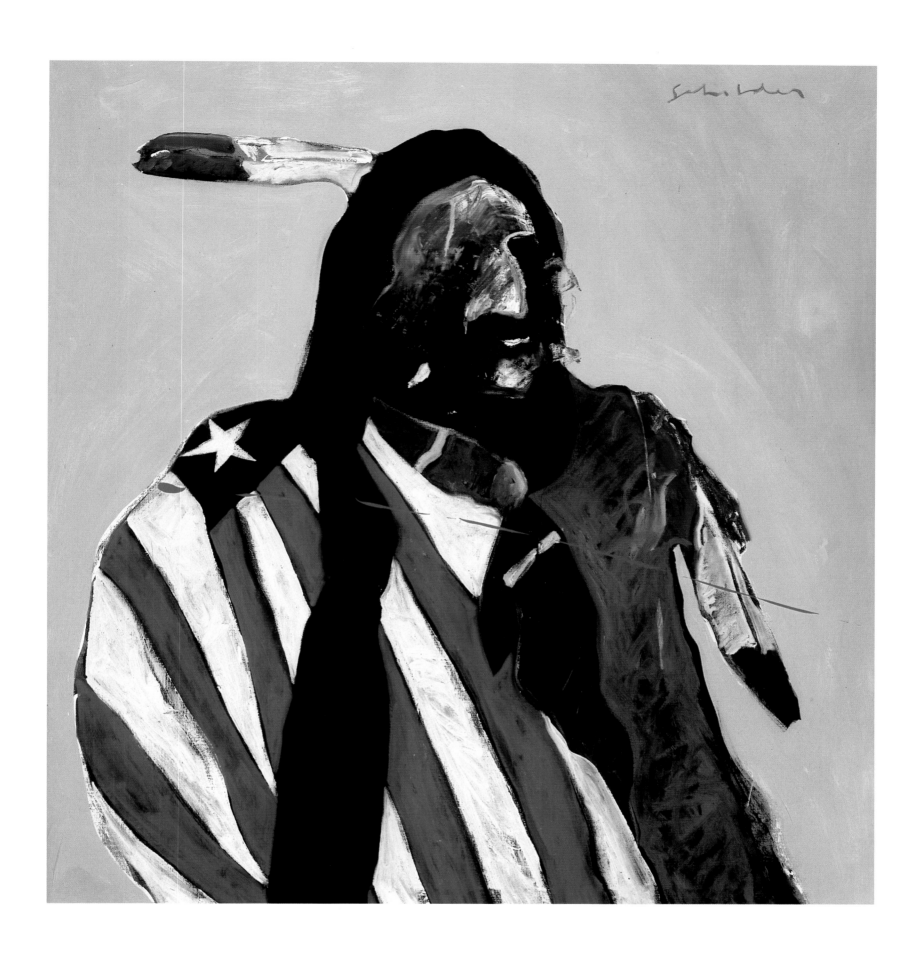

An American Portrait, 1979
Fritz Scholder – Luiseño
Oil on canvas
40 × 35 inches
Courtesy the Anschutz Collection, Denver,
Colorado
Photography by James O. Milmoe

Young Girl with Old Bull, 1988
N. Scott Momaday – Kiowa
Monotype
30 × 20 inches
Courtesy Lew Allen Gallery, Santa Fe, New
Mexico

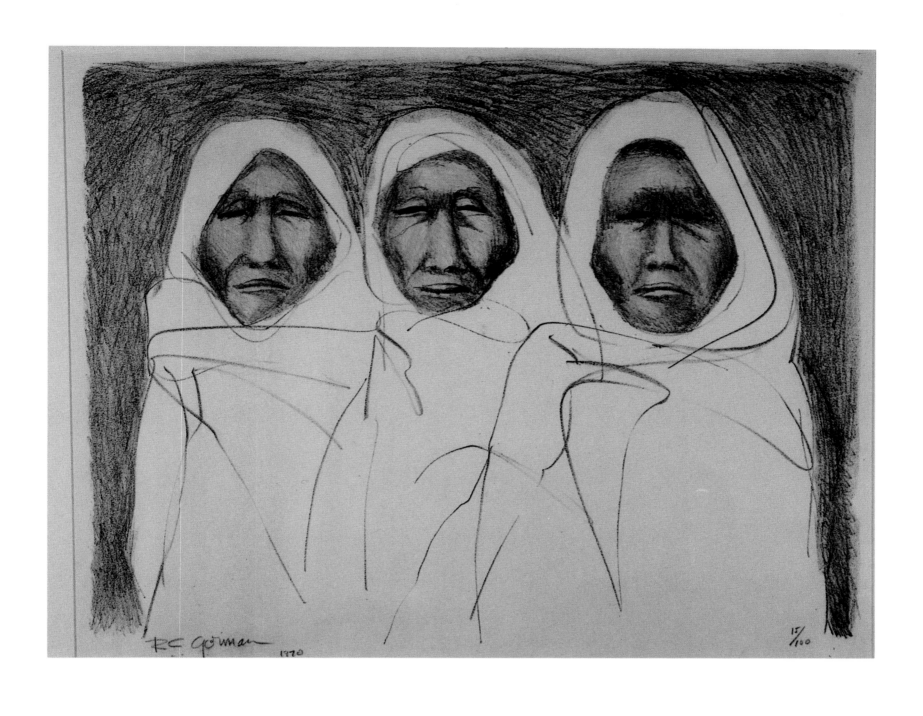

Three Taos Men, 1970
R. C. Gorman – Navajo
Charcoal drawing
19½ × 24 inches
Permanent Collection of the Institute of
American Indian Arts Museum, Santa Fe, New
Mexico
Photography by Larry Phillips

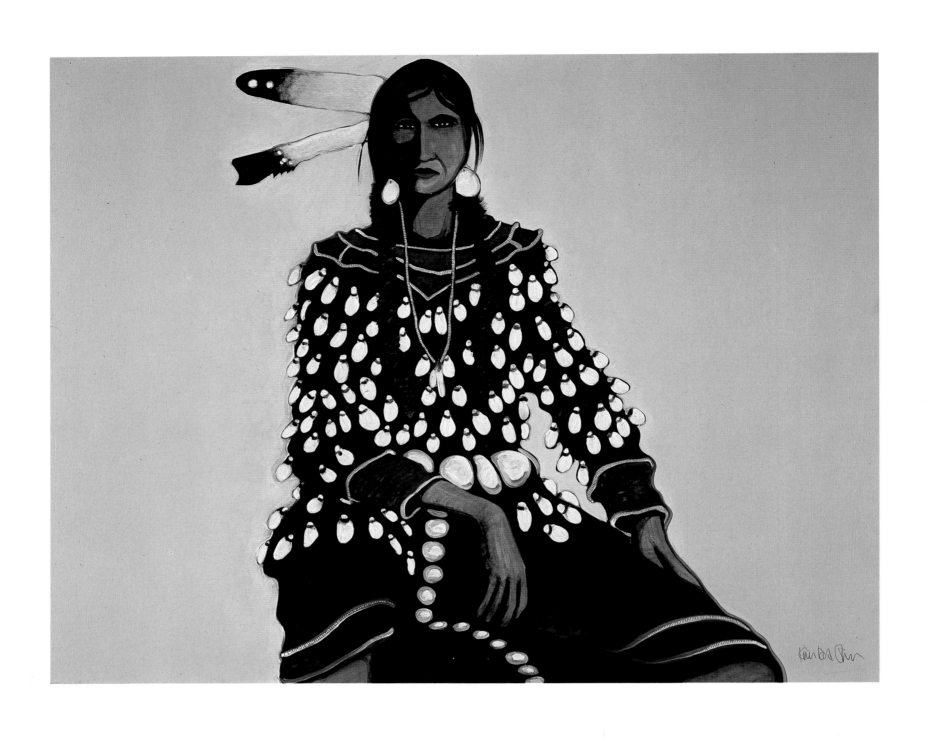

Crow Indian Woman, c. 1988
Kevin Red Star – Northern Plains Crow
Oil on canvas
30 × 40 inches
Courtesy Merida Gallery, Red Lodge, Montana

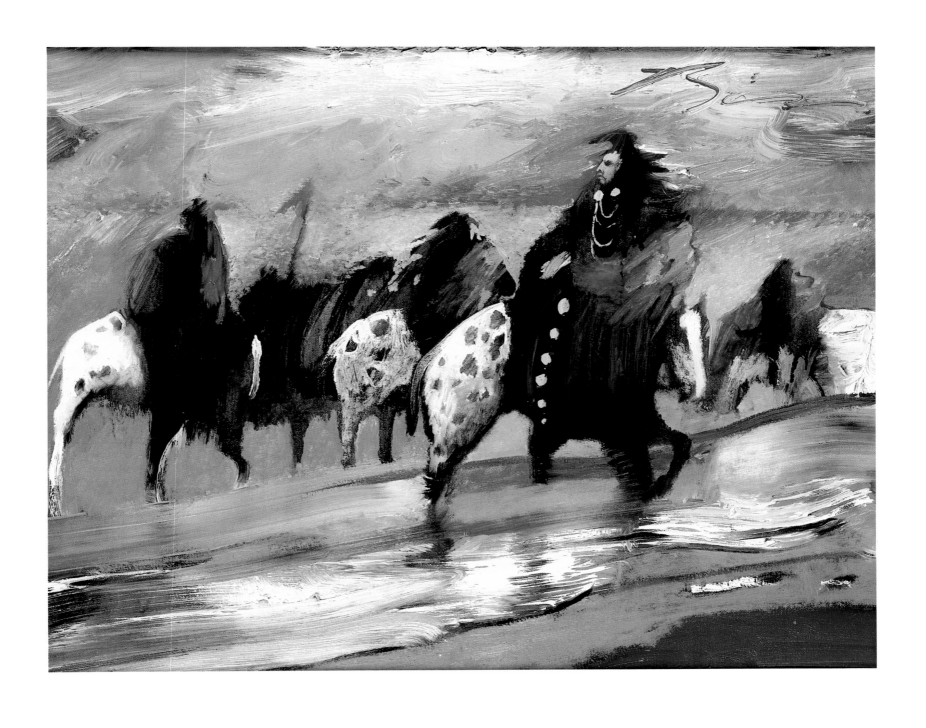

**Retreating Through the Back
Waters,** 1992
Earl Biss – Crow
Oil on canvas
18 × 24 inches
Collection of the Artist
Courtesy Joyner Publications, Ltd.

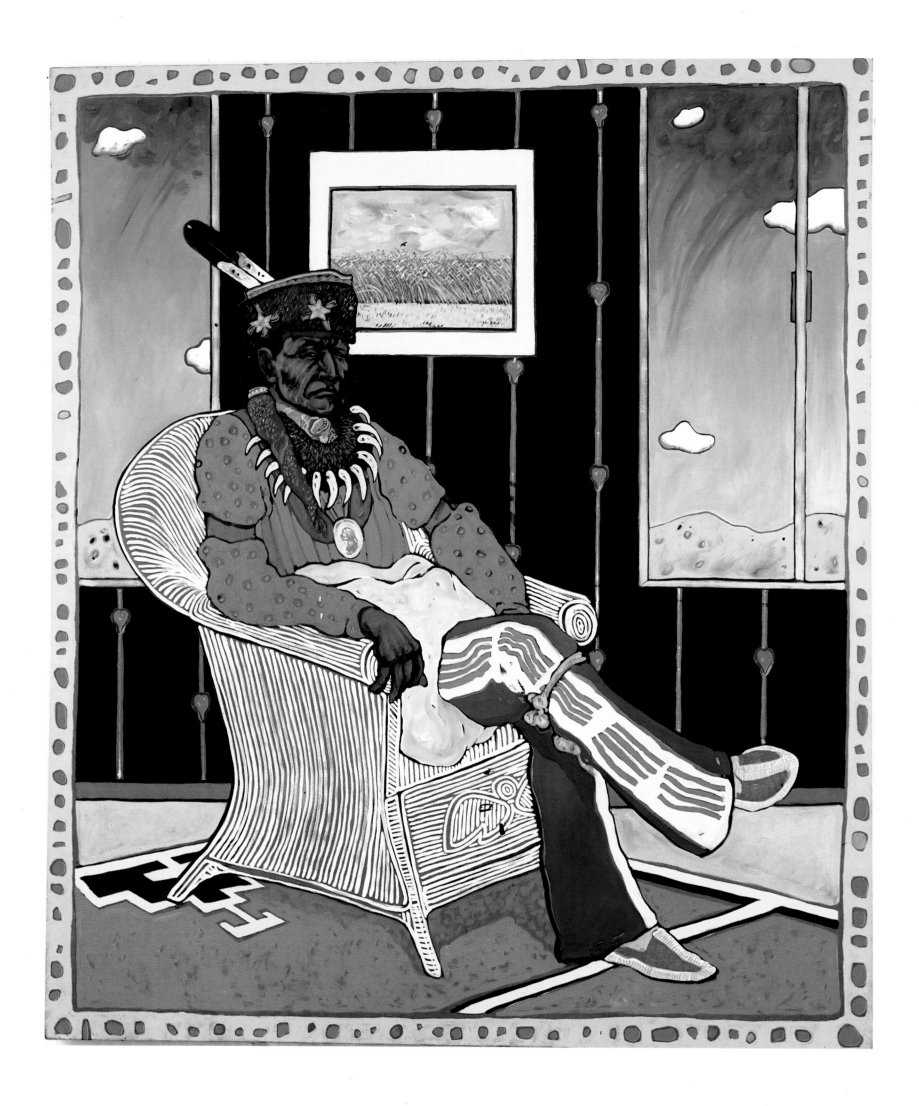

Collector #5, 1975
T. C. Cannon – Kiowa/Caddo
Oil and acrylic on canvas
80 × 72 inches
Private Collection

The Conversion, 1992
Emmi Whitehorse – Navajo
Pastel, oil, paper on canvas
51 × 78 inches
Courtesy Lew Allen Gallery, Santa Fe,
New Mexico
Photography by Dan Morse

She Walks With Spirits, c. 1992
Merlin Little Thunder – Southern Cheyenne
Watercolor
8½ × 6 inches
Courtesy Oklahoma Indian Art Gallery,
Oklahoma City, Oklahoma

RIGHT:
As He Awaits Dinner's Arrival,
1992
Bill Soza – Cahuilla/Apache
Oil on canvas
30 × 24 inches
Courtesy of Copeland Rutherford Fine Arts,
Ltd., Santa Fe, New Mexico

Oh! Zone, 1992
Jaune Quick-to-See-Smith – Cree/Flathead/
Shoshone
Mixed media/recycled material
48 × 60 inches
Photograph courtesy Lew Allen Gallery, Santa
Fe, New Mexico

173

Nocturne #12, 1990
Harry Fonseca – Maidu/Niesenan
Acrylic and paint stick on canvas
6 × 5 feet
Courtesy of the Artist

INDEX